THE
IRISH REVOLUT
AN ILLUSTRATED HIS
1912–25

THE
IRISH REVOLUTION
AN ILLUSTRATED HISTORY
1912–25

FERGAL TOBIN

GILL & MACMILLAN

Gill & Macmillan, Hume Avenue, Park West, Dublin 12
with associated companies throughout the world
www.gillmacmillanbooks.ie

Text copyright © 2013 Fergal Tobin

ISBN 978 07171 5603 0

Design and layout copyright © 2013 Red Lion Media, Northwich, Cheshire,
England

Index compiled by Grainne Farren
Design and Cartography: Red Lion Media

The picture credits on page 224 constitute an extension to this
copyright page.

A CIP catalogue record for this book is available from the British Library.

Printed in Poland

The paper used in this book comes from wood pulp of managed forests. For
every tree felled, at least one tree is planted, thereby renewing natural
resources.

Typeset in Sabon and Trajan

5 4 3 2 1

For
Isobel and Eoin

"The moment the very name of Ireland is mentioned, the English seem to bid adieu to common feeling, common prudence and common sense, and to act with the barbarity of tyrants and the fatuity of idiots."

Sydney Smith

"'Twas Irish humour, wet and dry,
Flung quicklime into Parnell's eye;
'Tis Irish brains that save from doom
The leaky barge of the bishop of Rome
For everyone knows the Pope can't belch
Without the consent of Billy Walsh.
O Ireland my first and only love
Where Christ and Caesar are hand in glove!"

James Joyce

CONTENTS

LIST OF MAPS AND GRAPHICS

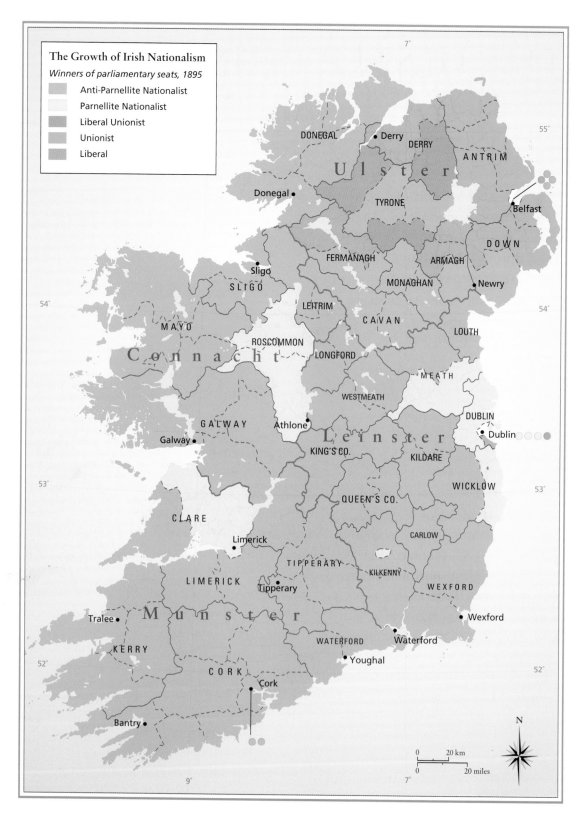

The Growth of Irish Nationalism
Winners of parliamentary seats, 1895

- Anti-Parnellite Nationalist
- Parnellite Nationalist
- Liberal Unionist
- Unionist
- Liberal

CHAPTER 1

THE ULSTER CRISIS: LOYALTY AND TREASON

The Ulster Crisis had been brewing since 1886. That was the year of the First Home Rule Bill, Gladstone's sensational demarche. The question of some kind of devolved administration in Dublin had, until then, been a taboo subject in British politics. The Act of Union of 1801, which had bound Ireland to the British metropolitan state, was simply non-negotiable. Ireland was an integral part of the United Kingdom, which could not contemplate the disaggregation of its core territory. Except that it had: when the Church of Ireland had been disestablished in 1869, a central pillar of the union had been subverted.

Ireland was an uncomfortable element in the UK. In an age when religious affiliation mattered, it was an overwhelmingly Catholic part of the British pan-Protestant state. True, there were different varieties of Protestantism on the larger island – most obviously in Scotland, where the sterner Calvinists might have thought the Church of England not much better than the Church of Rome. But a common opposition of continental Catholic power was the glue that bound Great Britain together.

While there were enormous cultural differences between the constituent elements of Great Britain, including linguistic differences, there were no corresponding political campaigns to weaken the

William Ewart Gladstone held the office of Prime Minister no less than four times between 1868 and 1894. He formed his last administration in 1892, at the age of 82.

Charles Stewart Parnell, founder of the Irish Parliamentary Party, described by Gladstone as "the most remarkable person I have ever met".

union: Scottish and Welsh nationalism hardly registered on any scale. Not so in Ireland, where the stark religious difference was compounded by precisely such a tradition. This went back to the 1820s or even, in some interpretations, to the 1790s. Whichever, by the 1880s it was in spate under the exceptional leadership of Charles Stewart Parnell.

It was his Irish Parliamentary Party, run with iron discipline, which held the balance of power at Westminster after the general election of 1885. He therefore had the leverage to put either the Tories or the Liberals into government. The Tories were never going to concede home rule as the price of power but Gladstone felt called upon to do so – whether out of expediency or genuine conviction is still a matter of dispute.

At any rate, Gladstone introduced the Home Rule Bill which was defeated in the Commons and prompted a split in the Liberal Party. He tried again in 1893; this time he won in the Commons and predictably lost in the House of Lords. By then, Parnell was dead and the Liberal Party had had quite enough of home rule for the moment. The last Gladstone government was merely a blip in an almost uninterrupted twenty-year period of Tory rule. In terms of practical politics, Irish home rule was a dead duck for as long as the Tories were in power.

In December 1905, however, the Liberals came back – winning one of the biggest landslides in British parliamentary history. They had no need of Irish support, so home rule did not return to the agenda. The Liberals had not forgotten the party split of 1886 and had no enthusiasm for constitutional adventures in Ireland. True, the Irish Parliamentary Party was still at Westminster. It had 82 MPs, making it the third largest party in the House of Commons.

But the Liberals had a majority of 124 over all other parties combined, so the Irish were not needed.

By the election of 1910, however, things had changed. The Liberals were able to hang on to office but only with Irish Party support – and the price for that support was home rule. This led to the third Home Rule Bill, which passed the Commons in 1912 and again was defeated in the Lords. But by now, their Lordships' wings had been decisively clipped: they now only had a power of delay, for two years, after which the will of the Commons would prevail. Home rule for Ireland would, therefore, become a reality in September 1914. That was the plan.

Ever since home rule had become a serious possibility in the mid-1880s, there had been a worm in the bud. It was correct to say that Ireland was overwhelmingly Catholic and that most Irish Catholics were political nationalists. But Ulster was not so: the historic nine-county province did indeed have a marginal Catholic majority, but the eastern part was solidly Protestant. It was also the only part of Ireland that had been touched by the industrial revolution: Belfast had developed into one of the great British industrial cities.

Ulster had always been different. Going back to antiquity, it had

Workers leaving the Belfast shipyard of Harland & Wolff. In the background, the Titanic *is taking shape.*

shared a common Gaelic culture with western Scotland whose principal Christian evangelist, St. Columba, had been Irish. It was girdled to the south by a network of low, undulating hills – drumlins – lakes and swamps which gave it very effective protection against incursions from the other three provinces. Until the development of metalled roads and the coming of the railway, seaborne communications with Scotland were easier than landward communications with the rest of Ireland. It had been the last redoubt of Gaelic Ireland to succumb to the English crown. But when it did – at the beginning of the seventeenth century – it was planted by a new population of English and Scottish Protestants who occupied Gaelic tribal lands forfeit to the crown.

The Plantation of Ulster was a transformative event in Irish history. It is too stark to say that it introduced an alien and inassimilable element into a country that had previously been homogeneous. None the less, the contingencies of history made assimilation hesitant and incomplete. In 1641, a Gaelic rebellion against the new order in Ulster ran out of control and resulted in horrible massacres of Protestants. The numbers of the dead were later exaggerated for propaganda purposes – something that helped to account for Cromwell's butchery of Catholics later in the decade – but the reality was bad enough. A suspicious sense of siege – of always being on guard against treachery – was forever close to the surface of Ulster Protestant consciousness thereafter.

Two things stand out about Ulster from that time on. First, the Plantation continued throughout the seventeenth century – more planters came in the second half of the century than in the first – and it aggregated to one of the biggest population transfers in Europe at the time. It was a major business. Second, it happened when Europe was convulsed by religious wars: 1641 and the Cromwellian campaign were a taste of what Germany was enduring in the Thirty Years War, the most destructive European conflict prior to 1914.

There was, therefore, nothing inevitable or foreordained about Ulster sectarian antagonism. That is not to deny its overwhelming reality. And that reality became more marked in the course of the nineteenth century, as Catholic nationalist power gained traction to the south, first under Daniel O'Connell and later under Parnell. At the same time, the agrarian south was devastated by the

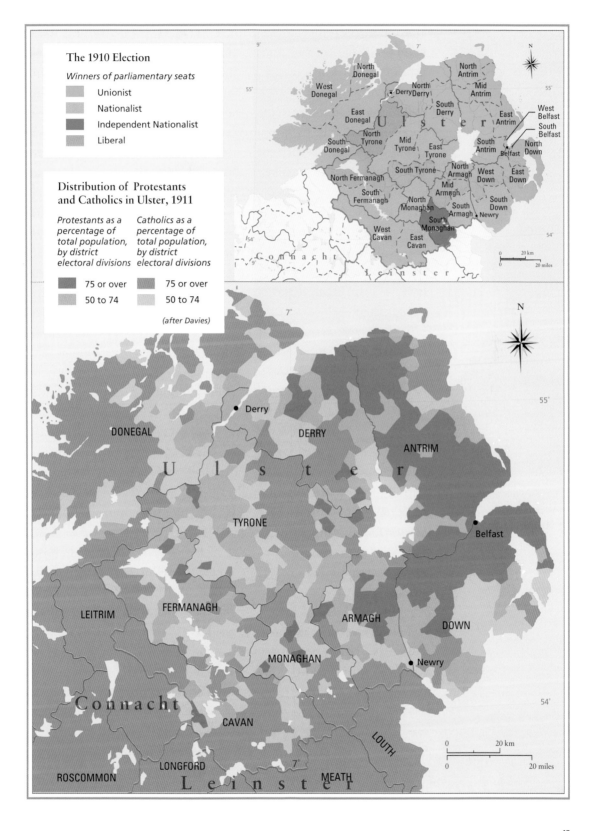

The 1910 Election

Winners of parliamentary seats

- Unionist
- Nationalist
- Independent Nationalist
- Liberal

Distribution of Protestants and Catholics in Ulster, 1911

Protestants as a percentage of total population, by district electoral divisions

Catholics as a percentage of total population, by district electoral divisions

- 75 or over
- 50 to 74

- 75 or over
- 50 to 74

(after Davies)

Sir James Craig, 1st Viscount Craigavon, ex-Imperial soldier, later MP for East Down, rallied and organised the Ulster Volunteers and purchased arms from the Kaiser's Germany.

Great Famine of 1845–52 while the industrial revolution was taking off in Protestant east Ulster: the contrast between the broken, impoverished south (Catholic) and the provident booming north (Protestant) was reassuring for people who found this kind of profiling congenial. Many did, in an age when 'race' was not yet a dirty word. Moreover, an evangelical revival in Ulster in the 1850s had reinforced the no-Popery element, especially in the Presbyterian tradition.

Thus it was that, by the time home rule became a live issue in the 1880s, Ulster was effectively divided between Protestant Unionists and Catholic Nationalists. The Unionists were concentrated in the eastern coastal counties and, to a lesser degree, in an east-west band running to the south of Lough Neagh. South and west of these areas, the map turned green. The 1885 general election – the one whose result prompted Gladstone's sudden conversion to home rule – established an electoral pattern in Ulster that has proved enduring. Every constituency with a Catholic majority returned a Nationalist, and each one with a Protestant majority a Unionist of some sort or other. The 33 Ulster seats split 17–16 in favour of the Nationalists across the nine counties.

Between 1885 and 1910, nothing changed to disturb this pattern. The 1910 election had produced a similar split in the province. The electoral map was a perfect reflection of this confessional demography. With just a single exception, every constituency in the three most heavily Protestant counties – Antrim, Down and Armagh – returned a Unionist. The exception was South Down which had a local Catholic majority.

With the benefit of hindsight, we know that Ireland was parti-

tioned. But in the years before the Great War, partition was on no one's mind. It was unthinkable – not in the sense of inducing horror, although it might, but in the sense of simply not being part of contemporary mental furniture. It just did not occur to people, so total was the assumption of insular unity and integrity on all sides.

This is important in all that followed, because in mobilising against the threat of home rule, Protestant Ulster was aiming to scupper it for the whole island.

In March 1905, the Ulster Unionist Council was formed in Belfast. Northern unionists had been alarmed at the conciliatory manner of their southern counterparts during the negotiations that preceded the Land Act of 1903. The differences between southern and northern unionism were clear. In the south, the remnants of the old ascendancy were reduced in fortune, land and prestige. In the north, a self-confident commercial plutocracy had been created by the industrial revolution.

Edward Henry Carson campaigned against home rule and was the first to sign the Ulster Covenant on 28 September 1912.

The formation of the UUC announced the creation of a communal solidarity that reflected that which existed on the nationalist, Catholic side. Given the fractious nature of Protestantism, with its emphasis on individual conscience and judgment, this was a more difficult task than it seemed. Indeed, the kind of organisational unity represented by the UUC was easiest to sustain in times of crisis. When the crisis passed or abated, the underlying tensions resurfaced.

One of the great ironies of the Irish Revolution is that it was started by those who least wanted it. The Ulster unionists wanted nothing more than the status quo, the maintenance of the union of Great Britain and Ireland that had subsisted since 1801. Their faith in parliament had been well placed for a generation, but now all

John Edward Redmond eventually achieved the Irish Home Rule Bill in September 1914 which granted a form of self-government.

that was changing. Since home rule first became an issue in the mid-1880s, Ulster could always rely on the House of Lords to torpedo any proposed legislation. By November 1910, however, the danger of a Liberal government beholden to the Irish Parliamentary Party for its majority was sufficiently real to push the Ulster Unionist Council over the brink. The Parliament Act was already over the horizon, set to remove the Lords' veto and therefore the surest bulwark against home rule.

Sir James Craig was the very epitome of the new Ulster plutocrat. He was the hatchet-faced heir to a distillery, very rich and from 1906 a Unionist MP at Westminster. He was meticulous. He was no orator and had little charisma, but he was at the heart of every Unionist intrigue in this period. One month before the election of December 1910, he was one of those on the Ulster Unionist Council who authorised the setting up of a secret committee to buy arms from abroad with a view to forming an Ulster army to resist home rule. In planning armed resistance to the will of parliament, they were set on the path of treason. And that is what the Ulster Crisis was all about: treason in defence of the constitution.

It was the Rubicon moment.

The work of securing arms for the putative Ulster army was devolved to an exotic. Major Frederick Hugh Crawford had been at the wilder margins of Ulster unionism since the early 1890s. As a member of the Ulster Loyalist Union – formed to focus opposition to the first two Home Rule Bills – he had imported arms from England and organised the drilling of volunteers. On the strength of all this, he founded an armed society called Young Ulster which toyed briefly with the idea of kidnapping Gladstone, at that time

84 years of age and in his fourth and final term as Prime Minister. Crawford later saw more orthodox service as an officer in the Boer War. This was the person to whom the Ulster Unionist Council devolved the business of arming Protestant Ulster.

With the passing of the Parliament Act the UUC plunged ever deeper in. As early as March 1911, it was voting funds for Crawford's enterprise. The first arms had been secured by the summer of that year. As early as April, a body of armed Orangemen in military formation had presented themselves at a rally in Craigavon, Sir James Craig's splendid country house outside Belfast. The paramilitary mobilisation would continue to gather pace throughout 1911 and 1912.

In the meantime, the political game moved on. Craig was the Ulster Carnot, the 'organiser of victory', but he was no leader and he knew it. Instead, he turned to Edward Carson to assume the leadership of the anti-home rule cause. Carson was an inspired if unlikely choice. He was not from Ulster, but from Dublin. He was born into a prosperous professional family – his father was a successful architect – and he himself became a barrister. He practised at first in Ireland, where he made a reputation for himself as a tough crown prosecutor during the land agitations of the 1880s. This brought him to the notice of the Chief Secretary, Arthur Balfour, nephew of the Prime Minister and later to be leader of the Tory Party and Prime Minister himself.

Carson was called to the English Bar in 1893, one year after his election to the House of Commons as MP for his alma mater, Trinity College. He was appointed Solicitor-General for Ireland and later Solicitor-General for England (1900–05). But his most celebrated and notorious achievement had been not in politics but at the Bar. In 1895, he was counsel for the defence in the libel action taken by Oscar Wilde against the Marquess of Queensberry, the father of Wilde's lover Lord Alfred Douglas. His destruction of Wilde in cross-examination confirmed his reputation as one of the most feared and respected lawyers in Britain.

The Unionists had therefore just found a leader from the heart of the Conservative establishment. Notwithstanding this background, Carson was under no illusions about the guns. Lawyer or no lawyer, he saw them as essential to the course that the Ulster resistance was now embarked upon. As a southern unionist,

The Titanic, *the most famous ship ever to sail and sink, and the supreme symbol of Belfast's industrial might.*

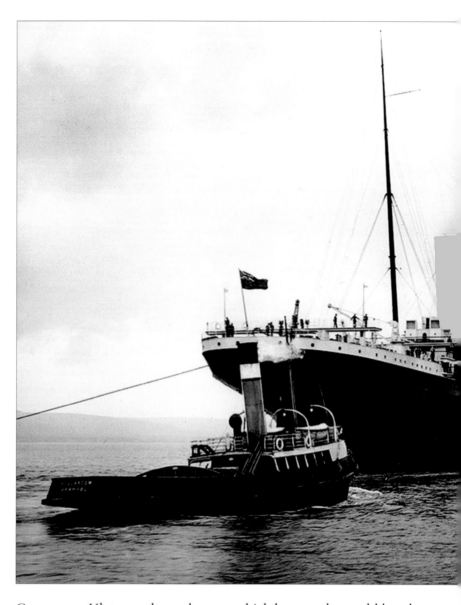

Carson saw Ulster as the rock upon which home rule would break, for he reckoned that if Ulster could stay out the whole enterprise would collapse. Carson's concern was for Ireland in the union, not just Ulster. Like almost everyone else among his contemporaries, he simply could not imagine the island partitioned.

Carson made his first major speech as Unionist leader in September 1911, once again at a rally in Craigavon. There was no ambiguity: "We must be prepared, on the morning home rule passes, ourselves to become responsible for the government of the Protestant province of Ulster." If this was not a threat of de facto seces-

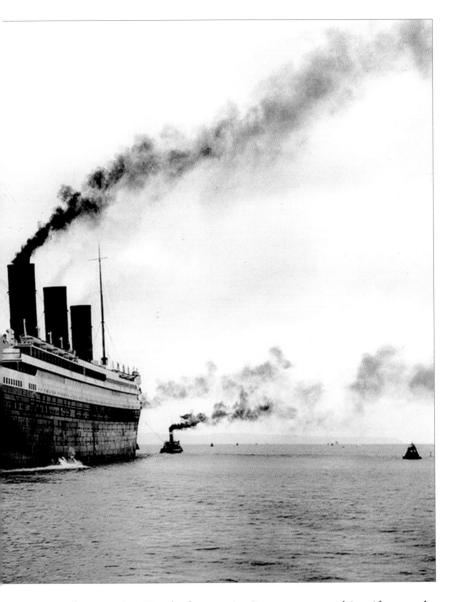

sion, what was it? Yet the lawyer in Carson was nothing if not subtle and ambiguous. Behind the scenes, he used his well-oiled political connections to try to reach successive accommodations with the government, while stirring up his Ulster audiences with inflammatory public speeches of great force and power. Carson was playing an Irish political game as old as Daniel O'Connell – he would hardly have welcomed the comparison – by using his control of the outraged mob as a lever to extract concessions from a frightened government.

Throughout 1911 and 1912, the process of political mobilisa-

tion, occasional importation of arms and drilling continued apace in Ulster. Drilling was illegal unless a permit was granted by a magistrate, but since most of the magistrates were unionist in sympathy, that little formality was seldom a problem. The threat against which it was all focused was made flesh in the House of

Edward Carson presents 'colours' to a newly-formed battalion of the UVF, late 1912.

Commons on 11 April 1912 when Asquith introduced the Third Home Rule Bill, a moment that prompted John Redmond, the leader of the Irish Parliamentary Party, to thank God that he had lived to see the day. It was, incidentally, just three days before the sinking of the *Titanic*.

With the safety net of the House of Lords now gone, Ulster was thrown entirely upon its own resources. Well, almost. The Conservatives were demoralised after the passage of the People's Budget and the Parliament Act and in November 1911 Arthur Balfour had been forced aside in favour of a very different type of leader, Andrew Bonar Law. He had been born in Canada and brought up in Glasgow and significantly was of mixed Ulster and Scots background. His father had been born in Coleraine and had been the Presbyterian minister there before leaving for Canada. Where Balfour had been a southern grandee, Bonar Law was closer in knowledge, sympathy and formation to the tough Presbyterian ethic of the Ulster Protestants with whom he shared a visceral sympathy. Bonar Law's arrival as Tory leader deepened the overt bond of sympathy and co-operation between the Ulster Unionists and the Conservative Party. He shared platforms with Carson and injected an element of righteous fury to the British anti-home rule opposition that sat very easily with the Ulstermen.

Bonar Law was the incarnation of growing British Tory opposition to home rule, most memorably captured in Kipling's poem *Ulster 1912*. At Easter that year, as the Home Rule Bill was being introduced in the Commons, he spoke to a loyalist crowd of over 100,000 in Belfast. Prayers were read by the Anglican primate and the Presbyterian moderator. Hymns were sung, resolutions against home rule passed, and the largest union flag ever made was flown aloft. Bonar Law spoke from the heart: "Once again you hold the pass, the pass for Empire. You are a besieged city. The timid have left you. Your Lundys have betrayed you, but you have closed your gates. The government have erected by their Parliament Act a boom against you to shut you off from the help of the British people. You will burst that boom."

This overt series of references to the siege of Derry in 1690, a moment of resistance that was central to the Ulster Protestant historical imagination, was no accident. (Lundy was the governor of Derry who had thought resistance futile.) In the end, the isolated Protestant garrison, besieged for 105 days by Jacobites, had been rescued by a ship that burst the Jacobite boom across the Foyle River and brought supplies and relief to the town. For Bonar Law's audience, this was stirring, emotional stuff establishing a direct connection with heroic ancestors. Nor did Law reserve his bravura

rhetoric for easily swayed Ulster audiences. Later that summer, in England, he declared unambiguously that "I can imagine no lengths of resistance to which Ulster can go in which I would not be prepared to support her." This man was the Leader of His Majesty's Loyal Opposition.

On 28 September 1912, Carson and Craig pulled off a stunning *coup de théâtre*. They had declared this to be Ulster Day and for it they prepared Ulster's Solemn League and Covenant, a declaration couched in suitably Biblical rhetoric which read in full as follows:

> *Being convinced in our consciences that home rule would be disastrous to the material well-being of Ulster as well as to the whole of Ireland, subversive of our civil and religious freedom, destructive of our citizenship and perilous to the unity of the Empire, we, whose names are underwritten, men of Ulster, loyal subjects of His Gracious Majesty King George V, humbly relying on the God whom our fathers in days of stress and trial confidently trusted, do hereby pledge ourselves in Solemn Covenant throughout this our time of threatened calamity to stand by one another in defending for ourselves and our children our cherished position of equal citizenship in the United Kingdom and in using all means which may be found necessary to defeat the present conspiracy to set up a Home Rule Parliament in Ireland. And in the event of such a Parliament being forced upon us we further solemnly and mutually pledge ourselves to refuse to recognise its authority. In sure confidence that God will defend the right we hereto subscribe our names. And further, we individually declare that we have not already signed this Covenant.*
>
> The above was signed by me at _____
> Ulster Day, Saturday 28th, September, 1912.
> God Save the King

This document was signed first by Carson at a table covered in the union flag and set up in the vestibule of the City Hall, Belfast. In all, 237,368 men signed the Covenant that day, some in their own

blood. A total of 234,046 women signed a similar document, highlighting a relatively neglected aspect of the Ulster Crisis, the very full part played by women. The clarity of the language in the Covenant speaks for itself, as does the plain determination of those who drafted it and signed it. The language is Biblical in tone, but the document contains a further religious context that would have resonated easily in Protestant Ulster. The original Solemn League and Covenant of 1643 was an agreement made between Scots Presbyterians and English Dissenters to join forces in the Civil War against King Charles I. Thus it could be represented as a union of the virtuous against the impious forces of overweening authority. This is roughly how the Ulster Protestants saw themselves in 1912.

On New Year's Day 1913, an amendment to the Third Home Rule Bill, to exclude Ulster from its provisions, was defeated. It was not the first such proposal: in the previous June, an amendment in the name of a Liberal MP, T.G. Agar-Robertes, had proposed the exclusion of the four most Protestant counties of Ulster: Antrim, Down, Derry and Armagh. It too was defeated, but these were significant amendments. Faced with the implacable advance of the nationalist demand and the adamantine resistance of the unionists, the possibility of partition as a solution was being raised for the first time. By 16 January, home rule was through the Commons. The Lords wasted no time over it: by the 30th, they had thrown it out. But thanks to the Parliament Act, their power was now only one of delay. In two years, there would be home rule for Ireland.

The very next day, the Ulster Volunteer Force was formed. This formalised what had been happening on the ground among the various drilling militias over the previous two years and brought them under a central command. In turn, the leadership of the UVF was under the control of the leadership of the Ulster Unionist Party. This was no rag-tag force. It numbered almost 90,000 men and its officers were retired British Army personnel, including such luminaries as the commander, General Sir George Richardson, and Captain Wilfrid Spender. For its first year of life, the UVF had very few arms and had to rely on wooden dummies instead. But always in the background, beavering away, was Fred Crawford. In little more than a year, his efforts were to transform the situation, as we shall see.

By September 1913, 500 delegates to the Ulster Unionist Coun-

cil approved the establishment of a Provisional Government of Ulster to be chaired by Sir Edward Carson. It met for the first time on 10 July 1914, just weeks before the world collapsed into war and shelved the Ulster impasse for four years. But it was a further raising of the stakes for all concerned. In December 1913, the government pronounced a ban on the importation of arms into Ireland.

The government supposed, naively as it turned out, that this eliminated any threat of arms from abroad being shipped into Ireland in support of militias, whether unionist or nationalist. Ulster was their main concern, and they now grew worried that the UVF might attempt to raid army arms depots in the province in order to arm themselves. Accordingly, the War Office in London gave instructions to Major-General Sir Arthur Paget, the Commander-in-Chief of the British Army in Ireland, to prepare plans for the movement of troops to protect the depots. Paget was stationed at the Curragh, about 35 miles south of Dublin. He foolishly let it be known that officers domiciled in Ulster could simply look the other way and would not be forced to move against their own province and people. All other officers would be expected to obey orders in the normal manner. At this, Brigadier-General Sir Hubert Gough, officer commanding the 3rd Cavalry Brigade, called a meeting which resulted in 60 officers offering to resign their commissions rather than have any part in coercing loyal Ulster. The fact that any such action was for the protection of army property and matériel and the maintenance of the law seems not to have occurred to them or, if it did, it did not weigh very heavily with them.

Gough led a delegation to see General Sir Henry Wilson, who was both the Director of Military Operations and a deep-dyed Tory ultra, in London. The War Office refused the offers of resignation, stating that the government intended to take no offensive action against Ulster. This statement was made without government authority and the subsequent furore brought the resignations of the Chief of the Imperial General Staff, Field-Marshal Sir John French, the Adjutant-General, Sir Spencer Ewart, and the Secretary of State for War, Colonel John Seely.

These were not little players and their defenestration shows just what a serious matter the Curragh Mutiny was. Some historians have preferred to call it the Curragh Incident, on the quibbling pretext that no direct orders were disobeyed. That is sophistry. The

Irish poison had run so far in the British bloodstream that for the first time since 1688 the civil power could not depend on the army to do its bidding.

Barely a month after the Curragh Mutiny, the arms depots became largely irrelevant. On the night of 24/25 April 1914, the UVF landed 25,000 rifles and 3 million rounds of ammunition at Larne, Co. Antrim (see Chapter 3).

The cumulative effect of these events in the first half of 1914 pushed the government ever more despairingly towards some attempt to reconcile the irreconcilable opposites. With home rule enacted and awaiting enablement, with the army uncertain after the Curragh, with the stony determination of Protestant Ulster in no doubt after Larne (not that there had been much doubt before), with Bonar Law's Tories shoulder-to-

David Lloyd George, lawyer, statesman and Liberal Prime Minister. Previously a supporter of home rule, he was present at the Palace Conference of July 1914 which attempted to bring all the principals together to find a solution for the Ulster Crisis.

shoulder with Carson, it seemed that something had to give. Lloyd George suggested that Ulster counties with Protestant majorities could opt out of home rule for the first six years, an offer spurned by Carson as "a sentence of death with a stay of execution for six years".

Finally, at the last minute of the eleventh hour, the Buckingham Palace Conference of July 1914 was an attempt by King George V to bring all the principals together in a final search for an accommodation. The rather touching British belief in the endless potential of compromise solutions hit a brick wall in three days. Asquith and Lloyd George; Law and the Tories; Redmond and John Dillon from the IPP; Craig and Carson: they were all there under the chairmanship of the Speaker of the Commons. The intractable question of Ulster simply could not be neutralised by a formula. The impasse that had prompted the conference was too great.

It is impossible for us to re-create the mid-summer of 1914 as contemporaries saw it. We know that they stood on the volcano's edge. The war that broke out less than a fortnight after the end of

the Buckingham Palace Conference transformed everything. Home rule became law in September but was suspended until the end of the war, by which time it was irrelevant. The UVF became the 36th Ulster Division of the British Army and were slaughtered on the first day of the Battle of the Somme. Nationalist Ireland's demands became more radical and urgent under the pressure of a new generation. It is to the nationalist side that we turn next.

Before we do, it is worth reflecting on the Ulster Crisis. In one sense, in the palpable existence of Northern Ireland, it is with us still. In terms of its contribution to the Irish Revolution, however, it seems to me to have two critical elements. First, under pressure from Protestant resistance to home rule, the very question of partition – literally unthinkable before 1910 – slowly seeped into the world of possibility. From Agar-Robertes' proposal in May 1912 to Lloyd George's "sentence of death with a stay for six years" was less than two years. In that time, the pressure of events got the previously unthinkable on to the political agenda.

Second, the Ulster Crisis fatally compromised the legitimacy of British government in Ireland in the eyes of nationalists. That legitimacy had always been partial and uncertain, but it is worth recalling that had home rule been enacted the union flag would still have flown over the GPO in O'Connell Street. By the end of the war, that possibility seemed as ludicrous as partition had seemed a decade earlier. In nationalist eyes, the British establishment had indulged the unionists. The Tories were openly colluding with their illegalities. The army could not be relied upon. The law of the land was being defied and government ministers could only urge wheedling compromises on the perpetrators, compromises which they summarily rejected. The whole progress of the Ulster Crisis might have been designed to erode nationalist belief in British good faith. It was fatal to those elements in Irish nationalism that had reposed hope in that good faith.

A Treaty was eventually agreed with the British in 1922 which gave the 26 counties independence outside the UK but not full republican status. This caused a split in republican ranks and a civil war, which the republican radicals opposed to the Treaty lost. However, in an eerie re-run of 1916, they too occupied public buildings in the city and were again routed by artillery, albeit this time fired by their own countrymen.

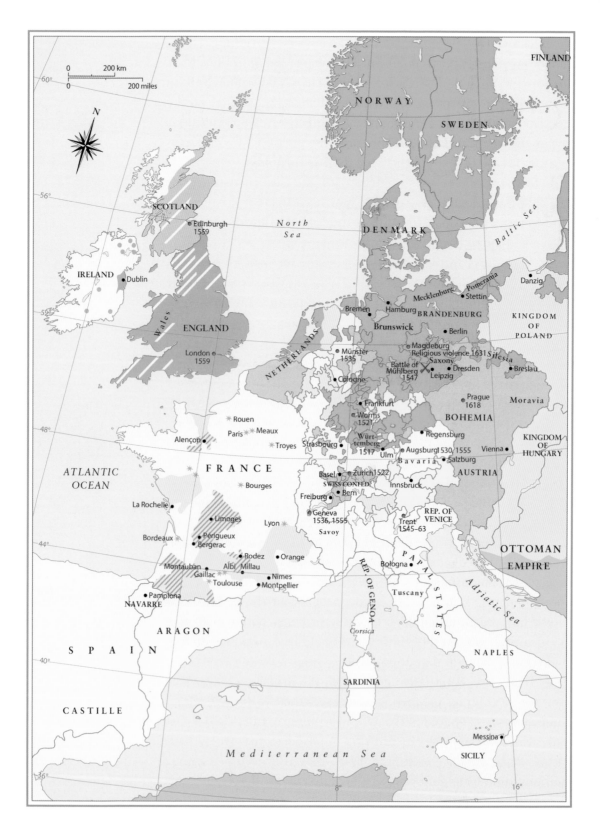

CHAPTER 2

THE NATIONALIST QUILT: A NERVOUS COALITION

Nationalist Ireland felt different and was different. Until the Reformation, Ireland was a lordship under the English crown. It was a very varied place, even comparing one part of the island to another, and it was also very distinct from England. There was nothing remarkable in any of that: many parts of England, especially north of the River Trent, were highly differentiated from London and the south, the centre of royal power and too easily thought of – then as now – as being all of England. Scotland and Wales, too, were different as Ireland was – in language, culture and custom. Distance was the key, in an age when land travel was arduous. It was sufficient to sustain these differences; sufficient, in the case of Scotland, to permit the establishment of a separate kingdom with a secure and continuous existence independent of the English crown.

So Ireland was different. So what? All of Europe was a vast patchwork of local differences, languages and dialects. Some territories coalesced into unitary or federated states – England, France, Spain. Others, principally Germany and Italy, did not. Difference was not a key political or constitutional variable in itself. What made the difference – and in the case of Ireland started it on the road to separation from England – was the Reformation.

From the 1530s, when the English crown broke with Rome, until the 1690s Ireland was a land of war. The issue was not just the Reformation, although it was crucial. The great religious split in the Latin Christian church was *the* ideological issue of the day, as passionate in its engagement of people's minds and emotions as communism or fascism were in the twentieth century. The first series of European religious wars were settled by the Peace of Augsburg in 1555. It was grounded in the famous formula *cuius regio eius religio*, which permitted kings and rulers to opt either for Catholicism or Protestantism. This choice was then binding on their subjects,

Reformation in Europe 1520–1600	
	Mostly Roman Catholic
	Mostly Calvinist
	Mostly Lutheran
	Mostly Anglican
	Mixed Catholic and Protestant areas
	Areas of waivering adherence
	Muslim or under Muslim control
	Seigneurial lands of the King of Navarre in France
*	St Bartholomew's Day anti-Protestant massacres,1572
●	Events of special importance

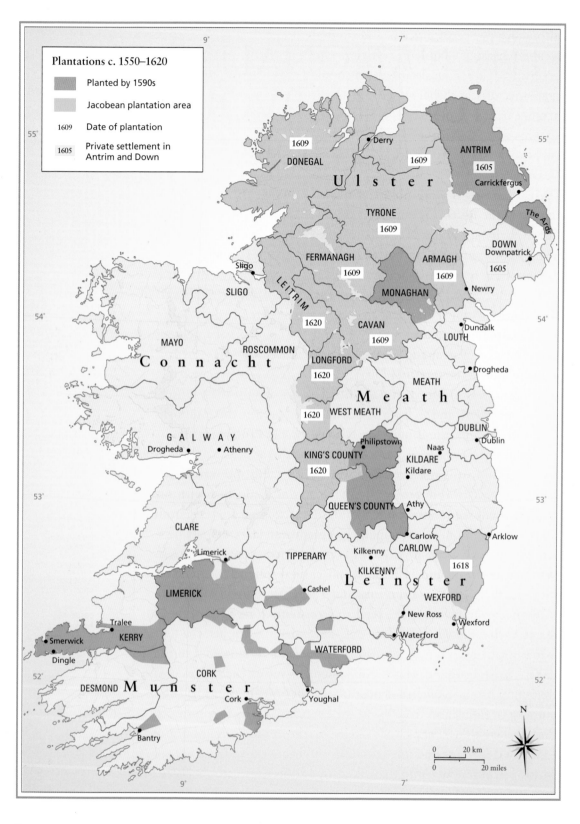

Plantations c. 1550–1620

Planted by 1590s

Jacobean plantation area

1609 Date of plantation

1605 Private settlement in Antrim and Down

Derry
1609
ANTRIM
1605
Carrickfergus
DONEGAL
U l s t e r
TYRONE
1609
The Ards
DOWN
Downpatrick
1605
FERMANAGH
1609
ARMAGH
1609
Newry
Sligo
SLIGO
LEITRIM
MONAGHAN
CAVAN
1609
1620
LOUTH
Dundalk
MAYO
ROSCOMMON
C o n n a c h t
LONGFORD
1620
Drogheda
MEATH
M e a t h
1620
WEST MEATH
DUBLIN
Dublin
GALWAY
Drogheda
Athenry
Philipstown
Naas
KING'S COUNTY
1620
KILDARE
Kildare
CLARE
QUEEN'S COUNTY
Athy
Carlow
Arklow
Limerick
TIPPERARY
Kilkenny
CARLOW
1618
KILKENNY
L e i n s t e r
WEXFORD
LIMERICK
Cashel
New Ross
Wexford
Tralee
KERRY
Waterford
Smerwick
WATERFORD
Dingle
CORK
DESMOND M u n s t e r
Cork
Youghal
Bantry

N

0 20 km
0 20 miles

although a period of grace was permitted to allow persons unable in conscience to accept the choice made for them to migrate to a territory where the confessional arrangement was more congenial.

This formula worked, at least for 60 years until the outbreak of the Thirty Years War in 1618. It worked in the sense that rulers were able to enforce their will on dissenting subjects, as happened brutally in France during the Wars of Religion. In an age when religious dissent was seen as a mortal threat to the integrity of states – a view that the horrors of the Thirty Years War did nothing to change – this kind of pragmatic arrangement made sense. The one significant royal territory in Europe where this Augsburg formula failed to stick was Ireland. Ireland stayed Catholic, despite the English crown embracing Protestantism.

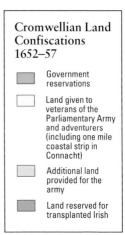

Cromwellian Land Confiscations 1652–57

▨	Government reservations
☐	Land given to veterans of the Parliamentary Army and adventurers (including one mile coastal strip in Connacht)
▨	Additional land provided for the army
▨	Land reserved for transplanted Irish

There were many reasons for the failure of the Reformation in Ireland, and this is not the place to rehearse them. But fail it did. Moreover, such feeble progress as it made was associated with the other key development of the age: the drive to impose the central power of the crown on marginal regions which had previously been autonomous. In sixteenth- and seventeenth-century Ireland, Protestantism marched hand-in-hand with the final English conquest of the island. The Plantation of Ulster; the destruction of Irish Catholic power by Cromwell; and the consolidation of that victory in the Williamite Wars all pointed in the same direction.

The Catholic interest comprised most of the so-called Old English – the descendants of the Anglo-Normans who had arrived in Ireland in the late twelfth century – and the Gaels who had been masters of the island from about 200 BC. The distinction between these 'two nations' persisted throughout the Middle Ages. But since they opted for the same side at the Reformation, they were regarded by the English as one and the same. Yet again, confessional choice and allegiance proved more important than ancient ethnic origins.

The community that stayed Catholic at the Reformation – whether of Old English or Gaelic provenance – was dispossessed of most of its lands in the 1650s. These lands were settled on soldiers and financiers who had been instrumental in the Cromwellian conquest of the island. And ever after, until the unravelling of that Cromwellian settlement in the Land Acts of the late nineteenth and early twentieth centuries, the title to those lands was regarded as illegitimate in the eyes of many of the dispossessed and their successors.

For many Irish Catholics, a potent brew of resentment was the result. In their eyes, the lands of their ancestors were not just held by strangers, but by heretical strangers. And despite the passage of time, and the long peace of the eighteenth century with its accommodations and conviviality, that subversive sense of injustice never fully abated. It was the emotional source of what became, in the nineteenth century, Irish nationalism.

Nationalism is a very modern idea. Grounded in the French Revolution, it asserts that authority flows upward from the people to the rulers, not downward from God through the king. Popular sovereignty implies coherent national communities united by some integrating force – as distinct from the multi-national and multi-ethnic arrangements that were the norm in imperial royal states. That force can be language, religion, some sense of shared ancestry and ethnicity or some amalgam of all these things.

This revolutionary idea provided a new context in which the long-felt sense of cultural difference in the Irish Catholic community could find expression. The second-class status to which Catholics had been reduced by Cromwell and his successors had bred resentment and a sense of exclusion. These were endured sullenly and passively, with occasional isolated acts of agrarian violence or sectarian outrage acting as an emotional discharge. Nationalism was altogether more coherent and incremental. It was a programme, a declaration that "we the people" asserted our rights in the public sphere. It was politics, specifically politics supported by the threat of violence and social unrest.

Whether Irish nationalism begins in earnest with the United Irishmen in the 1790s or Daniel O'Connell in the 1820s is neither here nor there in the context of this book. By the latter decade, it is a reality and its salient feature is the appeal it makes to the col-

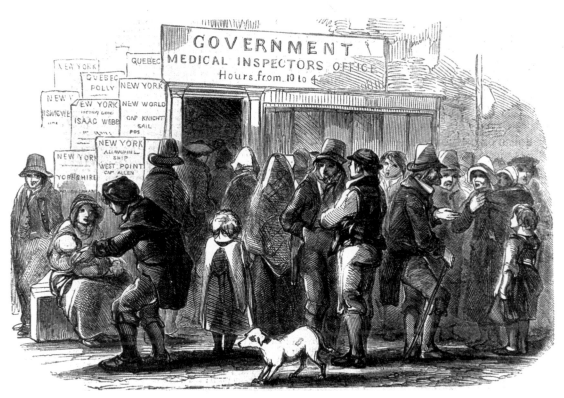

lective memory and consciousness of the Catholics of Ireland. In the course of the nineteenth century, its purpose is to weaken to the greatest degree possible the connection with England by subverting the Act of Union and restoring the greatest practical measure of autonomy for Ireland. In effect, the Catholic community develops a collective political consciousness that alienates it progressively from the British pan-Protestant state.

This withdrawal of legitimacy from Britain was hugely accelerated by the trauma of the Great Famine in the middle of the nineteenth century. Ireland, nominally an integral part of the richest and most powerful state in the world, was left to starve in the service of an economic theory. More particularly, it was the most Catholic parts of Ireland that suffered worst: in east Ulster, as we saw, the industrial revolution created a wealthy local elite. Elsewhere, a million died, a million emigrated.

It was 60 years – 1852 to 1912, a single lifetime – from the end of the Famine to the beginning of the Irish Revolution. In that lifetime, the conditions that made the revolutionary changes possible gradually coalesced – although the single condition that furnished its immediate context, the Great War, could not have been anticipated.

The Great Famine: hunger, eviction and emigration was the experience of millions, especially in the most Catholic parts of Ireland. This engraving shows people gathering at the Government Inspector's Office determined to take a ship for America.

We will return to the war in the next chapter; for the rest of this one, we'll concentrate on the developments that made the events of 1912 to 1925 possible. This is the period when not only Irish nationalism but also Irish Catholicism acquires real institutional muscle.

It is best to start with the Church. The institutional Catholic Church in Ireland had survived the penal era in remarkably good shape. By the middle of the eighteenth century, all diocesan sees were occupied. Thereafter, the influence of the Catholic hierarchy increased steadily. It was a tentative business at first but by the 1820s the traditional set of relationships had been inverted. Lord John George de la Poer Beresford (1773–1862), Church of Ireland Archbishop of Armagh, summed it up in simple language: "When I was a boy 'the Irish people' meant the Protestants; now it means the Roman Catholics."

Within that community, the trauma of the Famine left the Church in a position of unassailable moral monopoly. The land tenure system; O'Connell's political structures; the idealists of Young Ireland: all had been scattered and broken by the Famine. The Church alone stood undamaged. The arrangements put in place by Irish nationalist society in the wake of the tragedy amounted to a social compact between the survivors and the hierarchy.

There was, ironically, an implicit acceptance that the free-trade ideologues in the Treasury – the ones who had stood aside and let the hidden hand of the market lead Ireland to starvation and ruin – might have had a point after all. The post-Famine social settlement acknowledged some of the evils that the ideologues had railed against. There was to be an end to partible inheritance of farms; primogeniture would now mean that the eldest son got everything and younger family members had to shift for themselves. (This accounts, in part at least, for the remarkably high level of female emigration from Ireland – compared to other European countries – in this period.) There was therefore to be an end to feckless marriages and sexual incontinence: the ferocious sexual Puritanism of the Irish Church dates from this period, bolstered by the secular need for a brutal clarity in testamentary matters.

These and other social disciplines were happily policed by the Church on behalf of a grateful community. The absence of any strain of anti-clericalism in Ireland until the 1960s is evidence of

how eagerly the sacred and profane hands of nationalism clasped each other. Moreover, the Church itself was changing under the influence of the so-called devotional revolution and these changes were equipping it to play its assigned role in the new consensus.

The devotional revolution is a shorthand term that describes a process whereby Irish Catholicism changed from being a peasant religion focused on the home to an institutional one based on the parish church. Traditional practices such as patterns, wakes and stations were discouraged (but not entirely eliminated). In their place, regular attendance at Sunday Mass and the sacraments as prescribed by canon law became the norm. New devotional practices such as the holy hour and sodalities were imported from the continent, along with teaching orders whose members widened the scope of Catholic education. This meant a kind of spiritual analogue to the industrial revolution: spiritual piece work at home was replaced by the devotional factory that was the parish church or school, with set times for services and devotions inviting a new and greater degree of social discipline – timekeeping and such like.

The key figure in all this was the austere spiritual apparatchik who became Ireland's first cardinal. Paul Cullen had been born in Ballitore, Co. Kildare, and educated in Rome where he spent almost 30 years in the papal service before returning, first as Archbishop of Armagh in 1850 and from 1852 as Archbishop of Dublin. It was under his influence that the Irish Church assumed its ultra-orthodox complexion and abandoned the Gallican independence that had previously been characteristic of it. Henceforth, unquestioning loyalty to Rome, canon law and the papacy was the overwhelming instinct of the Irish Church. Dissenting voices were not welcome.

Along with Roman orthodoxy came an unvarnished hatred for secret revolutionary societies along the continental model, for these had much vexed the Vatican in recent times. Mazzini had proclaimed the Roman Republic in 1848, forcing Pope Pius IX to flee the city in disguise and fatally weakening the temporal power of the papacy. Cullen had witnessed these sorry events at first hand and he never forgot them. This did not equip him to look kindly on the Fenians.

The Fenian Brotherhood and the Irish Republican Brotherhood (IRB) were technically two separate organisms but were in effect

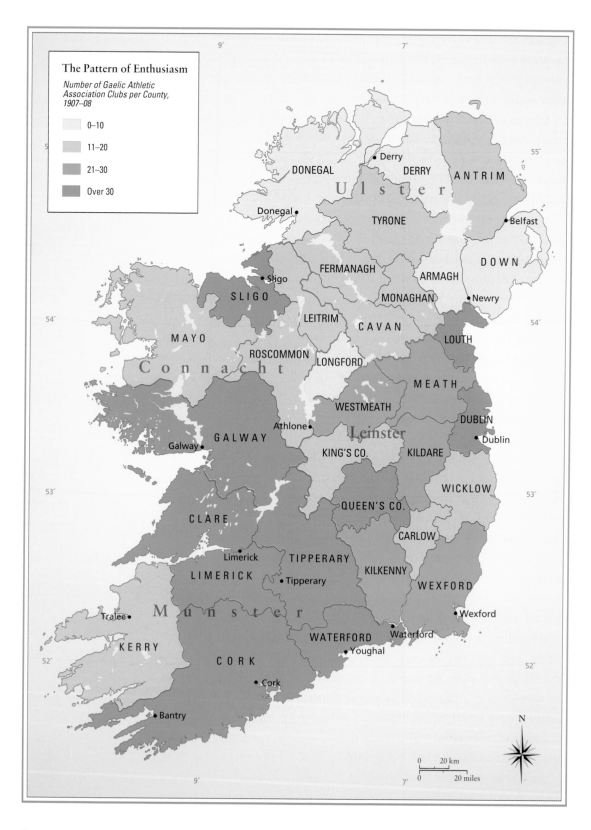

The Pattern of Enthusiasm

Number of Gaelic Athletic
Association Clubs per County,
1907–08

0–10
11–20
21–30
Over 30

one and the same, having been founded in the same year – 1858 –
on either side of the Atlantic. The Fenians, named for a legendary
warrior-group in pre-historic Ireland, were a secular revolutionary
expression of the new Irish-American diaspora. They were mainly
led by men who had participated in the doomed Young Ireland
movement which had collapsed in farce in 1848 and which in its
turn had been opposed to the clericalism of O'Connell and drew
vaguely on the republicanism of the 1798 rebels. They were dedi-
cated to a separatist Irish republic to be established by force of
arms, without any temporising with politics or parliaments.

Many years later, the Fenian John O'Leary told W.B.Yeats that
in Ireland a man either had to have the Church or the Fenians on
his side, a remark that fixes the Fenians as a kind of internal op-
position within the larger Irish nationalist tent. There was no
doubt that the Church, post-Cullen, could command the numbers;
but the Fenians had the passion. Cullen regarded them as a local
variant of the Mazzini virus. His priority was to advance Catholics
in every secular sphere, especially in the influential professions,
and to enfeeble Protestantism. The secular republicanism of the
Fenians represented an existential threat to these essentially cleri-
cal ambitions.

The Fenians set off a rising in 1867 that was scarcely less farci-
cal than the Young Ireland effort in 1848. But it was mythologised
as part of an apostolic succession of uprisings against British rule
and so passed into the nationalist imagination. Moreover, it fur-
nished prisoners and martyrs. The campaign for the release of
prisoners became a political rallying-cry for all nationalists. The
execution of three Irishmen who killed a policeman while trying to
rescue Fenians from a prison van in Manchester provided the coun-
try with an unofficial national anthem – 'God Save Ireland' – for
the next 50 years.

At a time when constitutionalism was fallow, the Fenians were
the most potent element in Irish nationalism. And despite their for-
mal avoidance of politics, the movement attracted precisely the kind
of young men – urban, lower middle class, ambitious, slightly edu-
cated – to whom public issues were irresistible. In the 1870s, the Fe-
nians were the largest single identifiable element in nationalist
Ireland. Later, they were eclipsed by the genius of Parnell – who
held them in a constrictor's embrace – but they never disappeared.

They were central to Parnell's early political coalition; to the Land League; to the dynamite terrorist campaign in Britain in the mid-1880s. They came to dominate the early Gaelic Athletic Association (GAA), the most popular of all nationalist endeavours, and they were never far from the cultural politics of the 1890s and after. Most of all, it was the Fenians/IRB – or a secret cabal within the movement – that tripped off the Easter Rising of 1916.

But first, there was Parnell. The family had originated in Cheshire. Thomas Parnell, whose uncle and grandfather had each been mayor of Congleton, was a beneficiary of the Cromwellian plantation. Whether he had supported the parliamentary cause in the English Civil War with money or in arms is unclear, but he secured an estate in Queen's County (Laois) and settled to life as a country gentleman. That was in the 1660s.

A number of descendants distinguished themselves, but the first to make an impact on Irish public life was Sir John Parnell who rose to be Chancellor of the Irish Exchequer. He was a principled opponent of the Act of Union, a fact that did no harm to his great-grandson's political prospects, but like many opponents of the union he was no friend to Catholic ambitions. One of his sons, William Parnell, inherited the house and estate at Avondale, Co. Wicklow, in 1795, from a cousin, Samuel Hayes, whose family was inter-married with the Parnells. The house dated from 1777. In turn, his son John Henry Parnell inherited it and lived there with his American wife, Delia Stewart. She was the daughter of Admiral Stewart – Old Ironsides – who had distinguished himself during the war with the British in 1812.

Charles Stewart Parnell was born here in 1846. He was reared in the manner of an Irish country gentleman, sent first to a girls' school in Somerset and later to a private academy in Oxfordshire, both of which he hated. In 1865, he went to Cambridge but was expelled before taking his degree. Back in Wicklow his chief preoccupation was cricket, at which he cheated. All in all, it was an unlikely background for a leader of Irish nationalism.

On 1 September 1870 the Home Government Association was launched in Dublin by Isaac Butt, a barrister and former MP. Its basic demand was for some form of devolved autonomy for Ireland or, in the brilliantly vague term in which it couched the demand, home rule.

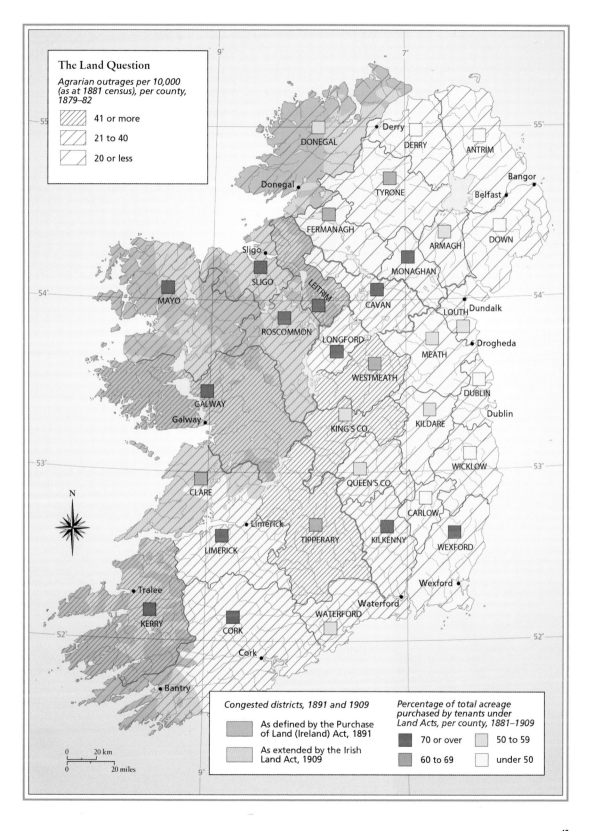

The Land Question

Agrarian outrages per 10,000 (as at 1881 census), per county, 1879–82

- 41 or more
- 21 to 40
- 20 or less

Congested districts, 1891 and 1909

- As defined by the Purchase of Land (Ireland) Act, 1891
- As extended by the Irish Land Act, 1909

Percentage of total acreage purchased by tenants under Land Acts, per county, 1881–1909

- 70 or over
- 60 to 69
- 50 to 59
- under 50

The term was deliberately elastic. In the early days, in Butt's formulation, it amounted to a call for devolved domestic parliaments for Ireland, Scotland and England (but not for Wales). Westminster would remain sovereign and would deal with foreign and imperial matters. Part of home rule's early appeal was to some members of the Church of Ireland who felt betrayed by the disestablishment of their Church in 1869 and who thought that a Dublin parliament could be a better safeguard for Protestant interests. Butt himself was a Protestant.

As the 1870s wore on, the home rule movement took on a more overtly nationalist hue. Constitutional nationalists and ex-Fenians were drawn to it; it also attracted the support of parish clergy, although not yet of the hierarchy. In the 1874 general election that ousted Gladstone and installed Disraeli, candidates pledged to home rule won 59 seats. But they did not constitute a party in any modern sense. Butt was a gentlemanly but ineffective leader; he lost the support of many of his original Protestant adherents without gaining the confidence of the Catholic hierarchy; and the Fenian and neo-Fenian element among his MPs were effectively out of his control. From 1876 on, they began disruptive filibustering tactics in Westminster.

Parnell was elected MP for Co. Meath in 1875 and within a few years had displaced Butt as leader of the Irish Parliamentary Party. Moreover, he had made influential Fenian friends. In 1877, Michael Davitt from Co. Mayo was released from prison after serving a seven-year sentence for Fenian activities. The next year, in New York, he agreed a programme with John Devoy, the leading Irish-American nationalist, called the New Departure. It meant that republicans, parliamentarians and agrarian radicals would co-operate. This led to the foundation of the Land League in 1879. Parnell as leader in parliament and Davitt as head of the Land League made a formidable coalition. The campaign for land reform – first for tenant rights, later for outright tenant ownership – convulsed the country in the early 1880s and set in train a process that eventually destroyed the Cromwellian land settlement.

The Liberals under Gladstone returned to power at Westminster in 1880 and passed a major Land Act the following year which conceded some of the headline

Michael Davitt, the founder of the Land League and a key figure in the modernisation of Ireland.

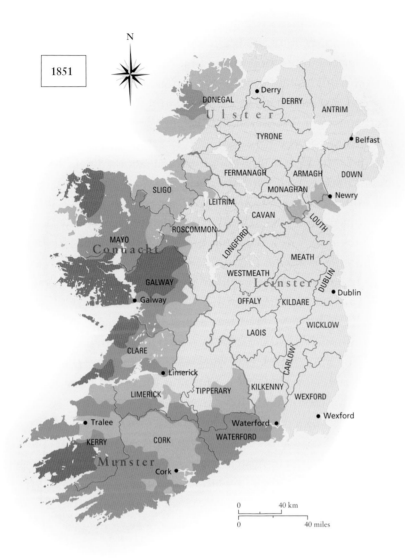

1851

The Decline of the
Irish Language

*Percentage of Irish
speakers*

over 80

50 to 80

25 to 49

under 25

(after Ó Cuív)

demands of the Land League. The uproar and agitation in the
countryside did not abate immediately. Parnell was imprisoned for
a while before a compromise was reached with Gladstone. By then,
the whole country was shocked by the vicious Phoenix Park Mur-
ders of May 1882, which brought the deaths of the newly-
appointed Chief Secretary (the London cabinet minister responsi-
ble for Ireland) and the Under-Secretary (the head of the Irish civil
service).

Gradually, and to Parnell's private relief, the emphasis now
turned from agrarian agitation to politics. His aim was to secure
the support of one of the mainstream British parties for the cause

of Irish home rule. At the election of 1885, the Liberal Party declined to do so, so Parnell advised Irish voters in Britain to vote Conservative. This unorthodox tactic resulted in a hung parliament, with Parnell's party – by now formidably disciplined and whipped under his leadership – holding the balance of power. Gladstone then discovered that he supported home rule after all, and introduced the first Home Rule Bill in 1886 which split his party and was defeated. But Parnell had achieved a political miracle: one of the two great parties was now committed to Irish home rule. Surely the pendulum of parliamentary politics would deliver the goods in time. What had been unthinkable a few years earlier was now one of the central questions in British public life. Parnell was a god in Ireland.

And like a god, he fell. When his affair with Katharine O'Shea, wife of one of his MPs, was discovered he was disowned by Gladstone's Liberals – the party was prone to fits of what was called the 'nonconformist conscience'. Gladstone was now faced with either sacrificing Parnell or losing the leadership of Liberalism. He presented the Nationalists with a hideous dilemma. They could have Parnell or the Liberal alliance but not both.

Katharine O'Shea, Parnell's lover and the mother of his three children.

The party split on 15 December 1890. The majority chose the Liberals. Parnell attempted to reconstruct his political fortunes in a series of three bitterly fought by-election campaigns in Ireland over the following year, all of which he lost. The Irish Catholic hierarchy, determined not to be out-moralised by a crowd of English Protestants, turned against him. The split was a savage business, with passions inflamed beyond reason on both sides. It darkened Irish nationalist life for a generation.

Parnell's frenzied by-election campaigns killed him. Never robust, he was drenched to the skin while addressing a meeting in Creggs, Co. Roscommon, and caught a chill which developed into pneumonia. He dragged himself back to Brighton, where he lived with Katharine, and died there on 6 October 1891. His remains were returned to

Dublin where his funeral attracted over 100,000 mourners. He is buried in the most impressive grave in Ireland, in Glasnevin cemetery under a single boulder of Wicklow granite bearing the simple legend PARNELL.

In 1893, the Gaelic League was formed. The founder was Eoin MacNéill, an historian of early and medieval Ireland. The first president was Douglas Hyde, the son of a Church of Ireland rector from Co. Roscommon. A scholar and linguist, he had delivered a lecture in 1892 under the title 'The Necessity for De-anglicising the Irish People', in which he called for an arrest in the decline of the Irish language and deplored the advance of what he regarded as a vulgar, English commercial culture.

The new organisation established itself quickly. It had as its aim the revival of Irish as the common vernacular. It conducted language classes. It published stories, plays and a newspaper, *An Claidheamh Soluis* (The Sword of Light). It opposed a campaign led by John Pentland Mahaffy, the Provost of Trinity College Dublin, to have the language removed from the Intermediate school syllabus. It established language teacher training colleges. By 1908, there were 600 branches of the League around the country.

The Gaelic League successfully revived the Young Irelanders' idea that cultural and linguistic autonomy was a good thing, and was part of a greater national revival. Hyde naively thought that the language was a non-political issue on which people of all religious and social backgrounds could meet without rancour. The League was indeed non-political for the first 22 years of its life. But its implied purpose was clear: the re-Gaelicisation of Ireland. That was a purpose that could not be kept innocent of politics forever, not in a country like Ireland. In some ways, it was a very Victorian phenomenon, appealing to the same kind of medieval nostalgia that animated the pre-Raphaelites and the arts and crafts movement in England.

It was in part a reaction to the sense of political despair that followed the Parnell split, something captured with timeless brilliance in the Christmas dinner scene in Joyce's *Portrait*. For ten years, the Irish Party remained divided, only patching things up in 1900 and electing one of the minority Parnell loyalists, John Redmond, as leader of the re-united party. But it was never the same again and never as lucky again. Redmond was a decent man; Parnell had been a lethal one.

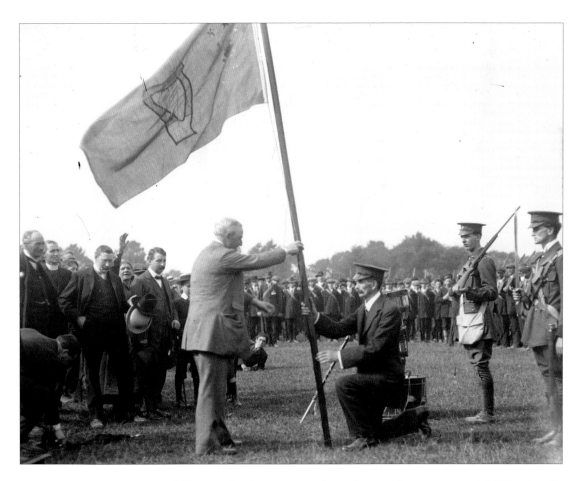

John Redmond presents 'colours' to a battalion of National Volunteers.

The reunited party was born into a changing world. The Gaelic League had swept the country with its agenda of cultural separatism. The Gaelic Athletic Association (GAA) was its equivalent in the recreational sphere. Founded in 1884, it was a Fenian possession right from the start. It grew to be the largest sporting body in Ireland with clubs in every Catholic parish on the island. Not only did it promote and nurture the Gaelic sports of hurling, football, camogie and handball, it forbade its members to participate in, or even to attend, four sports denominated as 'foreign' – for which read English. This recreational tariff wall echoed the economic prescription being proposed by a new nationalist fringe party, Sinn Féin.

Sinn Féin was founded in 1905 by Arthur Griffith, a journalist. It was one of a number of marginal nationalist movements, all of them in one way or another more 'advanced' than the Irish Party. Many had developed out of opposition to Britain's prosecution of

the second Boer War or out of movements formed to celebrate the centenary of the 1798 Rising. Griffith was involved in both of these endeavours. Sinn Féin was not a republican separatist party; rather, it advocated withdrawal from Westminster, the establishment of a national assembly in Ireland and a courts system that drew its authority from that assembly. Its policies were a conscious echo of those pursued in Hungary in the years after 1848. Griffith was much more drawn to the methods of the moderate Deák, who reconciled Hungary to the Habsburg connection in the *Ausgleich* of 1867, than to those of the separatist Kossuth.

None the less, Sinn Féin and all the other marginal nationalist ginger groups were consistently to the left of the Irish Party, which they disliked for its smugness, its clericalism, its clientelism, its self-assured sense of entitlement. And in all truth, it was hard to blame the party for ignoring them, because it had the numbers. It was the only political force in nationalist Ireland capable of any consistent electoral traction. From 1900 to the outbreak of the Great War in 1914, the party won every Nationalist seat, except for a single loss to Sinn Féin in a by-election in 1908 when local factors rather than party allegiance determined the result.

Arthur Griffith, founder of Sinn Féin.

Following the general election of 1910, it seemed that its hour had struck at last. For the first time since 1886, a Liberal government needed Irish Party votes to secure a parliamentary majority. The price was home rule, and a bill was duly prepared, causing ructions in Ulster as we saw. It was nevertheless passed into law in early 1912, although the House of Lords – whose revising power had been reduced to a mere delaying one – predictably voted against it, ensuring that it would not come into force until September 1914. By then the whole world was transformed. The Great War – World War I – had broken out. It carried whole empires away and destroyed a civilisation.

The Great War was the indispensable context for the Irish Revolution.

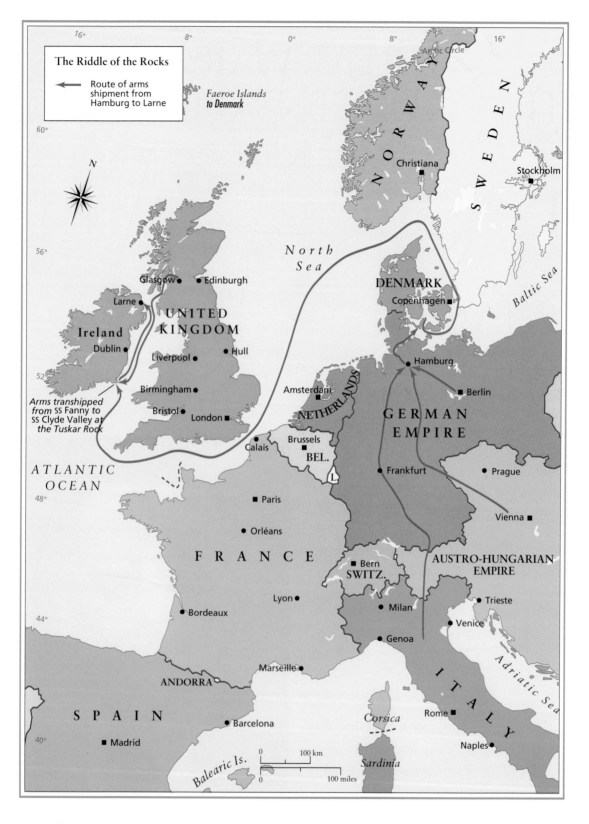

The Riddle of the Rocks

⟶ Route of arms shipment from Hamburg to Larne

Faeroe Islands to Denmark

16° 8° 0° 8° 16°

60°

56°

North Sea

NORWAY

Christiana

SWEDEN

Stockholm

Arctic Circle

DENMARK

Copenhagen

Baltic Sea

Glasgow ● Edinburgh

Larne ●

UNITED KINGDOM

Ireland

Dublin ●

Liverpool ● ● Hull

52°

Arms transhipped from SS *Fanny* to SS *Clyde Valley* at the Tuskar Rock

Birmingham ●

Bristol ● ● London

NETHERLANDS

Amsterdam

Hamburg

● Berlin

GERMAN EMPIRE

Calais ●

Brussels ●

BEL.

L

● Frankfurt

● Prague

ATLANTIC OCEAN

48°

■ Paris

● Orléans

FRANCE

Bern ■
SWITZ.

AUSTRO-HUNGARIAN EMPIRE

Vienna ■

Lyon ●

● Milan

● Trieste

44°

● Bordeaux

Venice

Genoa ●

Marseille ●

Adriatic Sea

ANDORRA

SPAIN

● Barcelona

Corsica

ITALY

Rome ■

Naples ●

40°

■ Madrid

Balearic Is.

0 100 km

0 100 miles

Sardinia

CHAPTER 3
THE GREAT WAR: THE INDISPENSABLE CONTEXT

In April 1914, Major Fred Crawford's efforts to obtain arms on behalf of the Ulster Volunteer Force finally succeeded. He had obtained over 200 tons of arms, comprising 25,000 rifles and 5 million rounds of ammunition. These had been sourced in Germany, Austria and Italy by an arms dealer named Benny Spiro, assembled in Hamburg and sailed through the Kiel Canal to the Danish island of Langeland. There, the cargo was transferred to ss *Fanny*, with the intention of sailing her to Ulster.

What followed was a moment of farce and muddle. The Danish customs service smelled a rat, suspecting that the papers had been falsified (they were right) and that the cargo was in fact arms (right again). They further suspected that these arms, if that is what they were, were bound for Iceland

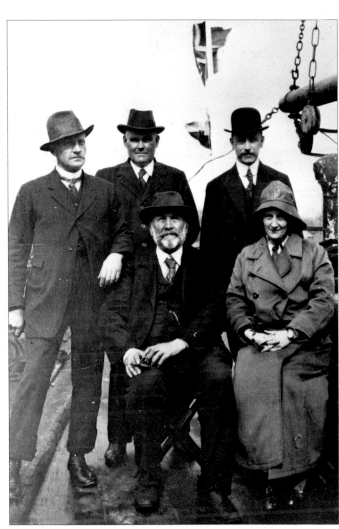

Major Frederick Crawford (left) *with arms dealer Benny Spiro* (front).

(wrong), then a Danish possession but one that had a vigorous nationalist movement. Crawford and the *Fanny* made a run for it and made it out onto the high seas. However, the *Fanny*'s cover was now blown and she was certain to be captured once she entered Irish waters.

Crawford solved this problem by slipping ashore at Glasgow and buying an old rust bucket called the SS *Clyde Valley*. She made rendezvous with the *Fanny* off the Tuskar Rock at the south-east corner of Ireland and the arms were transferred. The whole escapade nearly ended there and then, because a Royal Navy battleship, steaming hard towards Scotland, came perilously close to the unlit and therefore invisible ships; as it was, she almost capsized both with her wake.

However, Crawford's luck held and in the early hours of the morning of Saturday 25 April he got his cargo ashore at Larne, Co. Antrim. It was an impressively disciplined operation, facilitated by the collusion of the local authorities and by the presence of a perfectly innocent decoy ship in Belfast Lough which behaved with sufficient suspicion to draw the attentions of the customs service. The arms got ashore without a hitch and were then distributed by a fleet of waiting cars to pre-selected depots all over the province.

The Larne Gun-Running was a spectacular coup for the UVF, although it all looked better than the reality. There were three different kinds of rifles and the amount of suitable ammunition was insufficient. Even with arms already in UVF hands, the Larne cache still left more than one UVF man in two without any weapon at all.

Few people were more impressed with the Larne landings than members of the Irish Volunteers. This was a nationalist militia which had been founded in Dublin five months earlier, in November 1913. It had been prompted by an article by Professor Eoin MacNéill, founder of the Gaelic League, in *An Claidheamh Soluis* entitled 'The North Began' (referring to a phrase in a Thomas Davis poem). He argued that nationalists should imitate unionists in forming their own militia, and that armed Ulstermen were a thoroughly good thing on the grounds that Irishmen were now taking the effective governance of Ireland into their own hands, thus weakening the British connection. Nor was MacNéill alone in this piece of heroic self-delusion: many other nationalists remained blind to the obvious fact that the UVF had armed itself precisely to strengthen the British connection.

The Irish Volunteers grew with such impressive speed that Redmond and the Irish Party felt the need to bring it under their control. They had not welcomed its formation, but they could hardly allow a nationalist grouping that numbered more than 130,000 people to remain outside their sphere of influence. Redmond

threatened to form a counter-militia if he was not granted twenty-five nominees on the Volunteer executive. With the greatest reluctance, MacNéill acceded to this dictate. The Irish Party's nationalist opponents – Sinn Féin and the other radical groupings – had always characterised the party as a cannibalising monster, suffering no ascendancy except its own. Redmond's démarche seemed to offer supporting evidence for this belief.

Except for one thing: the Fenians. The IRB had fallen into a long decline after its period of influence in the 1870s and 1880s. Its secular focus had been elbowed aside by the cultural revival and the Irish-Ireland movement. It had not, however, completely disappeared albeit its membership barely numbered 1,000 people in 1912. Young men like Michael Collins and Sean MacDermott joined its ranks. Older men, the most celebrated of whom was Tom Clarke, represented continuity with the glory days. Clarke's role in the revival of the IRB has been exaggerated but he was an important figure none the less. He symbolised resistance as well as continuity. He had served 15 years in Portland prison in savage conditions for his part in the dynamite war of the 1880s, a campaign ineptly orchestrated from New York by Clan na Gael, an Irish-American Fenian umbrella organisation. In deference to his seniority, he was to be the first signatory of the 1916 Proclamation.

The Irish Volunteers had a natural attraction for the IRB. It had always been part of Fenian belief that the mass mobilisation of

Eoin MacNéill, historian and founder of the Gaelic League.

Irish people would accelerate the political demands of nationalism, by creating an active citizen force so potent as to move radical positions hitherto merely aspirational into the world of reality. In this, their belief appears to have been justified, because the radicalisation of nationalist politics from this point on is the salient feature of the era. A voluntary body with a membership of 130,000 people and growing was a lot of active citizens.

From the beginning, IRB men were involved in the Volunteers. Bulmer Hobson and Sean MacDermott were among the founders. The effect of all this was to make Redmond's takeover less complete than it might have been, something that would become starkly evident within a few months. The IRB – and indeed, Irish-Ireland radicals not in the organisation – had no time for the party. They worked from within to resist Redmond as far as possible.

The Irish Volunteers lacked the two things that the UVF had in abundance: money and arms. A small attempt was made to remedy the latter deficiency on Sunday 26 July 1914, barely a week before the start of the Great War. Unlike the secret operation at Larne, a cache of arms was landed in broad daylight on the east pier at Howth, a fishing village on the northern arm of Dublin Bay. The haul was unimpressive: fewer than a thousand rifles, most of them obsolete Mausers. None the less, it gave a psychological fillip to

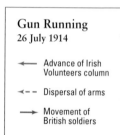

Gun Running
26 July 1914

← Advance of Irish
Volunteers column

◄– – Dispersal of arms

→ Movement of
British soldiers

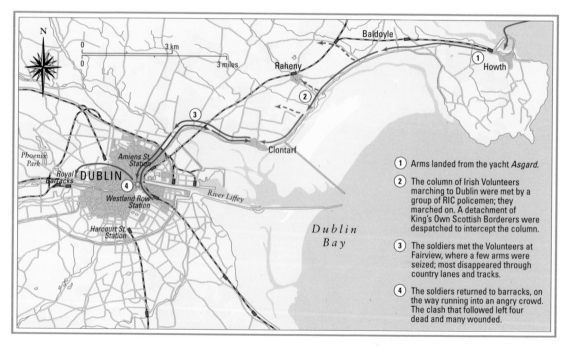

① Arms landed from the yacht *Asgard*.

② The column of Irish Volunteers marching to Dublin were met by a group of RIC policemen; they marched on. A detachment of King's Own Scottish Borderers were despatched to intercept the column.

③ The soldiers met the Volunteers at Fairview, where a few arms were seized; most disappeared through country lanes and tracks.

④ The soldiers returned to barracks, on the way running into an angry crowd. The clash that followed left four dead and many wounded.

Molly Childers and Mary Spring-Rice examine some of their haul of weapons on the yacht Asgard.

the Volunteers, who marched back into the city in high good humour. This was added to when they were intercepted by a detachment of RIC men at Raheny, a village about half way in from Howth, who made no attempt to obstruct them and even fraternised with them, admiring the new weapons. Most RIC men were Catholic and nationalist and still harbouring the expectation of imminent home rule.

The euphoria did not last. As the Volunteers continued towards the city, Assistant Commissioner Harrel of the Dublin Metropolitan Police (DMP) mobilised as many policemen as he could – supported by troops, the King's Own Scottish Borderers – to try to cut them off. They failed in this effort following an affray. While the Volunteers got their guns away, the soldiers began to make their way towards the Royal (now Collins) Barracks at the western end of the Liffey quays. They were accompanied all the way by taunts

and jeering and had acquired an ill-disposed and salty-tongued retinue by the time they reached the city centre. When they turned into the narrow confines of the quays, the crowd thickened and whether out of panic or acting on orders, the troops fired, killing three and wounding 85, one of whom later died.

It was a disastrous contrast to Larne. Dublin was incensed. All troops were confined to barracks that night. The Lord Lieutenant wished to visit the injured in hospital but was advised against it because his physical safety could not be guaranteed. The funerals took place the following Wednesday, huge affairs with every strand of nationalist Ireland represented. It marked Dublin's psychological withdrawal from the British connection. It was not the first such sign and would not be the last, but the eroding legitimacy of British rule in nationalist Ireland was accelerated by the murders of unarmed civilians by crown forces. Those forces seemed less and less the troops of legitimate authority, more than ever an army of occupation.

In time, the killings on Bachelor's Walk came to seem small beer. The previous day, at the far end of Europe, Austria had declared war on Serbia and within a week the Great War would convulse the continent.

On 3 August, Redmond spoke in the House of Commons and offered the Irish Volunteers to the war effort. He spoke of the Irish Volunteers fighting for a common cause beside the Ulster Volunteers, something that hardly pleased the latter. In fact, the offer from the UVF came with strings attached: the suspension of home rule, the UVF to serve as a single unit retaining the 'Ulster' designation in its title as well as its divisional number. All of August was consumed with the negotiations surrounding these unionist demands, so that the announcement of the formation of the 36th (Ulster) Division was not made until 3 September.

When Redmond made his offer, he envisaged the Irish Volunteers fulfilling a role similar to the eighteenth-century Volunteers, defending Ireland against invasion and freeing up regular troops based in the country to go to the front. On 18 September the Home Rule Act was finally passed but its implementation was suspended for the duration of the war. Two days later, back in Ireland, Redmond made a speech at Woodenbridge, Co. Wicklow, in which he called on the Irish Volunteers to join the fighting "wherever the firing line extends".

This caused a split in the movement. In effect, Redmond now ex-

Redmond spoke in the House of Commons offering the Irish Volunteers for the war effort, fighting for a common cause beside the Ulster Volunteers. However, the UVF had other ideas.

posed himself to the charge of being England's recruiting sergeant in Ireland. It is not known what prompted him to make his call to arms. Perhaps he felt that, with home rule now on the statute book, he was honour bound to stand by Britain in her hour of need. Westminster had delivered its side of the bargain; Ireland should now reciprocate. The war was not expected to last long and when it was over home rule would become a legislative reality. If that was his thinking, it stands to Redmond's credit as a decent man but not at all as a politician. He was offering something that he could not deliver – or deliver in full. He was sure to split his own movement, which he did, and draw the wrath of all his enemies within the nationalist camp. Indeed, his open-handed offer can be contrasted with Carson and Craig's tougher terms demanded – and secured – when offering the services of the UVF.

None the less, Redmond's prestige was such that he brought the vast majority of the Volunteers with him. The dissenting minority, which retained the name Irish Volunteers, numbered no more than 12,000. The National Volunteers, as the majority were re-named, formed the main body of the 10th and 16th Irish Regiments in Kitchener's new army. More than 30,000 Irishmen were to die in the war. Those who returned came back to a country transformed

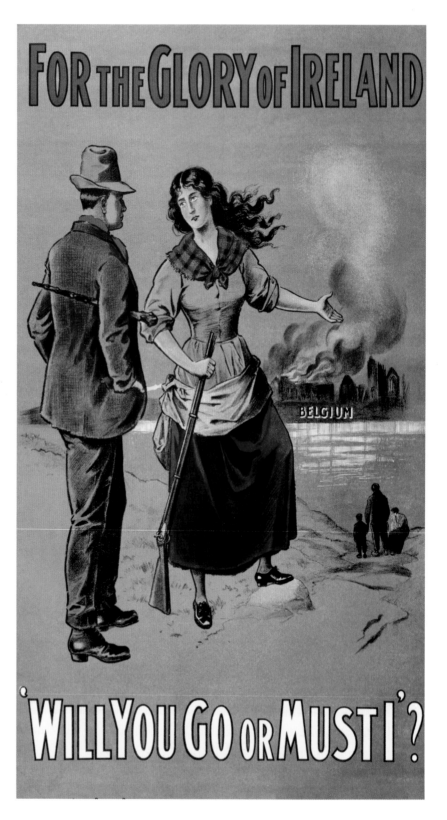

Over 30,000 Irishmen would give their lives in the First World War – most serving in the 10th and 16th Irish Divisions and the 36th Ulster Division.

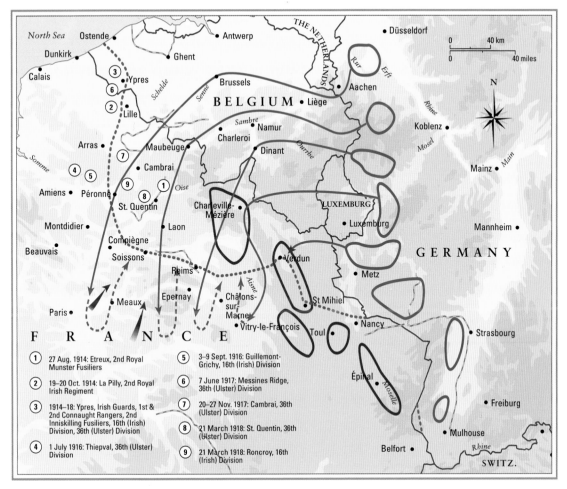

1. 27 Aug. 1914: Etreux, 2nd Royal Munster Fusiliers

2. 19–20 Oct. 1914: La Pilly, 2nd Royal Irish Regiment

3. 1914–18: Ypres, Irish Guards, 1st & 2nd Connaught Rangers, 2nd Inniskilling Fusiliers, 16th (Irish) Division, 36th (Ulster) Division

4. 1 July 1916: Thiepval, 36th (Ulster) Division

5. 3–9 Sept. 1916: Guillemont-Grichy, 16th (Irish) Division

6. 7 June 1917: Messines Ridge, 36th (Ulster) Division

7. 20–27 Nov. 1917: Cambrai, 36th (Ulster) Division

8. 21 March 1918: St. Quentin, 36th (Ulster) Division

9. 21 March 1918: Roncroy, 16th (Irish) Division

The Great War
1914–18

⬭ German armies

⬮ French armies

→ German advance, Aug. 1914

⇢ German retreat, Aug. 1914

➤ The Marne counter-offensive

···· Front line, Nov. 1914– March 1918 (with minor variations)

① Irish involvement in battles

by the dissenting minority who had defied Redmond. He himself did not live to see either home rule or the armistice.

The Irish Volunteers now had an IRB representation that was proportionately more significant than it had been in the larger organisation. It maintained its separate identity and purpose within the overall Volunteer structure. However, it was itself disunited: a secret cabal within the IRB formed a military council with the express intention of having a rising in arms against British rule before the end of the war. Not only was the leadership of the Irish Volunteers kept in the dark about this, many leading figures in the IRB were as well.

In September 1914, when the Volunteers split, MacNéill's dissenting minority declared that "Ireland cannot, with honour or safety, take part in foreign quarrels other than through the free action of a national government of her own." The signatories of this document included names that would be prominent in Easter Week: Patrick Pearse,

Thomas MacDonagh, Joseph Plunkett, Eamonn Ceannt, Sean Mac-Dermott and The O'Rahilly. None of them survived the rising. The first five were among those executed afterwards by the British; O'Rahilly died bravely in a fire fight on the Friday of Easter Week.

In all that follows, it is important to remember that the IRB were only one element – although the most important and determined element – within MacNéill's Irish Volunteers. The rising was made in the name of the Volunteers but was actually the result of a secret IRB plot. The IRB itself was terribly enfeebled at the start of the war but a nationwide tour by MacDermott arrested the decline by swearing in influential local Volunteer officers. Tom Clarke, meanwhile, was arguing for a rising while Britain was engrossed in the European war, a reprise of the old nationalist adage that "England's difficulty is Ireland's opportunity".

Small though its numbers were, the IRB now had key people in the councils of the Volunteers. Moreover, it had the ear of others who, although never members of the Brotherhood, were growing in influence. Pearse was the Volunteers' director of military organisation; Plunkett was director of military operations; MacDonagh was director of training and Ceannt was director of communications. None were members of the IRB, although all were sympathetic to the idea of a rising.

Patrick Henry Pearse, writer, educator and Nationalist politician. He joined the Irish Republican Brotherhood and directed the Easter Rising in 1916.

A complicated structure thus emerged in the run up to the rising. There was the formal body of the Irish Volunteers under the leadership of Eoin MacNéill whose purpose was frankly confused and unclear. Within its ranks, there were sworn members of the IRB, whose inner circle of Clarke, MacDermott and Bulmer Hobson were planning a rising of some sort. They in turn had the ears of sympathisers like Pearse who, although not themselves in the IRB, were beginning to accept the necessity for a rising.

Out of this confusion, there merged a military committee of three persons – Pearse, Plunkett and Ceannt – although what exactly they were a committee of was unclear, since they were affiliated neither to the Volunteers nor to the IRB. The difference was that whereas the leader-

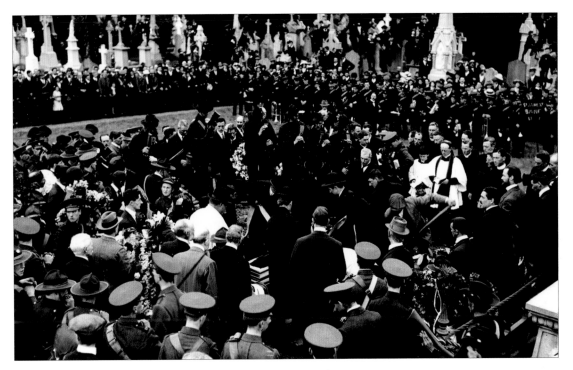

The funeral in Glasnevin Cemetery of Jeremiah O'Donovan Rossa, 1915.

ship of the Volunteers was perfectly ignorant of the committee's existence, Tom Clarke was well aware of it. So it might be regarded as a kind of outwork of the IRB, in external association with it. This situation persisted until the committee was joined by MacDermott, who had just served a prison term for a seditious speech and who promptly swore the other three into the IRB at last and renamed the body the military council.

There were, therefore, three concentric circles in all this. The outer circle was the Irish Volunteers with Eoin MacNéill at its head. The middle circle was the IRB element, many of whose leading figures such as Bulmer Hobson and Patrick McCartan were ignorant of the existence of the inner circle, which was the military council.

In the meantime, Pearse had made his name. He was the son of an English monumental sculptor whose nationalism had been formed by his cultural concerns rather than by pure politics in the Fenian manner. He was an Irish-language enthusiast, journalist and teacher. His school, St. Enda's in the southern suburbs of Dublin, was a hothouse of cultural nationalism, educationally progressive by the standards of the day, and financially precarious. He was a member of the Wolfe Tone club, an IRB front of which Clarke was president and MacDermott vice-president. It was Clarke who asked Pearse, by now well

known as a public speaker, to deliver the funeral oration at Glasnevin Cemetery, Dublin, over the coffin of Jeremiah O'Donovan Rossa. Rossa was an IRB veteran of the 1860s, imprisoned until 1871 and only released on condition that he left Ireland, which condition he fulfilled by going to America and helping to organise the dynamite war of the 1880s. By the time of his funeral, on 1 August 1915, he was an antique relic of earlier Fenian campaigns, but Pearse linked the generations in a speech of genuine brilliance, culminating with what is justly regarded as one of the finest perorations in Irish oratory:

> *In a closer spiritual communion with him now than ever before or perhaps ever again, in a spiritual communion with those of his day, living and dead, who suffered with him in English prisons, in communion of spirit too with our own dear comrades who suffer in English prisons today, and speaking on their behalf as well as our own, we pledge to Ireland our love, and we pledge to English rule in Ireland our hate. This is a place of peace, sacred to the dead, where men should speak with all charity and with all restraint; but I hold it a Christian thing, as O'Donovan Rossa held it, to hate evil, to hate untruth, to hate oppression, and, hating them, to strive to overthrow them.*
>
> *Our foes are strong and wise and wary; but, strong and wise and wary as they are, they cannot undo the miracles of God who ripens in the hearts of young men the seeds sown by the young men of a former generation. And the seeds sown by the young men of '65 and '67 are coming to their miraculous ripening today. Rulers and Defenders of Realms had need to be wary if they would guard against such processes. Life springs from death; and from the graves of patriot men and women spring living nations. The Defenders of this Realm have worked well in secret and in the open. They think that they have pacified Ireland. They think that they have purchased half of us and intimidated the other half. They think that they have foreseen everything, think that they have provided against everything; but the fools, the fools, the fools! – they have left us our Fenian dead, and while Ireland holds these graves, Ireland unfree shall never be at peace.*

The plans that might give substance to Pearse's rhetoric proceeded apace. All those plotting the rising agreed on one essential: the necessity for German arms and aid, just as the United Irishmen in the 1790s had required the help of revolutionary France. That unhappy precedent – too little, too late – would later appear lavish in comparison to what would be forthcoming from the Reich.

Plunkett went to Berlin in June 1915 accompanied by Sir Roger Casement, one of the most exotic of the Irish nationalist leaders. He had been born in Ulster of a comfortable Protestant family. He joined the British colonial service and produced two reports which were major humanitarian documents, one detailing the horrific conditions under which native workers were maltreated in the Belgian Congo, the other a similar report on conditions among rubber plantation workers in South America. Knighted in 1911, he retired from the colonial service the following year. He had always been something of an outsider – his homosexuality might have played a part here in what was still an unenlightened age – and his attraction to Irish nationalism was certainly not blunted by his first-hand experience of colonialism at its worst in Africa and South America. He joined the Irish Volunteers in 1913.

Two years later, he found himself in Berlin with Plunkett. The latter had sketched out a rough plan for a rising with Pearse, uninhibited by the fact that neither of them had any military experience and were both men of letters rather than men of action. Plunkett was a journalist and poet of a mystic bent, the scion of a distinguished old Catholic family whose father was a papal count. He now tried to persuade a clearly sceptical German government of the feasibility and practicality of a rising on Britain's domestic flank. The Germans remained non-committal.

Casement meanwhile stayed in Germany and tried to recruit an Irish brigade from Irish prisoners of war, with scant success. He did, however, eventually secure 20,000 rifles and a million rounds of ammunition together with the means to ship them from Hamburg to Ireland in support of the rising.

The first concrete plans for the Easter Rising were laid at a meeting in Clontarf Town Hall in north Dublin in January 1916. It was decided that regardless of all other circumstances a rising would take place in the coming April, on the symbolic occasion of

Easter Sunday. Contact was made with Clan na Gael in New York. At the same time, James Connolly was taken into the confidence of the military council. He was not an IRB man, but a socialist, trade unionist and historian. He had been James Larkin's right-hand man during the Lockout of 1913, the greatest labour dispute in Irish history. In November of that year, he had founded the Irish Citizen Army as a militia to protect the beleaguered strikers, who had been very roughly treated by the DMP. It remained in place after the end of the Lockout, becoming a uniformed and disciplined force. But it was tiny, no more than 400 men at most; Connolly was its commandant.

In the early years of the twentieth century, socialism usually meant internationalism. The greatest contemporary European socialist, the Frenchman Jean Jaurès, advocated the solidarity of working-class people across all borders and was accordingly opposed to the Great War. This opposition cost him his life at the hands of an enraged French patriot. Connolly likewise opposed the war, but he was also a nationalist. Fantastically, as it appears in hindsight, he was planning a rising of his own with his miniscule army. Connolly seemed to believe that his tiny force could precip-

John Redmond inspects a parade of Volunteers.

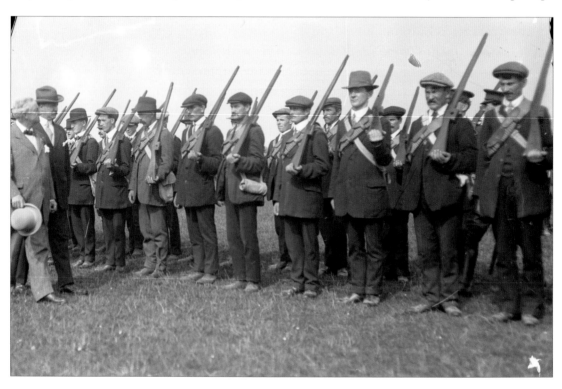

itate such a violent counter-reaction from the British that it would trip off an international socialist rebellion across Europe such as would end the war and destroy the ruling classes.

Word of this reached the military council, which is why they moved preemptively to include him in their plans. In the end, just over 200 ICA men out of a total of 340 at the time were out in 1916.

The plans advanced ever more secretly. By now, there was a division not just between the military council and the leadership of the Volunteers but between the council and the Supreme Council of the IRB itself, some of whose members – most notably Bulmer Hobson – were kept in the dark. Hobson was a known opponent of a futile rising, quoting the very constitution

Sir Roger Casement, British Consular official and Irish patriot. He escaped the scuttling of the Aud *only to be arrested and sent to trial.*

of the IRB itself in support of his view that a rising should only be attempted with clear public support and a reasonable prospect of success. The first condition was plainly absent and the second out of reach for want of German arms. The Casement shipment would be some help. It was on the high seas and was due to make landfall off Banna Strand in Co. Kerry on Good Friday.

In the event, the landing was a fiasco which ended in the capture and then the scuttling of the *Aud*, the ship carrying the arms. Casement got ashore only to be arrested and to begin the final journey that would lead him to the scaffold in Pentonville.

Fearing that the influential Hobson would scupper their plans at the last minute, the military council kidnapped him and held him until the rising was safely under way. Not part of the heroic narrative, he was ignored in the later glorifications of the rising and forgotten by his countrymen.

MacNéill, the formal head of the Volunteers, knew that something odd was afoot but was unsure exactly what. He had previously dismissed any proposals for an early rising in a document of devastating clarity and logic, concluding that "to my mind, those who feel impelled towards military action … are really impelled

Augustine Birrell, Chief Secretary of Ireland, 1907–16. He was the longest serving person to hold that office under the union.

by a sense of feebleness or despondency or fatalism, or by an instinct of satisfying their own emotions or escaping from a difficult and complex situation". In April 1916, he asked Pearse for reassurances that no insurrection was planned or imminent. Pearse gave him a bland assurance to that effect. Still not satisfied, he confronted Pearse again only to receive the crushing reply: "We have used your name and influence for what they were worth, but we have done with you now. It is no use trying to stop us."

But try to stop it he did. MacNéill issued an order countermanding all Volunteer manoeuvres planned for Easter weekend, correctly seeing them as cover for the intended rising. Such manoeuvres had been a growing feature of Volunteer activity, especially in Dublin where every available man paraded in military formation the previous St. Patrick's Day.

Moreover, MacNéill despatched people who had cars to the provinces with countermanding orders. The O'Rahilly was the best known of these. He spent all of Saturday, day and night, driving around the midlands personally delivering the instruction that all previous orders for Easter Sunday "are hereby rescinded, and no parades, marches or other movements of Irish Volunteers will take place". MacNéill also ensured that the countermanding order was carried in the early editions of the *Sunday Independent*.

By now, on Easter Sunday morning, the troops mobilising for the rising were beginning to muster at Liberty Hall. The Proclamation of the Republic was being printed nearby and all was in readiness. The effect of MacNéill's démarche was to leave the leaders of the rising in two minds: Clarke wanted to proceed immediately, or at least later on Sunday, on the sensible grounds that if they postponed to the Monday, even fewer men would mobilise. He was overruled. And so it was to be Easter Monday that would go down in Irish history.

In all this activity in the early months of 1916, what of the British authorities in Dublin Castle? The fabled seat of British rule, with its spy system and surveillance apparatus, had been a constant bulwark against every species of militant nationalism since the Act of Union.

Times had, however, changed. Asquith's Liberal government had espoused and passed the longed-for Home Rule Act and awaited the end of the war to hand over the domestic Irish

administration to Redmond and his lieutenants. In such circumstances, a heavy-handed security policy along traditional coercive lines seemed inappropriate. Moreover, the Chief Secretary, Augustine Birrell, who had been in the job since 1907 (he was the longest serving of all Chief Secretaries), was neither of a confrontational nor an authoritarian temper. His Under Secretary – the head of the Irish civil service – Sir Matthew Nathan had come to the post as late as 1914 with no previous experience of Ireland and was, in many respects, still feeling his way. His previous postings had been in Sierra Leone, the Gold Coast (Ghana) and Hong Kong.

There were warnings from within the Irish administration of growing insurrectionary feeling. This was usually denominated as Sinn Féin activity, although it had absolutely nothing to do with that tiny and almost moribund party. Still, Sinn Féin became a generic for all advanced nationalism and the name stuck. Major Ivor Price, the Irish Command's intelligence officer, argued that the Irish Volunteers was a seditious organisation. This was re-

Members of the Irish Citizen Army parade outside Liberty Hall.

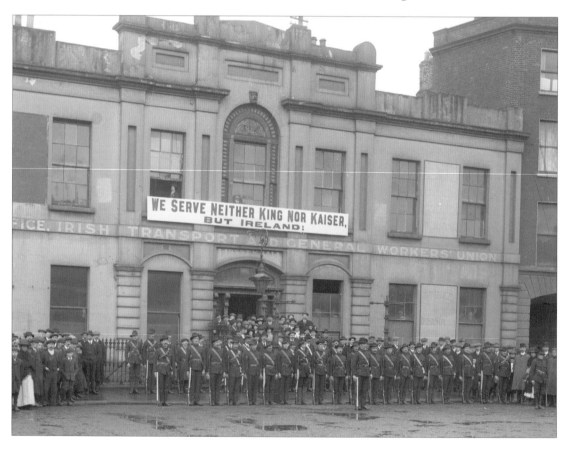

garded by Birrell as alarmist and exaggerated and perhaps only to be expected from a former senior RIC officer.

Birrell argued, not without reason, that to proscribe the Irish Volunteers while leaving the National Volunteers – and worse, the UVF – untouched made no sense. Birrell was a charming, witty, bookish man, a good literary critic and a dinner party favourite in London, where his bon mots were remembered. Temperamentally he was a liberal, reflexively averse to heavy-handed security measures. But he was not a heavyweight at the cabinet table, where his brief seemed a distraction from the rather more important business of the war. He was the wrong man in the wrong place (or rather, not in the wrong place, for the most frequent complaint against him was that he spent far too much time in London and too little in Dublin). Given the weakening legitimacy of British government in Ireland, it is hard to see how policies such as those being urged by Major Price could have been carried through without playing totally into the radicals' hands.

Arthur Hamilton Norway was the head of the Irish postal service. He was aware of subversives in his service, for the post office was a favourite place of employment for IRB men and other advanced nationalists. Michael Collins was merely the best known of them, but in early 1916 they included such influential IRB figures as P.S. O'Hegarty. He too was struck by the apparently casual and relaxed view of the Castle. In a sense, the open parading and marching of the Volunteers in early 1916 acted as an unconscious bluff, lulling the authorities into the view that no actual conspiracy would declare itself so openly. It seemed to make sense to believe that the Volunteers were merely playing at soldiers.

The capture of Casement on Good Friday confirmed the authorities in their view that if something had been afoot, it was all scuppered now. It was a bank holiday weekend. Birrell, in London for a cabinet meeting, decided to stay there and make the most of the break. The army commander in Ireland, General Friend, left Dublin for London after hearing of the capture of Casement, assuming like so many others that that was that. The Irish Grand National would be run at Fairyhouse, north-west of the city, on Monday. That was to be the destination of choice for many officers and gentlemen. Dublin Castle would be left with fewer than 30 troops to guard it. The capital of Ireland was off to the races.

POBLACHT NA H EIREANN.
THE PROVISIONAL GOVERNMENT
OF THE
IRISH REPUBLIC
TO THE PEOPLE OF IRELAND.

IRISHMEN AND IRISHWOMEN: In the name of God and of the dead generations from which she receives her old tradition of nationhood, Ireland, through us, summons her children to her flag and strikes for her freedom.

Having organised and trained her manhood through her secret revolutionary organisation, the Irish Republican Brotherhood, and through her open military organisations, the Irish Volunteers and the Irish Citizen Army, having patiently perfected her discipline, having resolutely waited for the right moment to reveal itself, she now seizes that moment, and, supported by her exiled children in America and by gallant allies in Europe, but relying in the first on her own strength, she strikes in full confidence of victory.

We declare the right of the people of Ireland to the ownership of Ireland, and to the unfettered control of Irish destinies, to be sovereign and indefeasible. The long usurpation of that right by a foreign people and government has not extinguished the right, nor can it ever be extinguished except by the destruction of the Irish people. In every generation the Irish people have asserted their right to national freedom and sovereignty; six times during the past three hundred years they have asserted it in arms. Standing on that fundamental right and again asserting it in arms in the face of the world, we hereby proclaim the Irish Republic as a Sovereign Independent State, and we pledge our lives and the lives of our comrades-in-arms to the cause of its freedom, of its welfare, and of its exaltation among the nations.

The Irish Republic is entitled to, and hereby claims, the allegiance of every Irishman and Irishwoman. The Republic guarantees religious and civil liberty, equal rights and equal opportunities to all its citizens, and declares its resolve to pursue the happiness and prosperity of the whole nation and of all its parts, cherishing all the children of the nation equally, and oblivious of the differences carefully fostered by an alien government, which have divided a minority from the majority in the past.

Until our arms have brought the opportune moment for the establishment of a permanent National Government, representative of the whole people of Ireland and elected by the suffrages of all her men and women, the Provisional Government, hereby constituted, will administer the civil and military affairs of the Republic in trust for the people.

We place the cause of the Irish Republic under the protection of the Most High God, Whose blessing we invoke upon our arms, and we pray that no one who serves that cause will dishonour it by cowardice, inhumanity, or rapine. In this supreme hour the Irish nation must, by its valour and discipline and by the readiness of its children to sacrifice themselves for the common good, prove itself worthy of the august destiny to which it is called.

Signed on Behalf of the Provisional Government,

THOMAS J. CLARKE,
SEAN Mac DIARMADA, THOMAS MacDONAGH,
P. H. PEARSE, EAMONN CEANNT,
JAMES CONNOLLY. JOSEPH PLUNKETT.

CHAPTER 4
THE RISING: THE FIRST TWO DAYS

Eoin MacNéill's countermanding order sowed sufficient confusion to ensure that fewer than 2,000 Volunteers and Citizen Army men – and a few women – turned out on Easter Monday morning, in what was an almost exclusively Dublin event. They occupied a series of locations around the city, chosen for their perceived strategic importance. For instance, the garrison established at Boland's Mills was able to block the railway line from the ferry port at Kingstown/Dun Laoghaire. That at the South Dublin Union was astride the south-west approach road to the city, and with greater numbers would have been able to gain control of the terminus of the Great Southern & Western Railway at nearby Kingsbridge/Heuston station. But the lack of numbers meant that the main railway terminus for traffic from the north – Amiens Street/Connolly – was not invested. It was originally intended to be Thomas MacDonagh's command, but instead he and his men were deployed to Jacob's biscuit factory on the other side of the city.

The principal garrison was the General Post Office, in Sackville/O'Connell Street. At 11.45 am Connolly led a group of about 150 from their gathering point at Liberty Hall, beside Butt Bridge, along Lower Abbey Street and then into the city's main thoroughfare. Halting opposite the GPO, he barked out the order: "The GPO – charge!" Which they did, capturing the building with ease and with the advantage of complete surprise. Having sandbagged the windows and generally prepared it as best they could for the inevitable British counter-attack, Pearse stepped out into the street and read out the Proclamation of the Republic to a bemused and sceptical audience, curious as to what the fuss was all about.

Principally the work of Pearse and Connolly, it is one of the most celebrated documents in Irish history. It had been printed by Christopher Brady in the basement of Liberty Hall the previous afternoon on a battered old flatbed printer. Brady displayed

Opposite: The Proclamation of the Republic – perhaps the most celebrated document in modern Irish history.

71

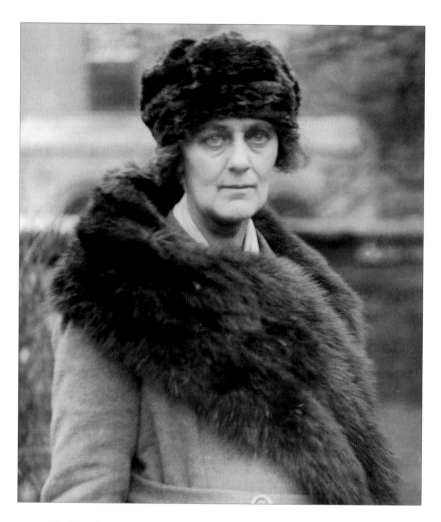

*Countess Constance
Georgine Markievicz,
née Gore-Booth.*

remarkable skill in utilising the inadequate amount of type available first to print the first part and then re-using it to compose and print the second half. Some letters were missing completely and had to be improvised using sealing wax. A thousand copies were run off, the first being grabbed by Constance Markievicz and read to a small crowd outside. Pearse's 'official' reading of the Proclamation outside the GPO the following day was therefore the second time the document was proclaimed.

The other rebel commands and commanders were at the Four Courts (Edward Daly), with sub-commands at the Mendicity Institution and Jameson's distillery; Jacob's (Thomas MacDonagh); Boland's Mills (Eamon de Valera), with a sub-command at Mount Street Bridge; South Dublin Union (Eamonn Ceannt), with sub-commands at Roe's distillery and Ardee Street bakery; and St.

Stephen's Green (Michael Mallin), first in trenches in the park itself, subsequently in the College of Surgeons on the west side of the Green. The GPO garrison had a sub-command across the way, at the top of North Earl Street, the street leading to Amiens Street station, and also occupied Clery's – the leading department store in the street – and the Imperial Hotel. The hotel was the property of William Martin Murphy, the employer-villain of the 1913 Lock-out, and Connolly took malicious pleasure in having the Irish socialist flag, the Starry Plough, raised on its roof.

Arthur Hamilton Norway, the head of the Irish post office, had been in his office at the GPO up to about 15 minutes prior to the capture of the building. He had left to go to Dublin Castle where Sir Matthew Nathan and Major Price were contemplating the weekend's events, the capture of Roger Casement in Co. Kerry and the sinking of the *Aud*. They wanted Norway to ensure that the post and telegraph service in the south be confined to the military until further notice. Although shaken by events in Kerry, they now took it for granted that whatever had been planned was fatally compromised and that the danger was past.

Not capturing Arthur Norway was one of two early near misses for the rebels. The second was at the Castle itself, the very nerve centre of British power in Ireland and a place of enormous symbolic resonance. It never occurred to the Volunteers that it was practically undefended but that was, in fact, the case.

Easter Monday was a public holiday. Moreover, by long custom it was the day on which the Irish Grand National was run at Fairy-house racecourse outside Dublin. Much of Dublin's fashionable society, including many British officers, was at the races. What was left behind in the Castle was a paltry force, fewer than 30 men and most of them without arms or ammunition. A detachment of Citizen Army personnel under the command of an Abbey actor, Sean Connolly (unrelated to James), arrived at the Castle and were challenged by a member of the DMP whom they promptly shot dead on the spot. Constable O'Brien, an unarmed Catholic, was the first person to die in the Easter Rising.

But having held a guardroom for a short period, they simply could not believe that their small number could hold the entire complex. They could not have done so indefinitely, but they could have held it long enough to secure a tremendous propaganda coup.

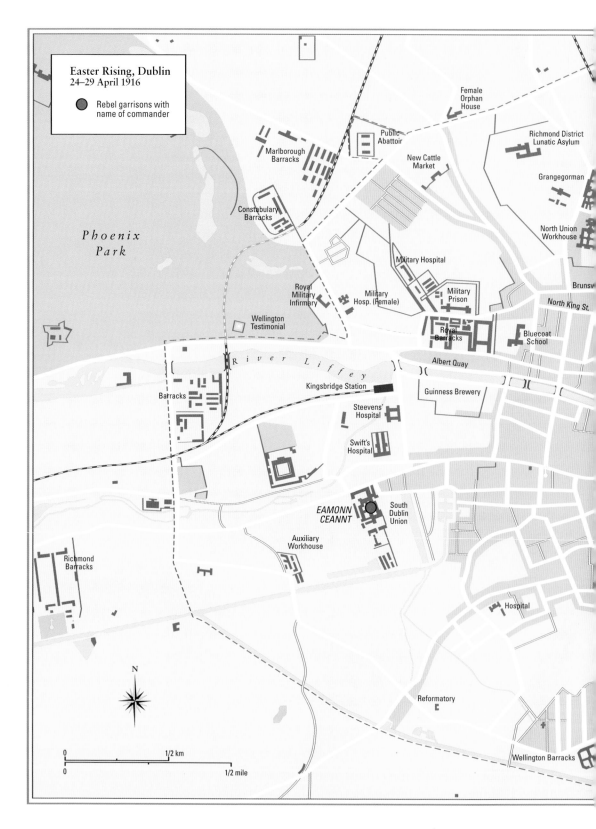

Easter Rising, Dublin
24–29 April 1916

Rebel garrisons with
name of commander

Female
Orphan
House

Public
Abattoir

Richmond District
Lunatic Asylum

New Cattle
Market

Marlborough
Barracks

Grangegorman

Constabulary
Barracks

North Union
Workhouse

*Phoenix
Park*

Military Hospital

Brunsv

Royal
Military
Infirmary

Military
Hosp. (Female)

Military
Prison

North King St.

Wellington
Testimonial

Royal
Barracks

Bluecoat
School

River Liffey

Albert Quay

Barracks

Kingsbridge Station

Guinness Brewery

Steevens'
Hospital

Swift's
Hospital

*EAMONN
CEANNT*

South
Dublin
Union

Auxiliary
Workhouse

Richmond
Barracks

Hospital

N

Reformatory

0 1/2 km

0 1/2 mile

Wellington Barracks

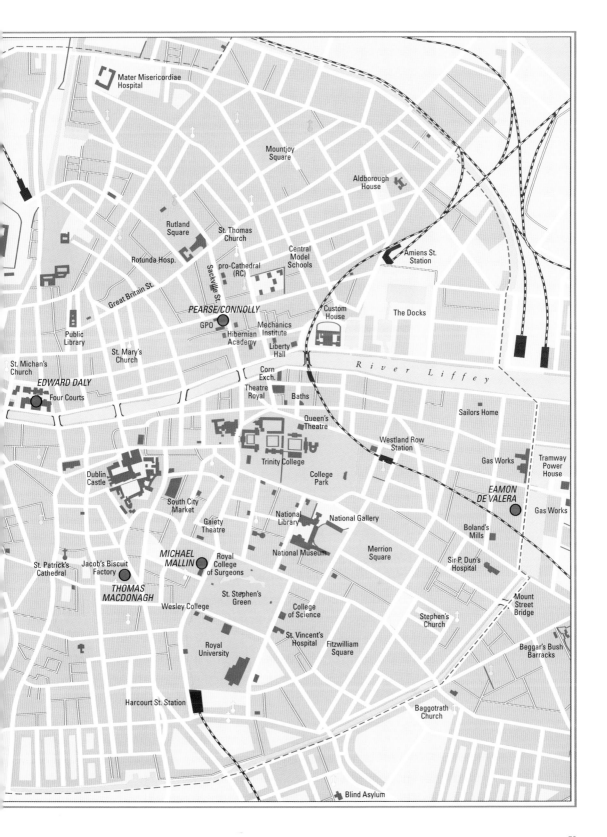

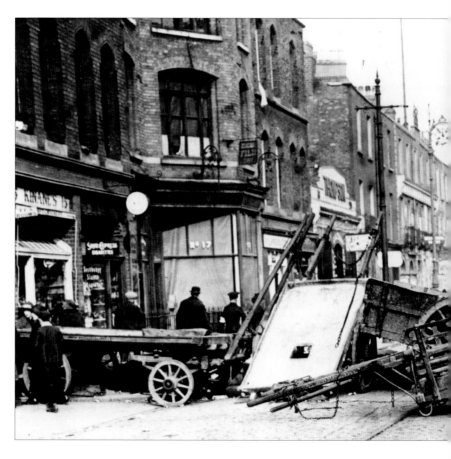

The Volunteers hastily erected a barricade across Great Brunswick Street in an attempt to slow down the British approach.

How could they possibly believe that the Castle – actually a collection of formal buildings, offices, barracks and stores rather than a single fortified structure – with all the mythology of its impregnability, was in fact at their mercy? They withdrew to nearby City Hall, where Sean Connolly became one of the early casualties on the rebel side at around 2 pm when a stray bullet killed him as he conducted a rooftop inspection.

In the meantime, a shipment of ammunition for the army was unloaded at the North Wall and was met by an escort from the 5th & 12th Lancers, who were to accompany it along the quays to Marlborough Barracks near the Phoenix Park. By a ludicrous coincidence, this took them past the end of Sackville Street just as the Volunteers were investing the GPO 200 yards away. Presently, they came upon a makeshift barricade at Church Street, thrown up by the Volunteer garrison from the nearby Four Courts. For the inexperienced Volunteers, mounted Lancers were a formidable and frightening sight. As much from terror as from any other consid-

eration, they fired at the cavalrymen. The effect was startling. Completely taken by surprise, the Lancers turned into a side street only to come under fire from other corners of the garrison adjacent. Two of their number died in the subsequent confusion.

Back at the GPO, two flags were raised aloft. One was the green, white and orange tricolour, first seen in 1848 as an Irish analogue of the French republican tricolore. Just as the French flag used colour symbols – the Bourbon white embraced by the Parisian red and blue – so did the Irish. In this case, the white symbolised peace between the orange and green traditions, an aspiration that has, in the life of the flag, been honoured as much in the breach as in the observance.

The second flag, flown at the Princes Street corner of the building, was a creation by Countess Markievicz. This exotic, née Gore-Booth, was a daughter of the Anglo-Irish ascendancy and had been presented at court as a young woman in the 1880s. She then pursued a bohemian career as a painter in London and Paris, where

she met her husband, a Polish-Ukrainian count. Returning to Ireland, she gradually embraced nationalist and labour causes and was a heroine of the 1913 Lockout where she organised a soup kitchen in Liberty Hall. She was the founder of a number of republican youth organisat

the warriors) which becar

The flag she designed co

green field. The material

spread. The third flag, the

was, as we saw, raised ove

the street. At all events, t

ther side of the capital's p

imagination.

Gradually crowds gath

looting, as people from th

the street began to take

priests tried to move the

O'Connell Bridge but it v

persuaded one group to move along than a larger one swelled in behind them. What eventually scattered the crowds was not priests but cavalry.

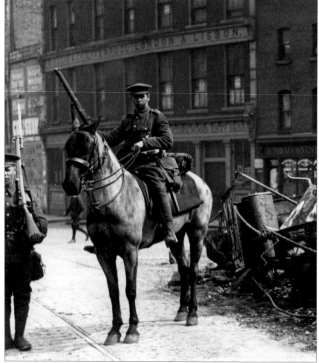

A Lancer of Colonel Hammond's command; it became clear to all that cavalry had no place on the urban battlefield.

Dublin was very sparsely defended by the British. Not only was the Castle itself denuded of troops, there were no more than 400 regular troops distributed at the four principal barracks in the city. It was a troop of Lancers from Marlborough Barracks, on the edge of the Phoenix Park, which made its way to the top of Sackville Street by the Parnell Monument – the far end from O'Connell Bridge – and surveyed the scene. In the GPO, Connolly gave strict instructions that in the event of their charging down the street no shots were to be fired until he barked out the order: he wanted them fully astride the

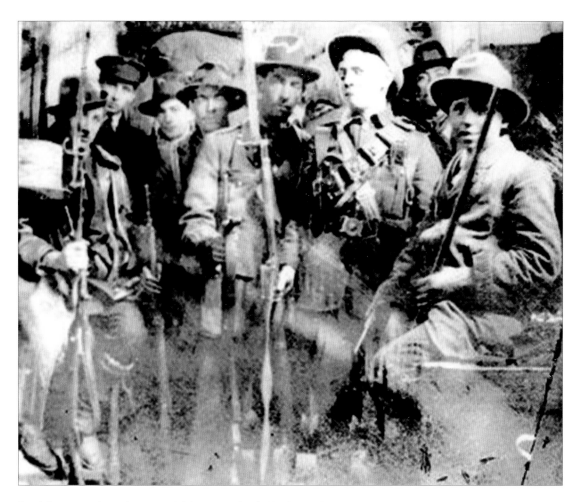

One of the few authenticated images from inside the GPO garrison. All but one of these men have been identified.

building so that they could be caught fully broadside.

The Lancers came all right. Their commanding officer, Colonel Hammond, appears to have had a cavalryman's traditional belief in the intimidating power of mounted troops, especially on irregulars. They started down the street at a trot and eventually broke into a gallop with sabres drawn. Hammond's calculation may not have been wholly wrong, because Connolly's order was ignored and the GPO garrison began firing before the order was given. The result was three Lancers dead before they hit the ground and a fourth fatally wounded. Hammond sounded the retreat, leaving his casualties where they had fallen, and withdrew whence he had come.

In the words of W.J. Brennan-Whitmore, an eye-witness to the event and shortly to be placed in charge of the Volunteer position at the head of North Earl Street, across from the GPO: "I cannot conceive anything more stupid than this sortie by mounted troops."

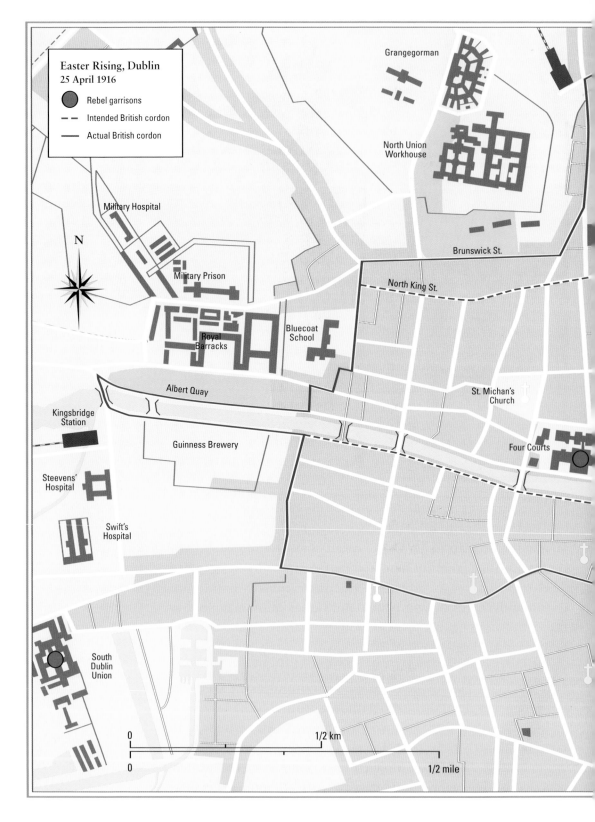

Easter Rising, Dublin
25 April 1916

● Rebel garrisons
--- Intended British cordon
— Actual British cordon

Grangegorman

North Union Workhouse

Military Hospital

Brunswick St.

Military Prison

North King St.

Bluecoat School

Royal Barracks

St. Michan's Church

Albert Quay

Kingsbridge Station

Guinness Brewery

Four Courts

Steevens' Hospital

Swift's Hospital

South Dublin Union

0 1/2 km

0 1/2 mile

N

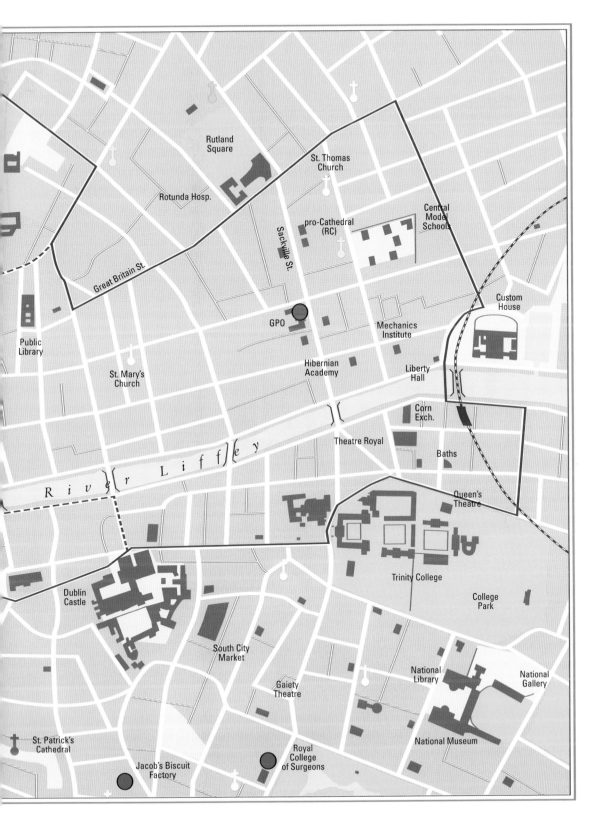

Rutland
Square

St. Thomas
Church

Rotunda Hosp.

Central
Model
Schools

pro-Cathedral
(RC)

Great Britain St.

Sackville St.

Custom
House

GPO

Mechanics
Institute

Public
Library

Hibernian
Academy

Liberty
Hall

St. Mary's
Church

Corn
Exch.

Theatre Royal

Baths

River Liffey

Queen's
Theatre

Trinity College

Dublin
Castle

College
Park

South City
Market

National
Library

National
Gallery

Gaiety
Theatre

St. Patrick's
Cathedral

National Museum

Jacob's Biscuit
Factory

Royal
College
of Surgeons

Once the word of the rising spread, the British responded by ordering troops from the Curragh Camp, about 35 miles south-west of Dublin, to enter the city. This they did in the course of Monday night, under the command of Brigadier-General W.H.M. Lowe, arriving by rail at Kingsbridge station (now Heuston). The inability of the Volunteer garrison at the South Dublin Union to take control of the station and its approaches – as had been part of Plunkett's original strategy – facilitated the arrival of these troops.

The contrast with de Valera's garrison at Boland's Mills was total: they were able to cut the Dublin & South-Eastern rail link from Westland Row/Pearse station, thus disabling the entire east-coast line and forcing any troops landing at Kingstown to march into the city, an eventuality that was to lead to the heaviest crown casualties of the rising on the Wednesday.

Lowe proceeded to throw a cordon around the city centre, sufficient to corral the various rebel positions within it. The rebel dispositions were entirely passive, simply investing the various

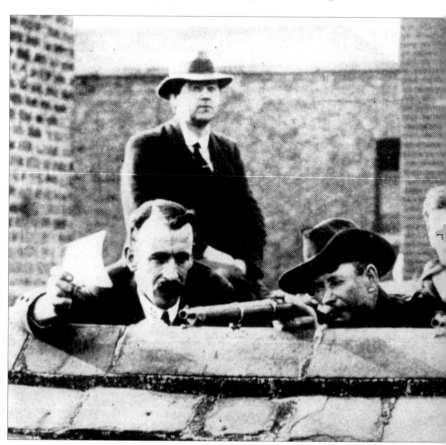

positions and awaiting the British response.

But the whole plan of the rising did not envisage success in conventional military terms. No one was under any illusion about the outcome. James Connolly admitted candidly to his trade union colleague, William O'Brien: "Bill, we are going out to be slaughtered." The O'Rahilly, having returned to Dublin following his countermanding mission in the midlands, found that the rising was under way after all. He promptly joined the GPO garrison. He met Desmond Fitzgerald and admitted: "They were determined to have a rising, so here we are." Fitzgerald asked him: "How long do you think that we can last?" "By a miracle we might last for 24 hours," O'Rahilly replied, "but I don't think we'll go for that long."

The knowledge that the rising was, *ab initio*, a gesture in arms rather than a full-blown struggle to replace British rule in Ireland undoubtedly influenced much rebel thinking, none more so than Sean Connolly's when he failed to press home his advantage at the Castle. By 1.40 pm, 180 relief troops had arrived at the Ship Street

This small group of the Irish Citizen Army occupy a rooftop position.

entrance to the Castle, out of sight and range of the rebels in the City Hall whose fate was now just a matter of time.

The signal to all rebel positions that the rising was on was to be given by an explosion at the Magazine Fort in the Phoenix Park. A party of Volunteers forced an entrance but were unable to access the high explosives store, for the simple reason that the key was not in its appointed place: the officer in charge had it in his pocket at Fairyhouse races. Instead they had to make do with lesser explosives which duly went off but gave a report that was not even heard at the South Dublin Union, the nearest garrison as the crow flew. The commander of the Magazine Fort was serving in France, but his 23-year-old son tried to raise the alarm, sprinting towards the nearest phone to warn the authorities. Volunteer Gerry Holohan gave chase, caught up with him in a doorway just outside the Phoenix Park and shot him dead. George Playfair – that was his name – was the second person to die on Easter Monday.

The outlying garrisons saw little action on the Monday. While the GPO and the Four Courts had the satisfaction of their engagements with Lancers and the City Hall group were now stoically awaiting their fate, which duly arrived overnight, the Stephen's Green detachment, under the less than confident leadership of Michael Mallin, was unaccountably digging trenches for

Dublin Castle
25 April 1916

● Rebel garrisons

→ British soldiers

① A detachment of Citizen Army men, led by Sean Connolly, shoot and kill Constable O'Brien, the first fatality of the Easter Rising.

② 1.40 pm: 180 British troops arrive.

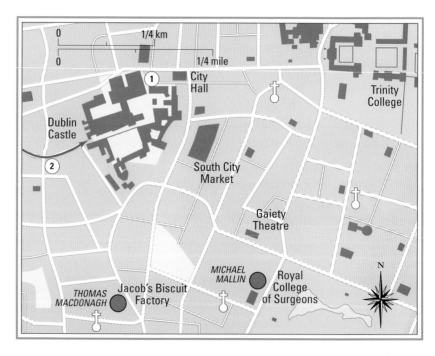

itself. Its reward was to get drenched, for it rained heavily on Monday night – the only exception all week to the fabled rebellion weather. No attempt was made to take over the Shelbourne Hotel, the tallest building in the area. Instead, Mallin's second-in-command, Countess Markievicz, enthralled the guests in the Shelbourne by prancing up and down along the north side of the Green in plain view and in full uniform. The garrison achieved nothing more heroic than killing an unarmed policeman and an elderly actor who was attempting to recover his property which had been commandeered for a rebel barricade.

Just as no attempt was made to capture the Shelbourne, neither was any assault made on Trinity College, strategically the most important position in the city. It was defended only by its Officer Training Corps (OTC) who would have been useless against a determined attack. More to the point, it would have given access to the OTC's arms and ammunition store, which would have augmented the Volunteers' scarce resources of matériel.

The first of the other principal garrisons was at Jacob's factory in the south inner city, commanding the crossing of the Grand Canal from Portobello Barracks in Rathmines. It was impregnable to attack from anything other than the heaviest artillery but equally its uselessness as an offensive possibility was underscored by its minimal contribution to the events of the week. It was the last garrison to surrender, not because of heroism but because of its remoteness from all that went on around it. Although geographically close to the action, it assumed the status of a medieval donjon wherein its troops were safely sequestered from the tumult without. It was the last garrison to get the news of the general surrender.

It missed an opportunity to inflict real damage on a party of troops from Portobello Barracks heading to the relief of Dublin Castle when – just as with the Lancers in Sackville Street – the inexperienced Volunteers fired prematurely in defiance of MacDonagh's orders. The military, alerted to the danger, withdrew and rerouted.

The second major garrison was Eamonn Ceannt's command at the South Dublin Union. This sprawling 52-acre site was in the south-west of the city and the idea of investing it was to harass any British troops being sent in as reinforcements via the nearby Kingsbridge station, the disembarkation point for troops from the Curragh Camp. As we saw, they lacked the resources to do this.

Any troops marching along the quays, on either side of the river, towards the Four Courts on the north side or its outpost at the Mendicity Institution on the south side, could be harassed. But given the paltry numbers that actually mustered and the difficulty of securing their base in the SDU with such scant resources, the garrison was nearly useless as an offensive force. Indeed, one is again struck by the essentially defensive disposition of all garrisons, based on an overall battle plan that did not actually envisage military success but a symbolic gesture in arms.

None the less, snipers from the garrison were able to mount an ambush on troops marching towards Thomas Street. This prompted a furious British response that resulted in an encircling counter-attack on the SDU itself, where weight of numbers quickly told. Ceannt's men fought all day with real courage as their garrison space shrank all the time.

The other major garrison was at Boland's Mills and its strategic aim was similar to that at the South Dublin Union. The mills, a formidable Victorian industrial structure approaching if not quite matching the scale of Jacob's, commanded the railway line from the south-east and specifically from Kingstown where any reinforcements sent from Britain would disembark. Again it was an essentially defensive disposition. But it was, none the less, to produce the best offensive performance by the rebels in the entire course of Easter Week.

First of all, the position gave direct access to the railway itself, unlike the SDU, which was at least a mile from the tracks. The garrison troops busied themselves by taking over the terminus at Westland Row – not without some farcical scenes – and, more to the point, by digging up the track on the approach. Incoming trains could now proceed no closer to the city than the suburban station at Lansdowne Road. It meant that any troops inbound would have to march in by road, almost certainly along Northumberland Road where they would cross the canal at Mount Street Bridge. With this in mind, the garrison sent a small force to occupy the tall houses that commanded the approach to the bridge. In addition, the Boland's Mills garrison was expected to 'dominate' the army barracks at Beggar's Bush which lay under the railway embankment that ran between Lansdowne Road and Westland Row stations. In fact, they could have invested it had they but known that it was completely undefended.

It would have been of little use to them for, like the garrison at the South Dublin Union, de Valera's men were too few in number to command the large area they were nominally assigned. However, the manner in which they concentrated their resources at strategic pressure points was to bring the rebel forces the greatest success of the week.

Once Lowe had arrived in the city and had thrown his cordon around the various rebel garrisons, the basic strategic logic of the rising was established. The rebels were passive, awaiting the British counter-attack in whatever form it might take. Their tactical naïveté was nowhere more evident than in St. Stephen's Green where, as we saw, Mallin's men dug trenches in the park as if they were on the Western Front. The British, by contrast, having sent a detachment of troops to this area, occupied the Shelbourne Hotel and got a number of Vickers machine-guns set up on the fourth floor. This gave them a clear field of fire into the sodden trenches in the park.

At first light on Tuesday morning, they opened fire. Five rebels died. It might have been more had the shrubs and bushes in the park not given some cover. The rest, about 100 in all, fled to the relative safety of the Royal College of Surgeons on the west side of the Green. It was the most imposing building on that side, although still much smaller than the Shelbourne. There they joined others from their garrison who had already occupied it, having abandoned their original intention of advancing south to hold Harcourt Street railway station and the crossing on the Grand Canal. Once more, lack of numbers was telling. There was not a scrap of food to be had in the College of Surgeons.

There was little action in Sackville Street on the Tuesday but the breakdown of law and order presented a priceless opportunity for people from the nearby slums to loot the undefended shops. It placed Connolly in a moral quandary. These were his people, the poorest of the poor from some of the most awful slums in Europe, but they were both disgracing the rising and hindering its progress. MacDermott was sent out to remonstrate with them, to no avail. Francis Sheehy-Skeffington, perhaps the best-known eccentric in Dublin, also tried in vain. 'Skeffy' was a pacifist, a feminist and a vegetarian given to wearing home-spun tweeds in the Shavian manner. Connolly was reduced to firing

over the heads of the crowd and sending a party under Sean T. O'Kelly to mount a guard on the shops.

The situation on the far side of the street from the GPO stabilised somewhat when W.J. Brennan-Whitmore was sent across by Connolly to invest various premises in the hope of holding off any reinforcements coming up from Amiens Street station either by Talbot Street/North Earl Street or by Abbey Street. His men constructed a barricade across the top of North Earl Street where it joined Sackville Street. Brennan-Whitmore was lucky in that one of his men somehow got hold of a long coil of wire which was used to interlace and strengthen the otherwise rickety barricade. Pearse and Connolly both came across separately from the GPO and declared the barricade flimsy. Connolly was particularly scathing. "What's the good of this thing? It'll never withstand a charge. Schoolgirls could knock it over." Brennan-Whitmore invited each in turn to try and disturb it. Braced by the wire, it held. Brennan-Whitmore admired Connolly, whom he described as "always sharp and decisive". He was less obviously admiring of Pearse whose "mind was obviously up in the clouds" but he acknowledged that Pearse "was not just respected by the little garrison, he was almost worshipped".

It was Pearse, the rhetorician and propagandist, who issued the first – and only – edition of *Irish War News* at 9.30 am on Tuesday morning. Propaganda of the deed was now followed by propaganda of the word. If the rising was a poets' rebellion, as was frequently stated later, the literary appeal to public sentiment was a logical corollary of the whole enterprise. It was also firmly in the tradition of the European nineteenth-century revolutionary and insurrectionary tradition. Pearse here stood with Lamartine, Herzen and Wagner – all veterans of 1848 – as much as with his apostolic succession of Irish resistance: 1798, the Young Irelanders, the Fenians and so on. Even the manner of the urban revolt itself was reminiscent of the European past: the barricades, the public buildings invested, the expectation of counterattack from the forces of the old regime. It might have been Paris or Dresden in 1848. It was a lesson not lost on Michael Collins, a 25-year-old Corkman in the GPO. When he came to direct the next phase of republican resistance to British rule in Ireland a few years later, he used methods remote from those of the ro-

mantic revolutions and well adapted both to Irish and twentieth-century circumstances.

Pearse's single-issue news sheet may have had a butterfly life but it made its point, albeit with some pardonable exaggeration, and established a narrative that long outlived its author and the rising itself.

April 25th 1916
<div align="center">

IRISH WAR NEWS

The Irish Republic

Vol. 1, No. 1, Dublin, Tuesday April 25th, 1916.

Price One Penny.

Stop Press!

The Irish Republic
</div>

Irish War News is published today because a momentous thing has happened. The Irish Republic has been proclaimed in Dublin, and a Provisional Government has been appointed to administer its affairs.

• The following has been named as the Provisional Government:

<div align="center">

Thomas J. Clarke,

Sean MacDiarmada,

P. H. Pearse,

James Connolly,

Thomas MacDonagh,

Eamon Ceannt,

Joseph Plunkett.
</div>

The Irish Republic was proclaimed by poster which was prominently displayed in Dublin.

At 9.30 am this morning the following statement was made by Commandant-General P. H. Pearse:

The Irish Republic was proclaimed in Dublin on Easter Monday, April 24, at 12 noon. Simultaneously with the issue of the proclamation of the Provisional Government the Dublin Division of the Army of the Republic, including the Irish Volunteers, the Citizen Army, Hibernian Rifles, and other bodies occupied dominating positions in the city. The GPO was seized at 12 noon, the Castle attacked at the same moment, and shortly afterwards the Four Courts were

occupied. The Irish troops hold the City Hall and dominate the Castle. Attacks were immediately commenced by the British forces, and everywhere were repulsed.

At the moment of writing this report (9.30 am, Tuesday) the Republican forces hold their positions and the British forces have nowhere broken through. There has been heavy and continuous fighting for nearly 24 hours, the casualties of the enemy have been much more numerous than those on the Republican side. The Republican forces everywhere are fighting with splendid gallantry. The populace of Dublin are plainly with the Republic, and the officers and men are everywhere cheered as they march through the city. The whole centre of the city is in the hands of the Republic, whose flag flies from the GPO.

Commandant-General P. H. Pearse is Commandant in Chief of the Army of the Republic and is President of the Provisional Government. Commandant-General James Connolly is commanding Dublin districts.

Communication with the country is largely cut, but reports to hand show that the country is rising. Bodies of men from Kildare and Fingal have already reported in Dublin.

Later in the day, Pearse issued a 'Manifesto to the Citizens of Dublin' which he read out from the foot of Nelson Pillar. "The Republican forces hold the lines taken up at 12 noon on Easter Monday and nowhere, despite fierce and almost continuous attacks of the British troops, have the lines been broken through. The country is rising in answer to Dublin's call and the final achievement of Ireland's freedom is now, with God's help, only a matter of days. The valour, self-sacrifice and discipline of Irish men and women are about to win for our country a glorious place among the nations... The British troops have been firing on our women and on our Red Cross. On the other hand, Irish Regiments in the British army have refused to act against their fellow-countrymen."

The country was not rising. There were no mobilisations of any significance outside Dublin. The scattered garrisons around the city, of which two were trapped within the British cordon, were on their own.

Yet Pearse's fictions were to have the last word. Out of this hopeless military position, a foundation myth was born.

Lord Wimborne, the Viceroy of Ireland, who illegally declared martial law during the Easter Rising, inspecting troops.

Connolly had argued that no capitalist government would deploy artillery and thus destroy private property within its own borders. He seemed strangely ignorant of the Paris Commune. At any rate, his illusions were shattered in the middle of Tuesday afternoon when a 18-pound field gun, recently arrived by train from Athlone and set up in the grounds of Grangegorman hospital in the north-west of the city, scattered an outlying rebel barricade in the suburb of Phibsborough. It was a portent of bigger things to come. A Citizen Army man in the GPO said to a Volunteer colleague: "General Connolly told us the British would never use artillery against us", only to receive the mordant reply, "He did, did he? Wouldn't it be great, now, if General Connolly was making the decisions for the British?"

Out beyond Phibsborough and Grangegorman, at the western end of the North Circular Road, lay the Phoenix Park. In the middle of the park stood the Viceregal Lodge, a house originally built

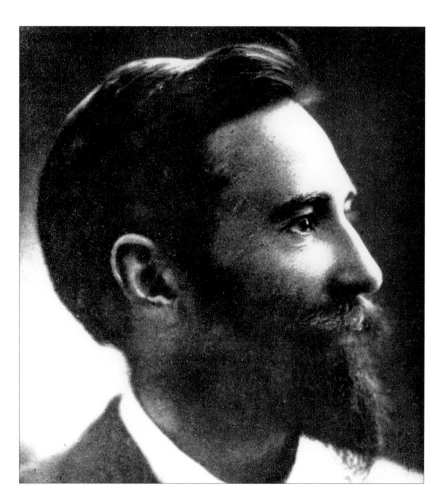

Francis Sheehy-Skeffington: murdered.

as a residence for the park ranger in the eighteenth century and later extended by Francis Johnston – ironically, the architect of the GPO wherein the forces of the republic were now established – when it became the official seat of the Viceroy (or Lord Lieutenant) of Ireland. The Viceroy was the representative of the crown in Ireland, just as Birrell the Chief Secretary was the representative of the government. The presiding Viceroy, only recently appointed, was Ivor Churchill Guest, otherwise Lord Wimborne.

Wimborne had not been impressed by the response of either Birrell or of Sir Matthew Nathan, the Under Secretary, to the alarums of the previous week. The rumours of rebel mobilisation and the Kerry landings had seemed to him causes for genuine concern and he had urged stern preventative measures on Birrell and Nathan. They temporised, arguing that precipitate arrests of suspects would be illegal. In this they were almost certainly correct.

But now Wimborne could at least reflect that he had been right and they had been wrong. The thing was: what to do? He was concerned for the safety of his family, isolated as they were in the middle of the same park where the murders of Burke and Cavendish in 1882 were still in living memory. The DMP had been withdrawn to barracks after losing three men to the rebels on the Monday. The civil government in the Castle was in disarray.

Wimborne declared martial law in Dublin. Whether he had the authority to do this without consulting the political and legal arms of government was moot. He was, after all, merely the ornamental and ceremonial representative of the crown in Ireland. In normal circumstances, any such declaration would require his official signature but it is doubtful if he had the authority to initiate such a decree on his own initiative. That said, the point was academic in the circumstances because of the impotence of the civil government and the communication gap. Birrell was still in England and did not return to Ireland until Wednesday.

Martial law had not been declared in Ireland since the aftermath of the 1798 rising. It was offensive to English sensibility, smacking of Prussian militarism and army rule. It was one thing to employ it in the farther corners of the empire, which perforce required a strong military presence to ensure law and order. It was quite something else to declare it in the heart of the metropolitan United Kingdom. Birrell, good liberal to the end, was horrified by Wimborne's action and tried to ensure that at least martial law would be confined to the city. But Birrell was a busted flush politically and so was Asquith's Liberal Party of which he had been such a luminary. The British war cabinet, in the middle of a European war that was going badly, was in ever growing hock to the military, upon whom the life of the nation now depended. The military knew what was wrong with Ireland. Kid glove liberals like Birrell were to blame. It was time for the smack of firm government. Martial law was extended to all Ireland until further notice.

It was soon to result in muddle and tragedy. Francis Sheehy-Skeffington had spent part of the day trying to stop the looting and to establish a citizen volunteer group to deter its further spread, in pursuit of which aim he had called a public meeting for Tuesday evening. Before going to the meeting, he intended to go home to his

house in Rathmines to check that all was well with his wife and small son. He was attended by a small gaggle of people: as a well-known eccentric and campaigner, he was used to this. His route took him over Portobello Bridge, beside which stood Davy's public house.

A small detachment of British troops from the nearby Porto-bello Barracks had occupied Davy's in order to command the canal bridge. (Davy's had earlier been one of the intended targets – along with Harcourt Street railway station – for an outwork of the St. Stephen's Green garrison, but again lack of numbers caused the plan to be reversed.) These troops had been given a bad time of it in the previous twenty-four hours by MacDonagh's men in Jacob's, which loomed over their position. They were tired, nervous and exposed. The officer in charge at Davy's regarded the small retinue attending Sheehy-Skeffington as a breach of martial law. He was arrested and led to the nearby barracks. He was detained without charge.

Later that night, Sheehy-Skeffington was hauled out of the guard room by Captain J.C. Bowen-Colthurst, an experienced officer and a veteran of the retreat from Mons in 1914. Bowen-Colthurst had taken it into his head, for reasons as obscure now as then, to lead a raiding party along Harcourt Road to the shop of Alderman James Kelly. This was probably a case of mistaken identity, for this Kelly was a Protestant and a unionist. Bowen-Colthurst may have confused him with Alderman Tom Kelly, a Catholic and a member of Sinn Féin. The raiding party comprised Bowen-Colthurst, a Lieutenant Wilson and forty men. Sheehy-Skeffington was to come along as a hostage. Bowen-Colthurst ordered the pacifist to say his prayers and when Skeffy refused – he was an atheist along with everything else – Bowen-Colthurst intoned the following words over him: "O Lord God, if it should please Thee to take away the life of this man, forgive him for Our Lord Jesus Christ's sake."

On Rathmines Road, the raiding party came upon two youths, Lawrence Byrne and J.J. Coade. Bowen-Colthurst, clearly agitated, roared at them that martial law was in force and that he could shoot them 'like dogs'. Which is precisely what he then proceeded to do to Coade. Leading his men, with poor Sheehy-Skeffington in tow, he continued to Portobello Bridge, where he left Wilson with the hostage and instructions to shoot him if the raid went

wrong or the position otherwise came under fire.

Alderman Kelly was not at home. Nothing daunted, the raiding party chucked in a hand grenade and went on to wreck the place. They found two perfectly innocent men there and arrested them. They were both journalists, Thomas Dickson, a disabled Scot, and Patrick McIntyre. They then returned to the barracks with this pair, collecting Sheehy-Skeffington along the way, and incarcerated all three. It was now after midnight, the early hours of Wednesday morning.

Sean Heuston, who commanded the sub-garrison at the Mendicity Institution during the rising. He was the youngest of the men executed afterwards.

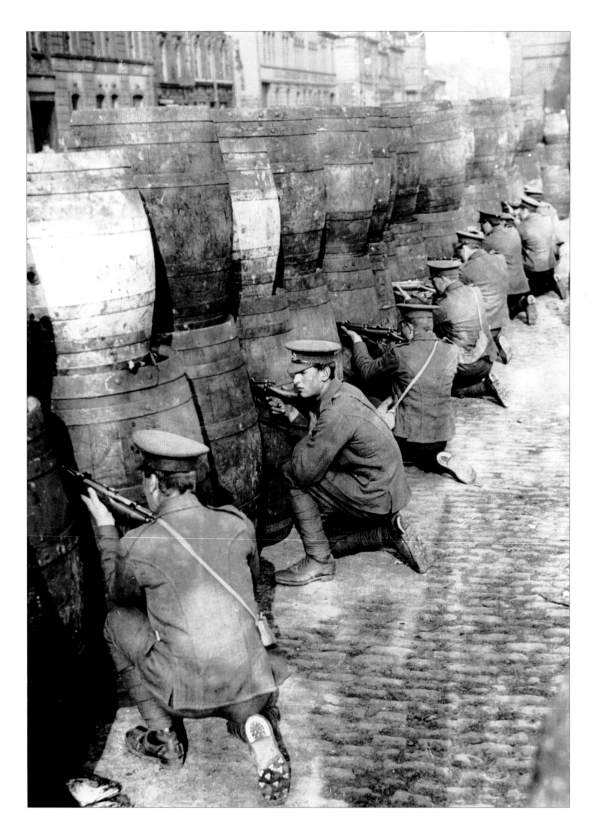

CHAPTER 5
THE RISING: THE BRITISH RESPONSE

Liberty Hall, at the east end of Eden Quay, faced across Butt Bridge – a road bridge beside the elevated Loop Line railway bridge – and had a clear view along Tara Street on the south side to the side wall of Trinity College. Early on Wednesday morning, 'workmen' were allegedly digging up parts of Tara Street to deal with some problems with the drains. In reality, they were members of the Officer Training Corps from Trinity, who had been relieved the previous evening by a detachment of the regular army that had entered the city under Lowe's command. They weren't digging drains. Rather they were digging out emplacements for two 18-pound artillery pieces that the army intended to deploy against Liberty Hall.

Precisely at 8 am the assault on Liberty Hall began. The *Helga*, a fisheries patrol vessel moored on the river opposite the Custom House, fired a shell that careered into the Loop Line Bridge, making a metallic clang that was heard all over the city. The crew adjusted their sights and fired again, and this time the shell described an arc that carried it across the bridges and hit Liberty Hall. Meanwhile, the 18-pounders in Tara Street opened up for good measure. In no time, Liberty Hall was a shell.

It was a lot of trouble to take over a building that was empty save for its caretaker. This man, Peter Ennis, very sensibly ran out onto Eden Quay and by some miracle dodged the sniper fire that was directed at him. He literally ran for his life – and made it. The assault on Liberty Hall was farce, prompted either by false intelligence as to its military significance or by its symbolic value. What happened next was tragedy.

Across the city, in Portobello Barracks, Captain J.C. Bowen-Colthurst had not slept much the previous night. According to his later testimony, he had pored over documents taken from Alderman Kelly's shop following the raid and over other papers found on

British soldiers take cover behind a stack of beer barrels.

**British Response
25–26 April 1916**

● Rebel garrisons with name of commander

– – Intended British cordon

—— Actual British cordon

1　Patrol ship HMS *Helga* fires on Liberty Hall.

2　Two 18-pounder guns in Tara Street join in the bombardment of Liberty Hall until the building is demolished.

3　British troops arrive by train and deploy towards the centre of the city.

4　A small garrison at the Mendicity Institution fires on the advancing British, inflicting casualties and slowing their advance.

Frank Sheehy-Skeffington's person. At 9 am on Wednesday morning, he led Skeffington and the other two prisoners from the guard-room, informing the officer in charge that he was "taking these prisoners out and I am going to shoot them as I think that it is the right thing to do".

He proceeded to do so, forming an ad hoc firing squad of seven to dispatch Skeffington, Dickson and McIntyre. It was a terrible irony. Skeffington, the best-known pacifist in Ireland, who had spent most of the previous day trying to stop looting and to start an anti-looting watch group, met his death before a firing squad. He could only have been considered a danger to the public by a madman, which is what Bowen-Colthurst was. Even then, Bowen-Colthurst was not relieved of his duties and he went on to kill at least two more innocents in cold blood before a stop was put to his progress. He would have got away with his crimes were it not for the courage of a single fellow-officer whose subsequent efforts – few if any of them welcomed by his brother officers – eventually

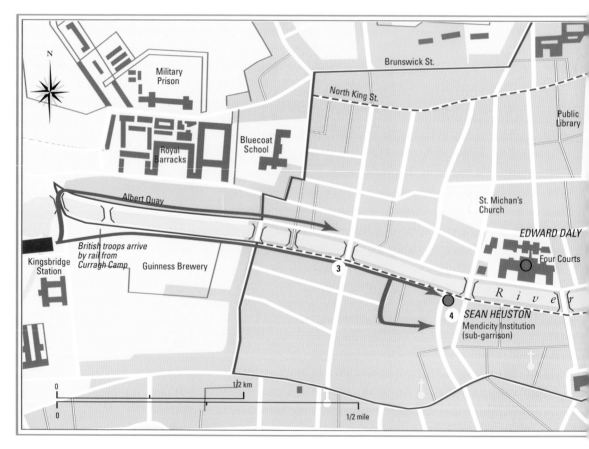

HMS Helga, *a navy patrol vessel which came upriver to add its firepower to the British Response. Seen here in her post-independence livery, flying the Irish tricolour.*

led to Bowen-Colthurst's court martial. He was found guilty but insane and was committed to Broadmoor. After a short spell there, he was removed to a hospital in Canada. Less than two years after his conviction, he was deemed cured and was released. He retired from the army at 40, was granted a pension and lived to be almost 90. Major Sir Francis Vane, the officer whose efforts led to his conviction, was rewarded with a dishonourable discharge.

Later that morning, the 18-pounder guns used so superfluously

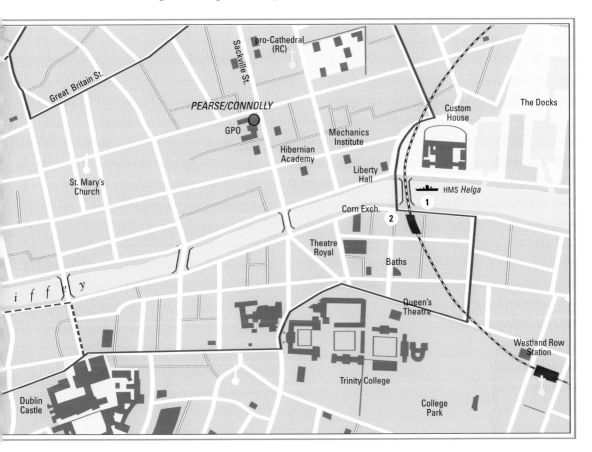

against Liberty Hall were soon re-deployed as part of the artillery barrage launched against the GPO garrison. The gradual destruction of Lower Sackville Street began. Up along the river, Sean Heuston's tiny sub-garrison at the Mendicity Institution on Usher's Quay was tying down army reinforcements marching up from Kingsbridge station, as well as providing some cover for the larger Four Courts garrison on the north side. James Connolly had not

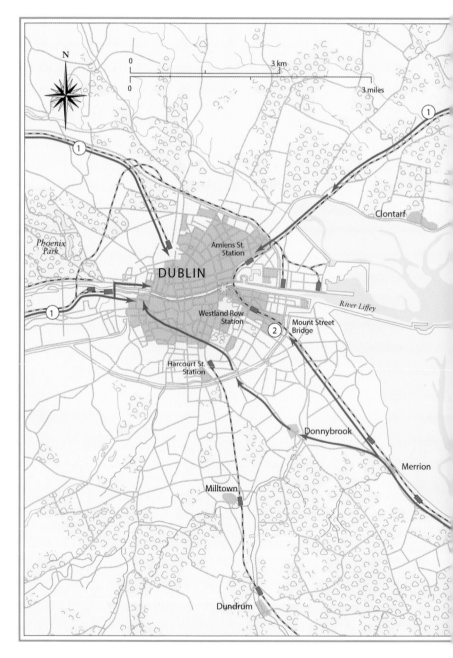

envisaged this outpost as being anything more than a temporary thing, designed to harry troops from barracks in the south-west of the city while the Four Courts garrison over the way was entrenching itself. Accordingly, it had been starved of rations and ammunition, since no one had expected it to be still functioning on the third day of the rising. Heuston's men were outnumbered by more than ten to one. None the less, they inflicted over a hundred casualties on

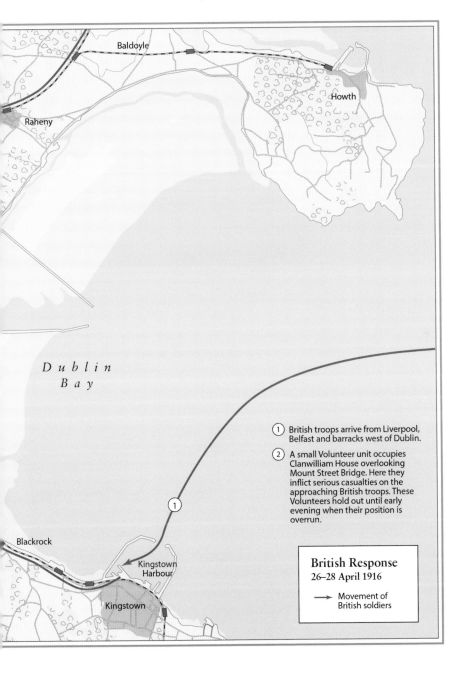

Baldoyle

Howth

Raheny

Dublin Bay

① British troops arrive from Liverpool, Belfast and barracks west of Dublin.

② A small Volunteer unit occupies Clanwilliam House overlooking Mount Street Bridge. Here they inflict serious casualties on the approaching British troops. These Volunteers hold out until early evening when their position is overrun.

Blackrock

Kingstown Harbour

British Response
26–28 April 1916

⟶ Movement of British soldiers

Kingstown

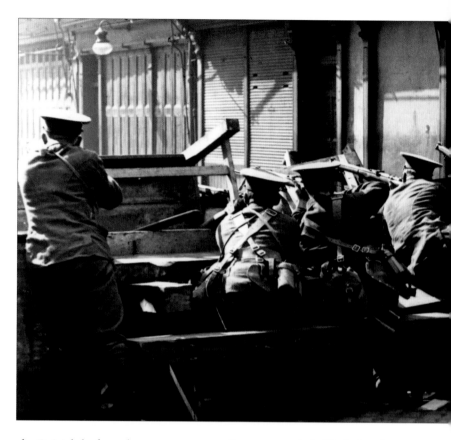

the British before they were eventually surrounded. Had they beaten a tactical retreat the previous day, they would probably have got away and been able to rejoin the Four Courts garrison. But by Wednesday they had made such a thorough nuisance of themselves that the army was determined to rout them out. Moreover, by investing the rising ground up towards Thomas Street, to the rear of Heuston's position, they had a clear field of fire.

The final assault began at noon and lasted an hour before Heuston hung out a white flag and the Mendicity became the first rebel position in the city to surrender.

The afternoon brought better fortune for the Volunteers, indeed their greatest single success of the week. A small detachment of men from the Boland's Mills garrison had been sent to occupy Clanwilliam House at Mount Street Bridge. This tall late Georgian building, four storeys over basement, commanded the approach to the canal bridge along Northumberland Road. An even smaller group invested 25 Northumberland Road.

Troop reinforcements had been arriving all night in Kingstown.

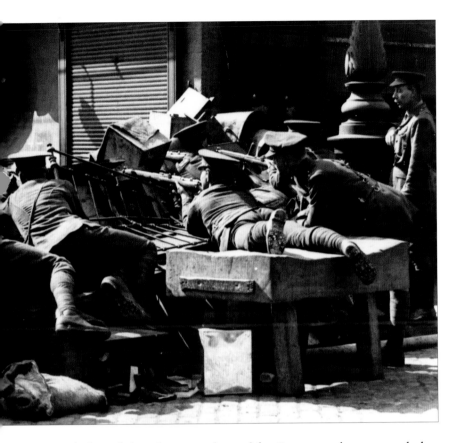

British troops man a makeshift barricade, typical of many hastily erected at key points across the city.

Many believed that they were bound for France and were startled to discover that they were in Ireland. It was decided that they should march towards the city in two columns. The Derbyshire troops were to take the inland route via Donnybrook to their destination, the Royal Hospital in Kilmainham, just west of the city centre near Kingsbridge station, which they reached safely. The Nottinghamshire troops appeared to be bound for Trinity College and marched via the suburb of Ballsbridge and along Northumberland Road, which brought them straight towards Mount Street Bridge.

The garrison in Clanwilliam House was tiny, a mere seven men, with a further five in 25 Northumberland Road and in a nearby school. The first volley was fired from no. 25 and accounted for ten men of the Sherwood Foresters. The inexperienced troops took time to regroup and identify the sources of enemy fire. A series of direct advances on the bridge itself were met with withering fire from the tiny group in Clanwilliam House. The troops were therefore under fire from their flank and from the position in Clanwilliam House directly in front of them.

The view from Clanwilliam House looking in the direction from which the British troops advanced.

The battle raged all afternoon and into the evening. The house at 25 Northumberland Road was not cleared out until 5 pm: one of the two Volunteers, Michael Malone, was killed but the other, Seumas Grace, escaped. It took until 8 pm to take the school. By nightfall, sheer weight of numbers told. Clanwilliam House was an inferno and was finally evacuated. The Volunteers had lost eight of their twelve men; the British had 230 dead or wounded.

There was a poignant interval in the course of the afternoon's battle, when a clergyman, accompanied by two young girls, suddenly materialised from Lower Mount Street, to the rear of Clan-

william House, and was able to see for himself the extent of the casualties. The firing stopped. The clergyman made his way back behind Clanwilliam House and down to Sir Patrick Dun's hospital nearby, more or less half way between Clanwilliam House and de Valera's main position in Boland's Mills. There, he gathered a group of doctors and nurses who returned to the battle scene under an improvised Red Cross flag, where they tended to the dying and wounded troops. The rebels held their fire and even gave a verbal permission to the doctors to remove the wounded. The battle then resumed and proceeded towards its conclusion.

The British had been woefully ill-prepared for the battle. They had neither hand-grenades nor machine-guns, which had been left behind in Liverpool, and which would have been essential in any efficient counter-attack on the Volunteer positions. Instead, officers untrained in urban warfare and inexperienced in general terms had ordered their troops to make frontal assaults on the rebel positions. The Volunteers could hardly believe their luck.

This extraordinary success for the rebels in the south-east approaches to the city could not disguise what was happening in the centre. With the Mendicity Institution knocked out of play, the army noose tightened ever more around the Four Courts. This was the second-largest command in the city, with almost 300 men there. Only the GPO, with about 400, was bigger. However, the two positions were cut off from each other because Lowe had been able to deploy troops along Capel Street, making passage between the GPO and the Four Courts impossible. The Four Courts was not quite surrounded, but between the Brunswick Street cordon and the Capel Street troops, it was in grave danger of being so.

As much to boost morale as anything, the garrison commander, Edward Daly, ordered an attack on the nearby Linenhall Barracks. It was defended, if that is the term, by its only residents: forty unarmed members of the Army Pay Corps. The Four Courts party duly captured the barracks but did not have the men to garrison it. So later in the day, they torched it rather than have it recaptured by the British. It would have been fatal to have allowed regular troops to occupy a position so close to the Four Courts itself. The fire was enormous, destroying not only the barracks but many nearby tenements. The smoke could be seen all over the city and Daly was sufficiently alarmed that the conflagration could engulf the entire city centre. Naturally, given the circumstances, the city fire brigade did not turn out.

As it was, things were getting hotter all the time for the city centre rebel garrisons. The British had established firing positions in high buildings on both sides of the river: the Bermingham Tower in Dublin Castle; Guinness's Brewery; Christ Church Cathedral; Jervis Street hospital; Broadstone station. From these positions, they kept up a constant and relentless fire on rebel positions. In addition, Lowe was able to deploy an outer cordon in the suburbs which kept railway communications open, so that troops and matériel could be

moved from Kingsbridge and Broadstone through Cabra Junction and down to Amiens Street station and the North Wall. This gave the British total control of the north-east quadrant: the Volunteers' failure to get MacDonagh's troops into Amiens Street station – wasting them instead in Jacob's – was now hitting home.

In fact, the British response to the rising was efficient and ruthless, considering that nothing in army training had prepared them for this kind of urban insurgency. It simply was not envisaged as something that the British army would ever be called upon to do: to suppress an armed rebellion in the heart of one of the most significant cities in the kingdom. Efficient it may have been in purely military terms, but the manner in which the rising was suppressed offended many, not least loyalist elements in the city who had the traditional British distaste for overweening militarism, which they associated with Prussia and other highly militarised states.

At 9 pm on Wednesday evening, the government announced the appointment of Sir John Grenfell Maxwell as the supreme military commander of British forces in Ireland. His instructions were "to take all such measures as may in his opinion be necessary for the prompt suppression of insurrection in Ireland and may be accorded a free hand in regard to the movement of all troops now in Ireland or which may be placed under his command hereafter and also in regard to such measures as may seem to him advisable…"

The vice was tightening. Militarily, the rising was a failure by Wednesday night. Brennan-Whitmore, still ensconced at his barricade on the north side of Sackville Street across from the GPO, reckoned that there was little point in fighting on in the current circumstances, sitting ducks for the final counter-attack. His favoured policy was to retreat through the back streets to the countryside and there to regroup for a guerrilla campaign.

There were, however, practical problems in the way of this. On his side of the street, any such retreat – even had it been sanctioned by Connolly, which it would not – would have been through Dublin's worst tenements. Here lived many 'remittance women' whose husbands were serving on the Western Front and who regarded the rebels as dreamy middle-class fools or worse. Moreover, many of the women were widows of men killed at the first battle of Ypres a year earlier and the coincidence of the anniversary and the outbreak of the rising did little to lessen their hostility. With no

sure guide through the back streets and with the north-east of the city – to which any successful retreat, however improbable, would have carried them – securely in government hands, all such thought was fantasy.

Yet Brennan-Whitmore was on to something. And across the street in the GPO, a 25-year-old Volunteer from west Cork was thinking similar thoughts, which he would have the opportunity to act on in due course. His name was Michael Collins.

But for the moment they were trapped. There was no plan B, no line of retreat prepared nor any alternative plan of battle. The rising was theatre and gesture, not really war at all. It was a symbolic statement written in blood. So, for the moment, as Wednesday passed into Thursday, there was nothing for it but to sit tight and see what the morrow would bring.

The morrow brought fire. The British relentlessly tightened their cordon around the city centre and increased their artillery attacks. The lower part of Sackville Street was in flames by day's end. The heat from the nearby fires made the GPO position almost untenable and only the hosing down of the sacking on the barricaded windows saved the garrison from evacuation.

At 10 pm, after twelve hours of relentless bombardment, an oil works opposite the GPO caught fire, making a dangerous situation truly desperate. A series of dramatic explosions set sparks showering onto the roof of the GPO.

The city's economy was near collapse. There were food shortages, as normal supplies could not get in. Shops closed. All classes suffered, but as always in these circumstances, the poor suffered most. There was genuine hunger in the city.

The fighting went on. At the South Dublin Union, Eamonn Ceannt still had over 100 men at his disposal. They were under ceaseless attack from the British. It was close fighting, with both sides tunnelling through walls to advance or retreat – and all this going on in a medical facility with more than 3,000 terrified and indigent patients and the staff who were committed to caring for them. For the Volunteers, the real hero was Ceannt's second-in-command, Cathal Brugha.

Brugha had been born Charles William St John Burgess in 1874 of mixed English and Irish parentage. His father was a businessman of sufficient means to be able to have his son educated by the

Jesuits at Belvedere, then even more than now an elite private school for the children of the Catholic middle class. He was therefore firmly in a tradition which also embraced other republican leaders: Plunkett, de Valera and Thomas MacDonagh had been privately educated and, along with Pearse who had been to the Christian Brothers, were among the tiny minority of Irish Catholics who had received a university education. Young Burgess did not get that far, for his father's business failed and he was withdrawn from Belvedere at the age of 16 and launched on the world of work. By the time he was 35, he was co-founder of a successful Dublin business house.

By now Charles Burgess had long since become Cathal Brugha. Like so many of his generation, the Gaelic League had made a profound impression on him. He had joined it in 1899, in his mid-twenties, and thereafter was a cultural nationalist. He was a founder member of the Irish Volunteers in 1913 and was appointed a lieutenant in the new body. A natural radical, he followed the most advanced nationalist positions and thus found himself a prominent figure in the rising. As second-in-command in the South Dublin Union, he was acknowledged as having rallied the Volunteers at a time when they might otherwise have thrown in the towel; his determination and example certainly extended the garrison's resistance.

Brugha paid a personal price for his courage. In defending one of the barricades, he suffered multiple wounds that left him disabled for the rest of his life. He survived the rising and went on to become chief of staff of the IRA from 1917 to 1919; he fought in the War of Independence, took the anti-Treaty side in 1922 and died almost literally in a blaze of glory in O'Connell Street (as Sackville Street had then become) in the civil war, charging suicidally from a burning building when all was lost.

Cathal Brugha, a founder member of the Irish Volunteers.

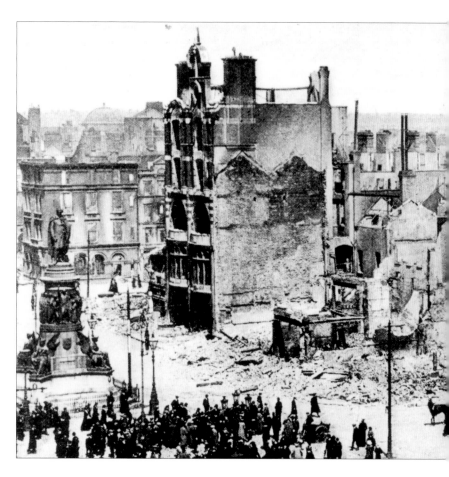

The ruins of Dublin at Sackville Street and Eden Quay on the banks of the Liffey. The buildings had been shelled by the British Admiralty gunboat HMS Helga.

Middle-class, educated, energetic and intelligent, entranced by a cultural and revolutionary myth, a radical unhappy with the accommodating bourgeois world that bred him, he was representative not just of the radicals who made the revolution in Ireland but also of that greater weariness with the late Victorian world that informed many of his generation in Europe.

His heroics at the South Dublin Union ensured that the little garrison was never overrun, despite the ferocious close-quarters nature of the fighting and the fact that the British had introduced reinforcements on Thursday. It was a tribute to the fortitude of the Volunteers that the British seriously overestimated their numerical strength at a time when they could in fact have overwhelmed them by sheer weight of numbers. In the end, the South Dublin Union garrison yielded only as part of the general surrender.

All over the city heavy fighting continued. At the small garrison in Marrowbone Lane distillery, in effect an outpost between

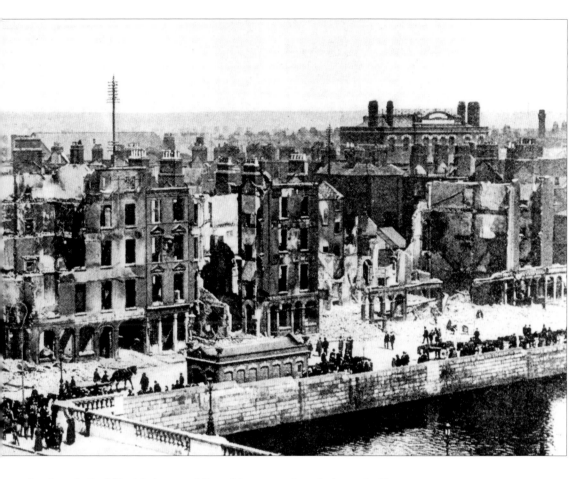

the South Dublin Union and Jacob's, a gun battle lasted all morning. Astonishingly, considering the superiority of British numbers and the fact that they effectively had the position surrounded, the British were beaten back in the early afternoon. The pressure was off for the moment.

Not so at the Four Courts, a far more important position. There, the closeness of the British cordon just behind them to the north in Brunswick Street and environs, together with the presence of artillery before them on the south quays and troops to the east of them along Capel Street, made their situation increasingly untenable. Gradually, the tough soldiers of the South Staffordshire regiments were deployed along the cordon and found themselves fighting a war for which they had no training. Ostensibly in the centre of a major city in the United Kingdom, they came under increasing sniper fire from unseen enemies in civilian clothes. There were casualties. And with the casualties came increasing bitterness

and resentment at the unseen enemy. It was a short step from this to suspecting the entire civilian population of complicity in the violence. Now no one was to be trusted.

The result was some of the most vicious fighting of the whole week, as combatants on both sides fought battles from house to house. These actions were to have especially tragic consequences the next day.

In the middle of the afternoon, back in the GPO, Pearse did what he did best. He rallied the garrison and gave them a speech in which he announced that the provinces had risen and that Volunteers were marching victoriously to the relief of the rebel city. It was a pure fiction but it served the short-term need to boost morale. It did nothing, of course, to reduce the ferocity of the artillery barrage which continued unabated.

Shortly after Pearse's address, Connolly formed a party of men and took them round to occupy the offices of the *Irish Independent* newspaper in Middle Abbey Street. He had been at this kind of thing all week: the previous day he had been across the street checking out Brennan-Whitmore's position. If Pearse was the orator, Connolly was the man of action, constantly chivvying his men, issuing orders and taking personal risks. His luck ran out on Thursday afternoon, however. Having established his men in the *Independent* office, he headed back along Middle Abbey Street towards the GPO. There he caught a ricochet bullet which shattered his left shinbone. In agony, exposed and alone he managed to crawl along an alleyway to Princes Street, beside the GPO. It was here that he was found by some of his men. He was carried back inside, but he was now physically disabled. He continued to issue orders but inevitably his authority was diminished by his condition. The mere fact that he was given morphine to dull the pain was enough to see to that.

And still the British cordon tightened and still the inferno raged. Towards midnight, to the rear of the Four Courts, the fire from the Linenhall Barracks spread to the nearby premises of a wholesale druggist, causing a series of spectacular explosions that lit up the night sky.

The scene was mirrored in Sackville Street, which now entered its death throes. Clery's department store and the Imperial Hotel were ablaze and four Volunteers who had been in occupation of

the building had to leg it across the street, under a hail of bullets, to the relative safety of the GPO. One of them fell and lay still but subsequently picked himself up and reached sanctuary.

On the same side of the street, Brennan-Whitmore decided on his own initiative that his position at the head of North Earl Street was now hopeless. For one thing, Hoyle's oil refinery which was adjacent was an inferno which left Brennan-Whitmore and his men in imminent danger of being incinerated. He was perfectly ignorant of his line of retreat to the north – he was from Wexford and did not know the city very well – but he felt that it offered the only hope.

He aimed to take his men, as he later wrote, "through back lanes, premises, old mews and alleyways". He formed his party of twelve into three groups of four each and slipped into Cathedral Street. They were headed for the North Strand, where they believed that they would be safe. That may have been a forlorn hope in any case, given that the British had complete command of that north-east quarter of the city. However, all the available streets leading to the North Strand were broad, exactly what Brennan-Whitmore had hoped to avoid. At first, they made satisfactory progress, but after about 500 yards they encountered the military. In the firing that ensued, Brennan-Whitmore and Noel Lemass were wounded. They and their party promptly occupied a ground floor room in an adjacent tenement. It was hostile territory, for the Dublin slums were full of army dependents, some of them war widows. Exhausted, Brennan-Whitmore fell asleep, despite being eaten alive by fleas.

They were duly betrayed. At first light one of the tenement women had slipped out to the British and alerted them to the Volunteers' position. They were captured, were lucky not to be summarily executed – something, Brennan-Whitmore believed, would have raised a cheer from the tenement women – and were marched off to be imprisoned in the Custom House.

All who recalled that Thursday night and Friday morning remembered the great fire. The centre of the city was a red glow, visible from distant suburbs on both sides of the city. The principal fires were north of the river, in Sackville Street and behind the Four Courts. The south city centre escaped, but the city's principal thoroughfare – the only street in Dublin with any pretentions to boulevard or processional status – was an inferno.

At 2 am on the Friday, General Sir John Maxwell, the new Commander-in-Chief of British forces in Ireland, sailed into the Liffey estuary and tied up at the North Wall. Maxwell was not to play a decisive role in events until after the rising – the day-to-day direction of military affairs remained in the hands of Brigadier-General Lowe. However, before dawn he had issued a proclamation which stated, among other things, that he would 'not hesitate to destroy all buildings within any area occupied by the rebels' and calling for unconditional surrender.

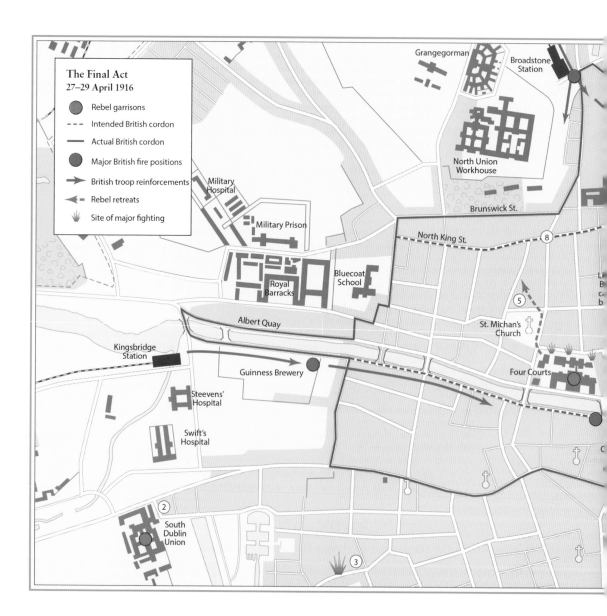

The Final Act
27–29 April 1916

- ⬤ Rebel garrisons
- ---- Intended British cordon
- ── Actual British cordon
- ⬤ Major British fire positions
- → British troop reinforcements
- ◄- Rebel retreats
- ⬇ Site of major fighting

1. Despite 12 hours of bombardment, the GPO garrison hold on. The area is slowly demolished and surrounding buildings are set ablaze.

2. South Dublin Union holds out until the general surrender is ordered.

3. A small unit of Volunteers fight on in Marrowbone Lane distillery temporarily holding back the British.

4. Connolly takes a small force and occupies the offices of the Irish Independent.

5. Members of the Four Courts garrison establish sniping positions in nearby streets.

6. Brennan-Whitmore and a small group of Volunteers attempt to escape but are betrayed and captured.

7. Pearse and Connolly move the GPO garrison in an attempt to join the Four Courts position but can only get to an area around Moore Street, where they take up their final positions.

8. Savage fighting takes place around Reilly's Fort area. The failure of this struggle leads to the final surrender of the Volunteers.

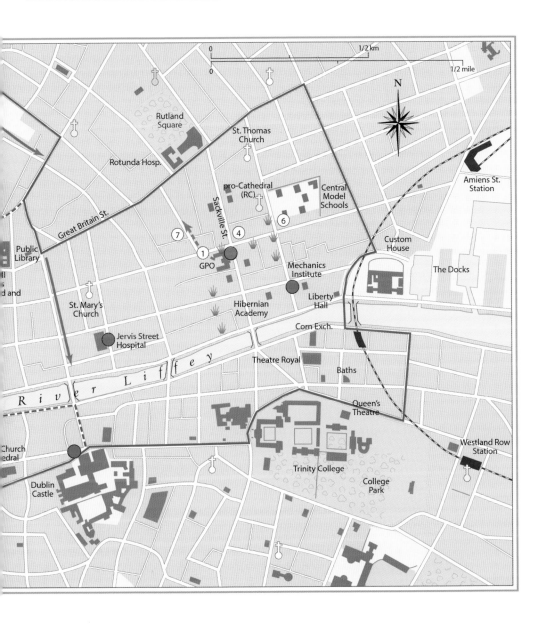

Pearse and Connolly in their turn issued morale-boosting proclamations of their own, even as the rising was being consumed in flames. The time for action had passed. Now it was all about the creation of a heroic foundation myth. In this Pearse and Connolly were completely successful.

Friday was the fifth day on which the tricolour of the republic was flying over public buildings in the Irish capital. It was the fifth day of armed resistance to defend that republic and that flag. Pearse and Connolly's words were to resonate beyond their immediate audience and reach a wider nationalist public. Total separation from Britain was not a fantasy: it was a serious business and its virtue had been asserted in blood. It was the work of serious people who were fighting a good fight. It was an honourable thing.

With every extra hour that the rebels could hold out, this message had a chance of getting through and of sinking in. The novelist James Stephens, whose diary of the rising is the most acute contemporary account, realised this early when he wrote: "The truth is that Ireland is not cowed. She is excited a little… She was not with the Revolution, but in a few months she will be, and her heart which was withering will be warmed by the knowledge that men have thought her worth dying for."

All Irish nationalists disliked British rule in Ireland, and the sight of Irish men and women fighting British troops under an Irish flag was something to stir the emotions. Mixed with the horror was a tiny surge of pride. The Volunteers might be half mad, but their hearts were in the right place. For most of the nineteenth century, total separation from Britain had seemed a fantasy. Home rule – domestic autonomy or devolution – was as much as could be expected in practical terms. What Pearse and Connolly were doing was reminding their men – and all Irish nationalists – that separation need not be a fantasy. A sovereign republic could be practical politics.

The position of the GPO was hopeless by mid-afternoon. The first direct hit from British artillery happened about noon. The roof caught fire at 4 pm and by evening it threatened to engulf the whole building and immolate all within. At 8 pm, the order to evacuate the building came: Pearse and Connolly were the last to leave.

Most of the garrison left by the Henry Street exit, heading across that street and into the warren of alleyways and lanes

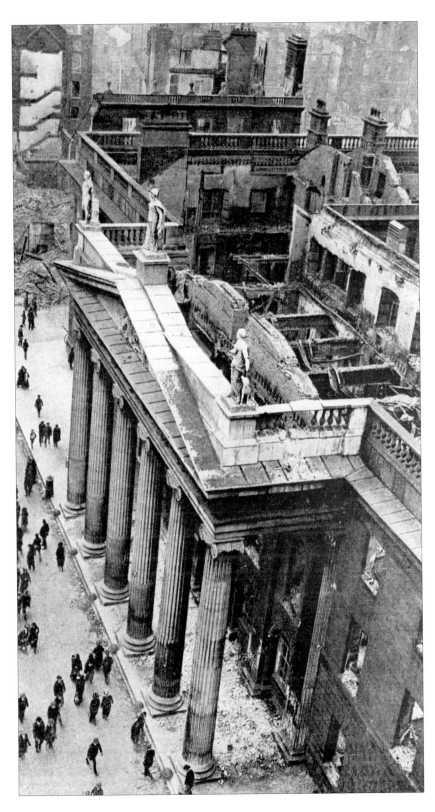

The ruins of the GPO building.

between it and Great Britain (now Parnell) Street. The principal street connecting Henry Street and Great Britain Street was Moore Street. It was into this street that The O'Rahilly led a group of Volunteers in a final assault on a British position at the Great Britain Street end. They were cut to pieces. O'Rahilly himself was killed. His real name was Michael Joseph O'Rahilly. He was a journalist, a Gaelic Leaguer and a founder member of the Volunteers. He had not been an IRB man and was unaware of the plans of the military council. He was of the orthodox Volunteer opinion that a rising should only be attempted when there was clear public support for it. He had spent the previous weekend driving around the provinces delivering Eoin MacNéill's countermanding order.

When he returned to Dublin, he was astonished to discover that the rising had started anyway and felt it his duty in all honour to join it. He offered himself to the GPO garrison. His death was a defining moment in how the rising was remembered. Not only was it gallant and courageous, quixotic even, it helped to take the rising from the realm of theatre to that of myth. Yeats wrote a ballad about him, putting these words in his mouth:

> "Am I such a craven that
> I should not get the word
> But for what some travelling man
> Had heard I had not heard?"
> Then on Pearse and Connolly
> He fixed a bitter look
> "Because I helped to wind the clock
> I come to hear it strike."

Pearse and Connolly had hoped to join with Ned Daly's garrison at the Four Courts but there was no way past British positions on Capel Street. Instead, various buildings in the Moore Street area were occupied. The main body found themselves in a grocer's shop whose proprietor was a Mrs Cogan. She offered them food – boiled ham – and shelter. In the course of the night, they began to tunnel through adjacent premises in the general direction of Great Britain Street. They got as far as Hanlon's fish shop at no. 16 Moore Street.

They could go no further without abandoning Connolly, now in agony with his foot. Gangrene had set in. The business of hauling

The flag of the Irish Volunteers that was flown over the GPO for four and a half days.

him up and down stairs and through narrow tunnelled holes made no sense. Hanlon's was as far as they got. It was from there that Pearse would walk out the following afternoon to deliver his unconditional surrender.

In the meantime, the remaining action was centred less than a mile away, to the rear of Daly's position at the Four Courts. The original idea behind General Lowe's cordon had been that it would run along North King Street, only a few hundred metres north of the rear of the Four Courts itself. However, it had been occupied by some of Daly's men who were dug in in good sniping positions in the street itself and in adjacent ones. In particular, two premises were significant. A pub called Reilly's, at the corner of North King Street and Church Street, proved a good position for rebel snipers and was afterwards mythologised as 'Reilly's Fort'. Even better was a distillery building on the corner of Beresford Street nearby, whose height was a sniper's paradise.

Lowe's cordon had to run instead along Brunswick Street, just to the north of and parallel to King Street. The point is that the combatants were terrifyingly close to each other. Maxwell now took a hand, his one decisive operational overruling of Lowe in the course of the rising. He had troops in reserve, some of them members of the South Staffordshire regiment that had been roughed up at Mount Street Bridge earlier in the week. He ordered them in to tighten the

cordon through North King Street, which would effectively strangle Daly's position in the Four Courts just down the street.

The South Staffs were in no mood for dainty soldiering. That, plus the unpredictability of the rebels – they were actually few in number, but managed to give the opposite impression – meant that the British assault descended into vicious house-to-house fighting, as the South Staffs suspected every house and tenement building of being a rebel nest. Maxwell had ordered all civilians out of the area but people had nowhere to go, least of all in the chaos that was gripping the immediate area and the city at large. Moreover, it had been the insurgents who controlled the area all week: Maxwell's writ no longer ran down there.

The local British commander at North King Street, Lt-Col Henry Taylor, resorted to rebel tactics by occupying houses and tunnelling through from one to the next in an attempt to flush out the rebels. It was a slow, wearying business and the rebels fought a clever, morale-sapping fight, leaving the British uncertain as to their positions and strength. For six hours this went on, for no British gains. The snipers on the top of the Beresford Street tower were still in action and the rebel barricade on North King Street, almost underneath it, remained solid, despite the deployment of an armoured car.

At 2 am on Saturday morning, the South Staffs occupied no. 172 North King Street, the home of a family called Hughes. Other families had taken refuge there to escape the relentless British advance. One of them, Mrs Ellen Walsh, described what happened next.

"We heard the soldiers banging at the street door.... We then heard a voice cry 'Are there any men in this house?' Immediately about 30 soldiers … ran at us like infuriated wild beasts or like things possessed. They looked ghastly and seemed in a panic. There was terrible firing going on outside in the street … and an armoured car was near the door. One of the soldiers with stripes on his arms seemed in command. He shouted 'Hands up' and they presented their rifles at us. We all stood round the room in groups, and my husband and Mr Hughes seemed petrified at the wild looks and cries of the soldiers.... The man in command shouted 'Search them' and they searched the two men and the two boys....

One of our men said 'There was no one firing from this house'.

The corporal with stripes said 'Not firing, eh?' and pointing to a rip in his hat said 'Look what a bullet did for me. I nearly lost my life.' The women and children were then all ordered down into the back kitchen and my poor husband and Mr Hughes were brought upstairs. I'll never forget the horror of it. Some time after I heard a voice upstairs crying 'Mercy! Mercy! Don't put that on me' and someone resisting as if being tied up, or having his eyes bandaged. The old man in the upper room close by heard my husband crying, and as they killed him they heard his last words: 'O Nellie, Nellie jewel.'"

The unfortunate men who were killed were joined by thirteen more before the night was out. It was dawn before the North King Street barricade was finally overrun but its conquerors were still caught between fire from Reilly's Fort on one side of them and the distillery tower above them. The frontal assault on the rebel position at North King Street was claiming a horrible toll in both military and civilian lives. It was not until 9 am on Saturday that the half-dozen remaining Volunteers in Reilly's decided to pack it in. They were painfully short of ammunition: an attempt to run down Church Street to get more from Daly had simply resulted in the death of the Volunteer who was carrying it.

In all, the battle had taken 16 hours and had brought the most concentrated fighting of the entire rising, albeit the aggregate casualties were not as great as at Mount Street Bridge on Wednesday. But it was the end. There was nothing left now but the surrender.

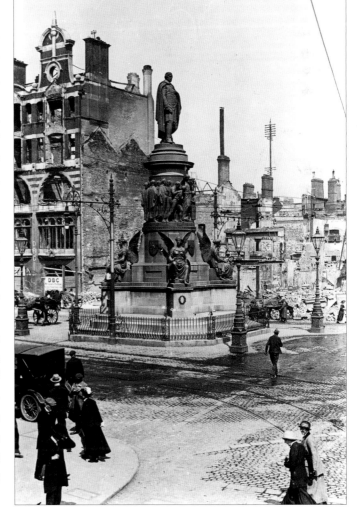

Unscathed, the O'Connell Monument amid the ruins of O'Connell Street.

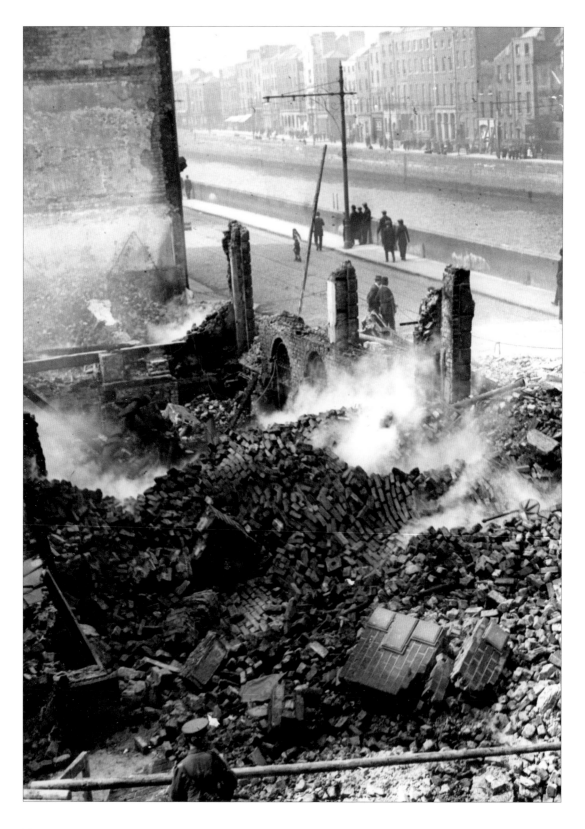

CHAPTER 6

THE RISING: FINALE AND AFTERMATH

The position in no. 16 Moore Street was hopeless. The remains of the GPO garrison were holed up there, with no realistic hope of escape. A plan to make a run for it down Henry Street was contemplated and abandoned. Then, burning embers from the gutted GPO set fire to a nearby pub. The owner, his wife and daughter fled their burning premises under cover of a white flag. It did not save them. They were gunned down by the British.

It was this incident – and the certainty that further resistance was sure to entail more loss of civilian life – that prompted Pearse to order the surrender.

At 12.45 pm, Nurse Elizabeth O'Farrell, part of the women's auxiliary that had loyally stood by its posts in a number of Volunteer commands all week, issued out into Moore Street wearing Red Cross markings and carrying a white flag. She was met at the British barricade at the end of the street by an officer to whom she said: "The commandant of the Irish Republican Army wishes to treat with the commandant of the British forces in Ireland."

The officer was perplexed. "The Irish Republican Army? The Sinn Féiners, you mean."

"No," she replied, "the Irish Republican Army they call themselves and I think that is a very good name too."

Nurse O'Farrell was held in a nearby premises – irony of ironies, it was Tom Clarke's tobacconist's shop – to await the arrival of Brigadier-General Lowe, who materialised in due course. He sent her back to Pearse with the message that only unconditional surrender was acceptable and that Pearse had a half an hour to decide, no more. Otherwise, lethal hostilities would resume.

At 2.30 pm Lowe received Pearse at the top of Moore Street. Pearse handed his sword to Lowe. He was taken off to meet Maxwell. Connolly was removed to a Red Cross station in Dublin Castle to have his wound treated. At 3.45 Pearse signed the

Opposite: *The smoking ruins of one of Dublin's quays. Unable to operate, the fire brigade had to leave the ruins to burn out.*

following surrender order: "In order to prevent the further slaughter of Dublin citizens, and in the hope of saving the lives of our followers now surrounded and hopelessly outnumbered, the members of the Provisional Government present at headquarters have agreed to an unconditional surrender, and the commandants of the various districts in the city and country will order their commands to lay down arms."

The men of the GPO garrison were marched to the top of Sackville Street beside the Parnell Monument and then corralled in the gardens of the Rotunda maternity hospital. Nurse O'Farrell, meanwhile, was given the task of conveying the surrender order to the various outlying garrisons. At Boland's Mills and Jacob's, the respective commanders, de Valera and MacDonagh, took some convincing that the surrender was not a hoax. They had been remote from the action, for seventy-two hours in de Valera's case and for the whole week in MacDonagh's. The latter eventually got word to Ceannt in the South Dublin Union and to the Volunteers in Marrowbone Lane.

The men in the Rotunda garden spent the night in the open before being marched to Richmond Barracks the following morning. They got a hostile reception in some of the tenement quarters through which they passed. The official casualty list reckoned 1,351 people dead or badly wounded – the majority of them non-combatants. The army had 440 casualties, 230 of them sustained at Mount Street Bridge on the Wednesday. The city centre, especially just north of the river, was devastated. Over 100,000 people needed public relief. In the same week, on the Western Front, the 16th Irish Division alone sustained almost 2,000 casualties.

The remark made by the British officer to Nurse Elizabeth O'Farrell when she first approached the barricade under a flag of surrender told a lot. "The Sinn Féiners, you mean?" To the British, it was the Sinn Féin rebellion right from the start. Sinn Féin, in fact, had nothing to do with it. It was a small, radical nationalist group – one of many that proliferated in the years before the Great War and by 1916 in no sense the most important or influential. Its leading spirit was Arthur Griffith, a journalist. He was a cultural and economic nationalist and a political radical, being both a Fenian and a member of the Gaelic League.

He had made his name in 1904 by publishing a proposal entitled

The Resurrection of Hungary in which he praised the *Ausgleich* of 1867 which split the Habsburg Empire into two spheres of influence, thus turning what had been the Austrian Empire into the Austro-Hungarian Empire. He proposed a similar Anglo-Irish arrangement. Whatever this was, it was not republicanism or anything like it. None the less, the early Sinn Féin – it was founded in 1905 – attracted attention, partly because of Griffith's talent as a propagandist and partly because of its dislike of the Irish Parliamentary Party. It ran candidates in by-elections and performed creditably, offering a form of radical alternative to the IPP for a while. But in the ferment surrounding home rule in the years preceding the war, it looked as if Redmond had won his point. Sinn Féin, in common with other radical nationalist groups, seemed to have shot its bolt.

Burnt-out remains of the Metropole Hotel.

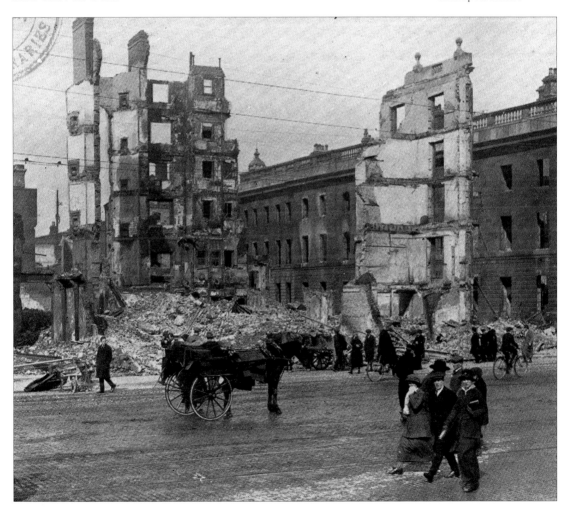

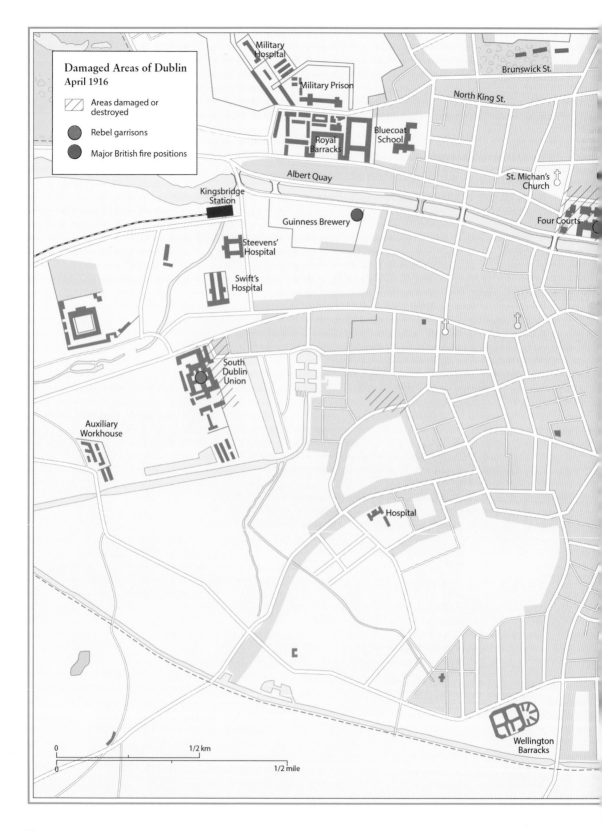

Damaged Areas of Dublin
April 1916

- Areas damaged or destroyed
- Rebel garrisons
- Major British fire positions

Military Hospital

Military Prison

Brunswick St.

North King St.

Royal Barracks

Bluecoat School

St. Michan's Church

Albert Quay

Kingsbridge Station

Guinness Brewery

Four Courts

Steevens' Hospital

Swift's Hospital

South Dublin Union

Auxiliary Workhouse

Hospital

Wellington Barracks

0 1/2 km

0 1/2 mile

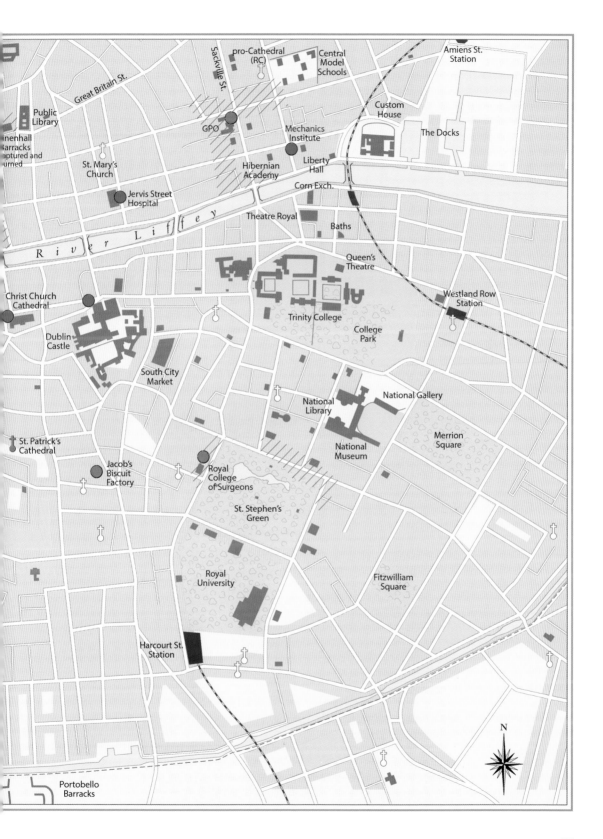

Great Britain St.

Sackville St.

pro-Cathedral (RC)

Central Model Schools

Amiens St. Station

Public Library

GPO

Custom House

The Docks

inenhall arracks aptured and urned

St. Mary's Church

Mechanics Institute

Hibernian Academy

Liberty Hall

Jervis Street Hospital

Corn Exch.

Theatre Royal

Baths

River Liffey

Queen's Theatre

Christ Church Cathedral

Trinity College

Westland Row Station

Dublin Castle

College Park

South City Market

National Gallery

St. Patrick's Cathedral

National Library

National Museum

Merrion Square

Jacob's Biscuit Factory

Royal College of Surgeons

St. Stephen's Green

Royal University

Fitzwilliam Square

Harcourt St. Station

N

Portobello Barracks

The British were eventually able to deploy around 18,000 men to put down the rising, in the course of which they suffered more than 400 casualties. Irish losses were estimated to be 1,000 killed or wounded (including civilians). At the time, material damage was estimated to be around £2.5m (about €500m, in modern values).

Irish Forces

British Army

Initial forces deployed 24 April

Reinforcements arriving after 24 April

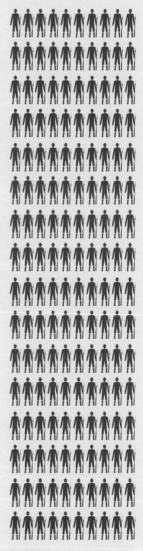

Forces Deployed by Combatants

 Each symbol represents 100 men

Total British force c. 18,000

And in a sense it and they had. But the name had entered the political vocabulary as a generic for all versions of nationalism to the left of the IPP – and the name stuck. So it was that in the aftermath of the rising, the British erroneously disinterred a name that might otherwise have sunk into historical obscurity. On the basis that if the cap fits it seems best to wear it, Sinn Féin became the omnibus term for all whose politics supported and celebrated the rising. From this time until the new Sinn Féin supplanted the IPP as the definitive voice of Irish nationalist politics in the general election of 1918, there was an internal contest for the soul of Irish nationalism. It was largely generational, with youth tending to Sinn Féin and age sticking with the IPP.

German Battle Squadron Raid on the East Coast of England
24 April 1916

← Route of German Battle Squadron

◄- Route of German retreat

Towns bombarded by German fleet 24 April

Easter Rising 24 April

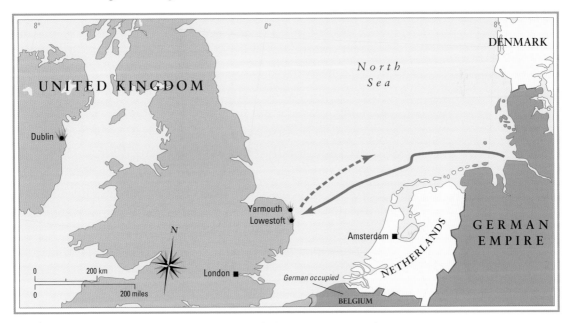

This was an unexpected side effect of the Great War. The emigration routes, which had been full of young Irish in every decade since the Great Famine of the 1840s, were closed for the duration of the conflict. Many of the most able and energetic, who might previously have sought a better life abroad, were now bottled up in Ireland. Their presence was, at a minimum, a contributory factor to the radicalisation of the nationalist demand. The Great War was the indispensable context for the rising. The instability it created made the old cry that "England's difficulty is Ireland's opportunity" meaningful again.

The Ulster Crisis had provided the proximate cause for the

The date of the Easter Rising coincided with a major expedition by the German High Sea Fleet on the east coast of England. This, together with captured German-supplied arms from surrendering rebel forces, triggered a major conspiracy theory amongst British High Command.

rising and all that followed by eroding whatever legitimacy still attached to the British connection in nationalist Ireland. Had there been no Great War, we don't know what would have happened: some version of civil war in Ireland, perhaps? Most counter-factual historical speculations are fruitless. We know only what actually happened. And what actually happened was that the United Kingdom was locked in a pitiless European war that collapsed a whole civilisation and threatened the integrity of every participating state. It accomplished the destruction of three empires.

It may be that the internal impasse in Irish affairs as they stood in July 1914 would have been sufficient to effect some transformation in the nationalist demand. The Irish Party did seem weary and ageing. Its evident failure to prevent partition would surely have damaged its credibility. A new generation, radicalised by the cultural revival and the resilience of the Fenian tradition, would have asserted the nationalist claim more vigorously. But without the war, what actually happened would not have happened.

The rising was a conspiracy pure and simple. It was the work of a secret cabal. The vast majority of the original Volunteers had heeded Redmond's call to the Western Front. Prior to 1916, radical nationalists were a negligible electoral presence. Even the minority of Volunteers who refused to follow Redmond were themselves opposed to a rising unless it had a realistic chance of military success or the obvious support of the populace, a position that echoed orthodox Fenian doctrine. The formal leaders of both the Volunteers and the Fenians were kept in the dark about the planned insurrection. Only the trauma of the war – England's difficulty – could have provided the context for such a desperate and reckless exercise.

The Sinn Féin that emerged from the rising was quite unlike the pre-war version. It quickly became a mass party and within a few years was to dominate nationalist politics. When it split in 1922 over the terms of the Anglo-Irish Treaty, its constituent elements formed the basis of the two dominant political parties in what is now the Republic of Ireland. Sinn Féin itself – or a version of it (it is a protean entity) – still exists, and at the time of writing is the junior partner in a devolved Northern Ireland executive.

Once the rising had been put down, the question arose of what to do with the leaders. General Maxwell was now the man of the

hour. He was in his fifties, a soldier with no more political sophis-
tication than most of his kind, whose career was stalled until this
moment. His country was engaged in a life-or-death struggle in
Europe and the war was not going well. To his way of thinking, the
matter was simple. The rebels had conspired with the German
enemy and the rising was nothing more or less than a stab in the
back. Ireland was properly a part of the United Kingdom; its peo-
ple owed a duty of allegiance to lawful authority, all the more so in
wartime; those who defied this duty deserved condign punishment.

Many voices pleaded with him. John Dillon, deputy leader of
the IPP, spoke passionately in the House of Commons against any
policy of executing the leaders of the rising. The influential Bishop
of Limerick, Dr O'Dwyer, spoke out likewise. So did George
Bernard Shaw and others. Maxwell was unmoved. A series of

*The Prime Minister,
Herbert Asquith, leaving
Richmond Barracks
during his visit to Dublin
in the aftermath of the
Easter Rising.*

Bishop Edward O'Dwyer of Limerick. His forthright exchange with General Maxwell was the first sign of a shift in episcopal support from the IPP to Sinn Féin which was to be complete by 1918.

military courts martial were constituted, the first of which sat on 2 May and sentenced Pearse, Clarke and MacDonagh to death. The sentences were carried out the following day.

All the garrison leaders, with the single exception of de Valera, were executed. But not just the garrison leaders: Willie Pearse, Patrick's younger brother, appears to have been shot for no better reason than that he was who he was. In all fifteen men were shot in a gruesomely drawn-out tragedy that dragged on until the 12th. On that day, James Connolly, unable to stand, was executed while sitting on a chair in the Military Hospital in Dublin Castle.

On the same day, the Prime Minister, H.H. Asquith, came to Ireland and re-established political control of the situation. By then, it was abundantly clear that all the warnings from Shaw and others were coming true. Because of its circumstances, Connolly's death caused particular public revulsion. But there was no undoing the damage that had been done. It would be wrong to say that the executions lost Ireland for England – because in truth she had been emotionally lost long since, inasmuch as there had ever been any more than a resigned and fatalistic acceptance of crown rule – but they were another nail in the coffin of the legitimacy of British rule in nationalist Ireland.

De Valera escaped the firing squad in circumstances that have been disputed. Having been born in New York, he could claim US citizenship. The fear of antagonising American opinion was traditionally proposed as the reason for his escape. Britain was desperate to get the United States into the war: executing an American citizen would hardly have been politic. However, the crown prosecutor at the courts martial, Lt W.E. Wylie, records that de Valera was saved by the growing political pressure arising from the earlier executions. Maxwell showed him a telegram from Asquith that sought a mitigation of the execution policy, at least to ensure that only prominent ringleaders were shot. He enquired of Wylie as to who was next on the list to be tried.

"Somebody called de Valera, sir," said Wylie.

"Who is he? I haven't heard of him before."

Wylie told him what little he knew of de Valera, to which Maxwell replied, "I wonder would he be likely to make trouble in the future?"

"I wouldn't think so sir, I don't think he is important enough. From all I can hear he is not one of the leaders."

There is no reason to doubt Wylie's testimony. He was there. He later went on to have a distinguished career as a judge. Wylie's judgment of de Valera was one of the great misreadings of an individual in modern Irish history. Dev went on to make a lot of trouble in the future, and to dominate independent Ireland until the mid-century.

More than 3,500 people were arrested in the aftermath of the rising, many of them on very poor intelligence. Almost half were released without charge within two weeks. Most of the others were interned, the principal camp being in Frongoch in Wales. In the classic way of these things, Frongoch turned out to be a revolutionary university. Many of those who made the Irish Revolution in the coming years were there. Michael Collins became the best known of them.

Collins quickly understood the antique nature of the Easter Rising of 1916, an urban insurrection looking back to a nineteenth-century tradition that was part of European folklore. The occupation of public buildings and the erection of barricades were reminiscent of the revolutions of 1848 or the Paris Commune of 1870. These dispositions were a passive invitation to counter-

attack. The contrast with the War of Independence a few years later, with Collins now running the show, was total. The war was concentrated in the countryside, using hit-and-run guerrilla tactics and an energetic propaganda machine on the political side.

In the immediate aftermath of the rising, the change of mood anticipated by James Stephens was not long in making itself felt. Both Redmond and Dillon spoke in the House against the policy of executing the leaders. Whatever misgivings the government may have had, it effectively left the matter to General Maxwell, the military commander on the ground. It is all too easy to characterise Maxwell as a standard-issue military dolt, indifferent to nuance. He certainly had an opinion of the Irish, articulated more than once, which was condescending at best and racist at worst. His imposition of martial law and his policy of executing the leaders were certainly politically inept, but from a soldier's perspective they made perfect sense. The rebels had invoked the assistance of Britain's principal enemy in the middle of the biggest war of modern times, this at a moment when the struggle at the front was at a desperate and uncertain stage. He may have considered that the political repercussions were nothing to do with him. But they certainly had to do with the government. And the government supported him.

Dillon, in particular, understood the effect that the executions might have on nationalist public opinion. His condemnation of the policy in the Commons was especially robust. He told the House that "it would have been a damned good thing for you if your soldiers were able to put up as good a fight as did these men in Dublin". Suddenly, for Dillon at least, the army on the Western Front was 'your army'. So who constituted 'our army' in Dillon's eyes? And were not the IPP horribly compromised by their pro-recruiting calls for 'your army' over the previous two years?

At least as significant as Dillon's outburst was the response of Bishop Edward O'Dwyer of Limerick to General Maxwell. The general had requested the bishop to discipline two of his priests who had publicly expressed republican views. The bishop let Maxwell have it: "You took good care that no plea for mercy should interpose on behalf of the poor young fellows who surrendered to you in Dublin…. Personally, I regard your action with horror and I believe that it has outraged the conscience of the

country." The bishops and the Party had been hand in glove since the 1880s. O'Dwyer's robust language was the first sign of a shift in episcopal support from the IPP to Sinn Féin which was to be complete by 1918.

More than 3,000 people were arrested after the rising and almost 2,000 of them were interned. The courts martial of the 15 men executed were summary affairs held in secret without any defence counsel or indeed any legally qualified person present except the crown prosecutor Wylie. The president of the court was Major-General Blackadder. In effect, the proceedings were what are commonly called drumhead courts martial. There was never the slightest question of trial by jury

– although the one executed leader who did secure trial by jury, Roger Casement, came to a similar end as the others. In all, 90 death sentences were handed down at the courts martial, of which 75 were commuted.

John Dillon, deputy leader of the IPP, spoke passionately in the House of Commons against any policy of executing the leaders of the rising.

While some of those shot, like poor Willie Pearse, did not merit their fate – at least in comparison to others like de Valera who survived, having held much more senior and influential positions – the case of Constance Markievicz was singular. There was no arguing about her importance in the rising and all that had preceded it. She had been one of the most prominent and visible figures in radical nationalism for many years past and was a national celebrity. There was never any question of her being executed, this despite her open and cold-blooded murder of Constable Michael Lahiff of the DMP on Easter Monday just inside the gates of St. Stephen's Green, as Mallin's troops – of which she was a part – were embarked on their doomed entrenching of that public park. She carried two weapons that day. Poor Lahiff

The 36th Ulster Division goes into action at the Battle of the Somme on 1 July 1916.

had the misfortune to be both unfashionable and unarmed (in common with most of the force).

She came before Blackadder in her turn. According to Wylie, she conducted herself badly. The court had been impressed by the bearing of some the doomed men antecedent – Pearse and MacBride were specifically mentioned by Blackadder for their self-possession and stoical bearing – but no one was impressed by the countess. She blubbered. According to Wylie's account – and again there is no reason to disbelieve him: he was an eye-witness, and one moreover who considered the policy of executing the condemned men an error – she broke down. "I am only a woman and you cannot shoot a woman. You must not shoot a woman."

Wylie described his own response years later. The countess "had been full of fight, but she crumpled up at the court martial. I think we all felt slightly disgusted.... She had been preaching to a lot of silly boys, death and glory, die for your country etc., and yet she was literally crawling. I won't say any more, it revolts me still." Her death sentence was commuted, unlike those passed on people braver and more honourable than her, and she lived on for another eleven years. She was a nationalist icon.

But why was there no question of her being executed? For the very good reason that she had never been in the slightest danger. When the political heat started to come on the government over the executions, Asquith had Maxwell come to London and agreed

with him that henceforth only the most prominent leaders would be shot. He would have preferred to stop the executions altogether, but the grip of the military over the civilian administration was now so far advanced that nice, accommodating Mr Asquith was no longer up to the rough stuff. But he absolutely forbade the execution of any woman. So the countess, who had been presented to Queen Victoria as a debutante years earlier, was saved by the old-fashioned gallantry of the administration against which her enmity was directed.

On Saturday 1 July 1916, barely a month after the Easter Rising, the 36th (Ulster) Division of the British army went over the top on the opening day of the Battle of the Somme. It was cut to pieces.

For the six days preceding, a vast artillery barrage had been directed at the German lines. Nothing was supposed to have survived

The 16th Irish Division take a breather after the first few days of action at the Somme.

it. But the German defences did: the barbed wire still held and the machine-gun positions were still in place when, after first light, the order was given to advance into no man's land.

What followed was the biggest single disaster in the history of the British army, which sustained 57,000 casualties before the day's end. The 36th advanced into a firestorm, many wearing orange lilies and shouting "No surrender!" In the old Julian calendar used in Europe until 1752, 1 July was the anniversary of the Battle of the Boyne – the highest of high days in the orange year. A few even wore orange sashes. They made deeper advances than any other unit of the British army, reaching the fifth German line. But they achieved this at a cruel cost and were unable to hold the position for long, for not only had they taken horrific casualties from enfilading German fire, they had been too successful and had run ahead of other British units, so far ahead in fact that they were also suffering casualties from British guns to their rear.

Even when they fell back to the fourth line, they were now trapped by the resurgent Germans who counter-attacked on three sides. More than most British divisions, the 36th were almost literally neighbours' children: the very littleness of Ulster – and indeed of Protestant Ulster – saw to that. It was this that gave the slaughter on the Somme a special poignancy. Survivors were able to write home to report of pals from the next street or the next farm who were missing presumed dead. The Armagh Volunteers sent 15 officers and 600 men over the top that morning. Only a single officer and 83 men came back in one piece. The Down battalion lost 90 per cent of its men killed, wounded or missing.

Of the 30,000 who had volunteered for the 36th, 5,000 were casualties of the opening days on the Somme. The battle dragged on into the autumn and the 36th later fought alongside the 16th Irish Division, composed overwhelmingly of Catholic Redmondite supporters from the south. Had the Great War not supervened, they might have been fighting each other in Ireland instead of fighting together in France. But it is difficult to identify what common cause – other than their own survival – now bound them together.

For the 16th, the events of the rising had already proved transformative. Tom Kettle, who was to die at Guinchy on the Somme in September, paid his last visit home to Dublin in May 1916. He was married to Mary Sheehy, whose sister Hannah had been mar-

ried to the recently murdered Frank Skeffington. He called to Hannah's house in uniform, to find his daughter Betty playing with her cousin Owen Sheehy-Skeffington, the only child of the murdered man. The children fled at the sight of him, for British troops wearing the same uniform had raided and ransacked the house after Easter week in the desperate hope of finding something incriminating that might have excused the murder.

As for the 36th, whose very raison d'être was hostility to Irish nationalism, the rising could only have furnished definitive evidence of the turpitude and treachery of nationalists. It marked something that nationalists found extraordinarily difficult to assimilate: that every increase in the nationalist demand meant progressive alienation of unionists, and therefore the increased certainty of partition. Now, if not before, republicanism and partition marched hand in hand. The prospect of some accommodation between the two sides had been vanishingly thin before the war and before the rising. Now it was gone for good.

Nationalists could have the greatest degree of freedom it was possible to extort from Britain – which is essentially what the next few years were all about – but they could not have that and a united Ireland. The rising marked the beginning of the end for the Irish Party and for Redmond and his generation. It was also the seal on the political division of Ireland. The 5,000 men that the 36th had left behind in France were enough to see to that.

There remained one final act of the drama to be played out. When Roger Casement had been captured at Banna Strand in Co. Kerry on Good Friday 1916, he was swiftly transferred to England and lodged in prison.

On 26 June, he was brought to the Old Bailey to face a charge of treason. The trial lasted three days. The Tory MP and later lord chancellor, F.E. ('Galloper') Smith led for the crown; Alexander Martin Sullivan, the King's serjeant in Ireland (the last person to hold that office) led for the defence. The trial judge was Mr Justice Darling, a former Conservative MP.

The treason statute dated to 1351 and Sullivan's defence was ingenious if rather desperate. The facts were not in dispute. Casement did not deny intriguing against the crown; nor that he tried to get Irish troops in Germany to desert; nor that he had sought German aid and arms in support of the rising. But Sullivan claimed

on his behalf that the statute only applied to treasonous acts committed in the King's realm and not outside. His conduct within the United Kingdom, including at the time of his arrest in Kerry, had been wholly pacific and unthreatening.

This plea was not accepted. An English judge and jury were being asked to accept that the law permitted open treachery against the state and the crown outside the jurisdiction, just as long as the person involved behaved himself upon return. It would have been a hard sell at any time, and the end of June 1916 – with the war going badly and about to get worse on the Somme – was no ordinary time. The English judiciary was in one of its less liberal phases during the war, consistently favouring executive power over civil liberties. It was a bad moment at which to plead Casement's innocence on a technicality. The plea turned on the interpretation of a comma in the ancient statute, with the defence arguing that it so qualified the meaning of the law as to deny it any extra-territorial effect. As a consequence, this gave rise to the charge that Casement "was hanged on a comma".

He was convicted on 29 June and sentenced to death. He appealed. On 30 June he was stripped of the knighthood bestowed on him five years earlier for his humanitarian work in Africa and South America. On 24 July, the Court of Appeal confirmed the conviction. Leading literary figures pleaded for clemency and the commutation of the death sentence. To the embarrassment of the government, the United States Senate passed a resolution on 29 July urging "clemency in the treatment of Irish political prisoners": the May executions had caused a storm of protest in America.

The result of all this was intense pressure on the British cabinet. On the one hand, it did not wish to do any more to alienate American opinion in circumstances where it was hoping that the United States would join the Allied war effort. On the other, a commutation of the death sentence would have caused a hostile reaction in British public opinion. Critically, the predictable opposition of the army High Command was a factor. The issue was so serious that significant parts of four cabinet meetings were devoted to it, until finally the sentence was confirmed.

The decision was eased by the leaking of Casement's diaries, in which frank accounts of homosexual acts were set forth. At a time when such acts were not merely criminal but widely regarded with

Roger Casement at his trial at the Old Bailey.

abhorrence, this was a clear attempt to blacken Casement's name and reputation. It succeeded, even to the point where the authenticity of the diaries was later disputed by Irish nationalists whose earnest piety made it impossible for them to believe that a patriotic icon and martyr could have been what was then considered a sexual pervert. The authenticity of the diaries is now generally accepted by scholars.

Casement was the 16th and last man to be executed for his role in the rising. He was hanged in Pentonville prison on 3 August by John Ellis. He had converted to Catholicism while awaiting execution and it seems he died well (as did most of the leaders, on the limited evidence we have of the other executions). Ellis said of Casement that he was "the bravest man it ever fell to my unhappy lot to execute".

His remains were buried in quicklime within the prison walls. In 1965, after many years of lobbying by Dublin governments, his coffin was disinterred and returned to Dublin, there to be awarded a full state funeral. He was re-interred in the republican plot in Glasnevin Cemetery.

The Easter Rising of 1916 was never intended to produce military victory or the immediate end of British rule in Ireland. It was a theatrical gesture and a cry to save what the rebels regarded as Ireland's lost honour. They were men and women of their time. Much of the talk of blood and conflict and honour that rang throughout Europe in the *fin de siècle* found an echo in Irish nationalist rhetoric as well. Pearse and Kipling were not as far apart as might first appear. To Pearse and the other separatists, the compromises and temporising of the Irish Parliamentary Party – the essential grist of work-a-day politics – represented a form of national humiliation. To them, these politicians were trimmers and prevaricators: they were local patrons and bigwigs with a political clientele of the comfortable and the satisfied. The young men who made the rising were little interested in politics or in political accommodation, although ironically Pearse himself had been prepared to accept the terms of a very anodyne measure known as the Irish Council Bill as recently as 1907. The radicalisation of Pearse's politics in the ten years prior to the rising found an echo in many others of his generation.

The rising was not simply a middle-class affair, although it was

centrally that. It was mildly bohemian and exotic. Pearse, Plunkett and MacDonagh were not ordinary bourgeois: they were part of an intellectual and literary subset of the nationalist middle class, a class which was for the greater part philistine, pious and materialist – more Samuel Smiles than Yeats. MacDermott and Clarke were revolutionary activists through and through. Connolly was a revolutionary socialist.

At some point, this mainstream nationalist opinion, or at least mainstream middle-class nationalist opinion, was bound to re-assert itself. For a few years the myth created by the martyrs of 1916 threw a blanket over nationalist life that concealed a lot. Only under the pressure of the Treaty debates in 1922 did some of the underlying tensions and divisions reappear. The working-classes were sidelined altogether. The Treaty was supported for the most part by the settled and the comfortable in Irish life and was opposed in disproportionate numbers by the marginalised.

There is, of course, an irony here. It was radicals and exotics that made the great mythical event that was the rising. They were revered in iconic images: Pearse's photograph in profile hung like a sacred icon in many an Irish kitchen. But the shabby-genteel, petit-bourgeois reality of the state that eventually emerged was disconnected from every kind of adventurous radicalism. It was a world made safe for small farmers and small businesses and small minds, where censorship was quickly imposed and divorce was quickly forbidden. It was a state in which the suffocating moral authority of the Catholic Church went unchallenged, indeed was positively celebrated.

Irish nationalist democracy traced its origins to the heroic foundation event of Easter week, to the theatrical challenge in arms to the might of England. But that event was kept at a considerable mental distance from the reality of post-1922 Ireland. In a sense, that's how it was fated to be.

The rising represented no identifiable constituency, had no political legitimacy in the ordinary sense of the term, and was a piece of symbolic theatre. It was never intended to be part of grubby quotidian reality. Indeed, it proposed itself in total opposition to the prevailing version of that reality, as expressed at the time by the Irish Parliamentary Party. But that reality was rooted in the sociology of the Land Acts that created the network of small farms

and small towns in a society that had not yet industrialised. This social reality had to reassert itself sooner or later. In all this, there is an ironic posthumous apotheosis for Pearse and the others. They had intended the rising as theatre, as symbol, as myth. And that is precisely what it became in the eyes of later generations, an enabling myth, something heroic to which the very ordinary and unambitious state that emerged from it and from subsequent

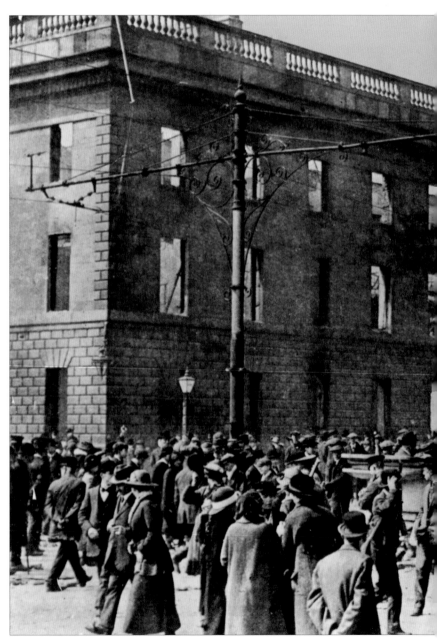

events could look up to as a symbolic ideal.

It did change the political weather for ever. For nearly a week the tricolour flag had flown over the GPO. It flies there today and it is inconceivable that any other flag should fly in its place. Had Ireland merely got home rule, the Union Jack would still have been in place. It might seem a small thing, the symbolism of flags, but it is not.

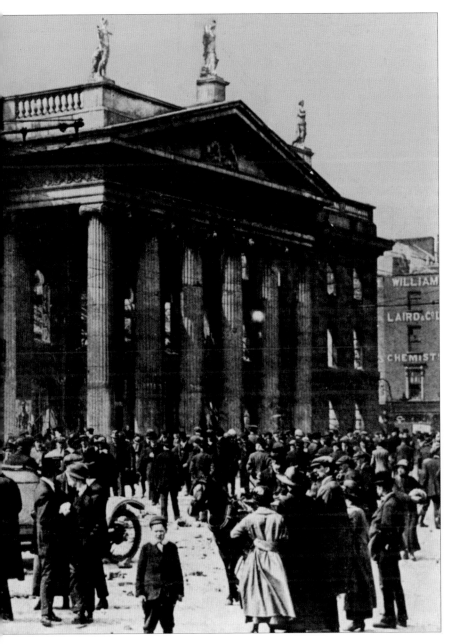

The burnt-out shell of the General Post Office above which had flown the tricolour flag of independent Ireland.

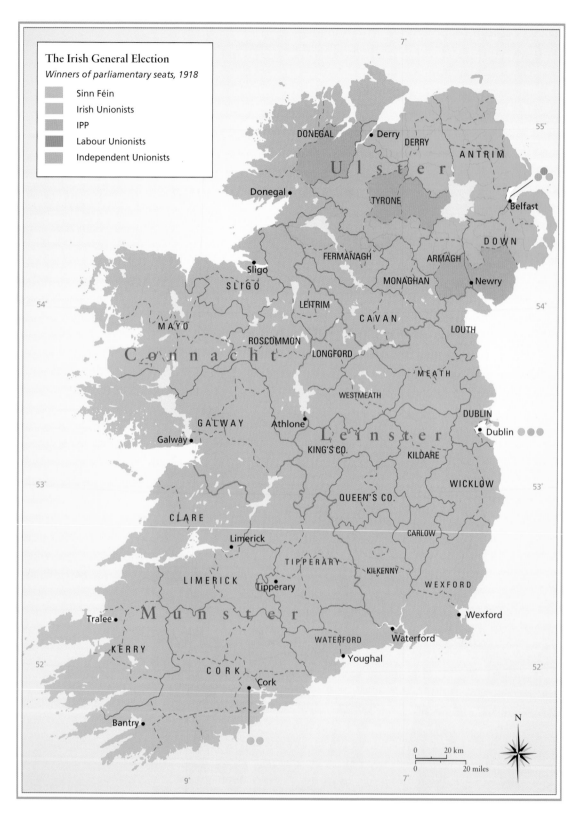

The Irish General Election
Winners of parliamentary seats, 1918

- Sinn Féin
- Irish Unionists
- IPP
- Labour Unionists
- Independent Unionists

CHAPTER 7
SINN FÉIN REDUX

The Easter Rising of 1916 and its aftermath are often seen as foundation events. They were not: they were transformative in raising the nationalist stakes and in the altered demands that nationalist Ireland was now making of Britain. The rising did not invent Irish nationalism or create the Irish nation.

None the less, that was how people remembered it. The whole relationship between the revolutionary and parliamentary elements in nationalism was inverted with startling speed. Within two and a half years, the IPP was wiped out. Sinn Féin, by then the declared heirs of the martyrs, was triumphant everywhere in nationalist Ireland. True, Sinn Féin turned out to be a broad church and elements of the old Parliamentary Party accreted to it, but this was by no means obvious in 1918 and 1919. It was as if the world had been made anew. No wonder the rising is remembered as a foundation event.

The change was evident even to Maxwell in the weeks after the rising. He grumbled about public commemorations of the executed leaders, with large public gatherings, requiem and commemorative masses and other manifestations of support. During the second half of 1916, there was a palpable shift in public attitudes to the rising, gradual at first but unmistakeable and gathering momentum. Mementoes of the dead men, including last letters, were copied and circulated widely. Mourning badges proliferated. Sinn Féin insignia were openly worn. Nationalist priests preached sermons sympathetic to the dead men, emphasising their Catholicism.

This question of religious observance was one of the things that marked the rising off from all that had gone before in the history of Irish nationalism. It was the first major event in nationalist history with no Protestant input. Although overwhelmingly a Catholic enterprise, Irish nationalism had always been able to claim Protestant support: Wolfe Tone, Emmet and Parnell were securely in the pantheon, and it is fair to say that the secular

republican ideals of the United Irishmen – and the tradition that they inspired – had been a counter-weight to a purely confessional reading of the project.

But rather as liberal unionism retreated to the margins of Ulster life as the nineteenth century advanced, so Protestant adherence to the nationalist cause – always a minority option within Irish Protestantism generally – was progressively diluted. The robust, authoritarian Catholicism of the post-Cullen Church was not exactly an enticing prospect for Protestants, who also recalled the vituperation visited by the priests upon their co-religionist Parnell at the time of the split. The open association of Catholicism and nationalism had ironically been facilitated by Parnell himself when he agreed to offer parliamentary support for the cause of Catholic education in return for episcopal support at home.

Nothing that had happened in Ireland in the 30 years leading to the rising had done anything to reduce the identification of Catholics with nationalism and Protestants with unionism. The exceptions on both sides were increasingly unrepresentative of their own communities. And for once, the word 'community' is apposite. Communitarian values, that shared sense of identity that binds people together in a collective, found its clearest expression in confessional allegiance. The Protestants of Ulster were blatant in this regard: there was no pretence of any secular theory in their endeavour. The Catholics were rather more mealy-mouthed (something that unionists found grimly reassuring) partly because of the 1798 legacy and partly out of a desire not to appear as a mirror-image of the Ulstermen.

None the less, there was no escaping the reality. In a world in which religion had not yet yielded to secularism, Ireland was conspicuously observant – and Catholic Ireland especially so. It was hardly to be wondered that the response to the rising should have found open religious expression: those masses for the souls of the executed men and public processions with prayers and priests. The identification with the martyrs of the rising as Catholics – good Catholics who had died in the faith (and by extension, for the faith) – increasingly became part of the unspoken and unquestioned mental furniture of life in nationalist Ireland.

Asquith, the Prime Minister, took the politics of the rising sufficiently seriously to charge Lloyd George with the task of trying his

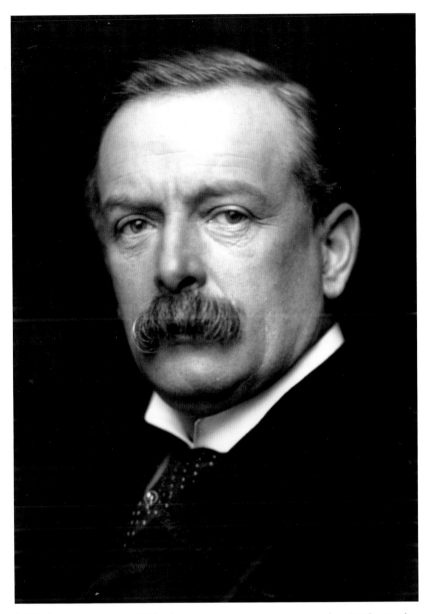

Lloyd George – his fabled negotiating skills failed to square the Irish circle.

fabled negotiating skills in an attempt to square the Irish circle. Lloyd George was Minister for Munitions, a critical function in the middle of the war, so it was a significant move to ask him to divert his attention from his principal duty. Its significance was not unrelated to the need to mollify American opinion, which, under pressure from the powerful Irish element in the Democratic Party, was sympathetic to the rising. Strategically, the hope of inveigling the United States into the war in support of the Allies was critical. So something had to be done, and to be seen to be done.

Lloyd George proposed home rule, along the lines of the suspended 1914 Act, but with six Ulster counties (the ones that eventually comprised Northern Ireland) excluded. He told the unionists that the exclusion would be permanent and the nationalists that it would be temporary. He was not the last British negotiator in Ireland to tell the two sides different things: Tony Blair repeated the trick over 80 years later during the negotiations that led to the Belfast Agreement of 1998. It did not matter: any proposal to implement home rule in any shape or form or with whatever conditions was anathema to the unionist right wing of the Conservative Party. Not only could Lloyd George not deliver a deal in Ireland, he could not deliver his own coalition government.

The Conservative ultras opposed any concession to nationalism as a reward for treachery and a danger to the state while the war lasted. They fulminated against the disloyalty of nationalist Ireland and its hatred for Britain – as they saw it – without ever asking themselves why this might be so. In a sense, their argument was supportive of the nationalist position: if the Irish were chronically disloyal and Anglophobe, did that not prove that they were Not British?

The real loser in all this was Redmond. He had temporised with a proposal that would exclude six Ulster counties from the putative settlement. This drew the wrath of Ulster Catholic bishops, further weakening the link between the party and the bishops. The shift in episcopal support from the party to Sinn Féin was now well under way.

Sinn Féin reconstituted itself. It was a gradual process, not complete until October 1917 when Eamon de Valera, the senior surviving commandant of the rising, was elected leader of the party, with Arthur Griffith as his deputy. In the meantime, candidates running under the Sinn Féin rubric had won a number of by-elections: Count Plunkett, father of Joseph Plunkett who was executed after the rising, had defeated the IPP candidate in North Roscommon by a margin of nearly 2 to 1. In line with Sinn Féin policy, he declined to take his seat at Westminster, having campaigned for an Irish parliament. His title was a papal one.

That was in February 1917. In May, Joseph McGuinness squeaked a narrow victory in nearby Longford South by a mere 32 votes out of almost 3,000 cast. McGuinness did not canvass the constituency, for the very good reason that he was in Lewes jail.

Opposite: *Eamon de Valera speaking in America.*

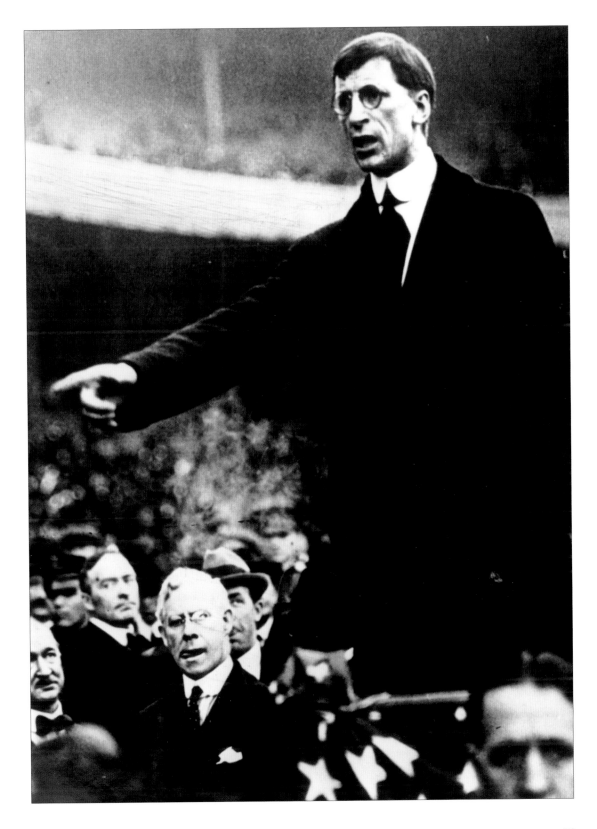

Sinn Féin coined the brilliant slogan: "Put him in to get him out".

In June 1917, Captain William Redmond MP, John Redmond's brother, was killed in action on the Western Front. In his place, de Valera was elected in East Clare (shades of Daniel O'Connell in 1828) polling over 5,000 votes to the IPP candidate's 2,000. Two days later, de Valera delivered himself of the view that "if Ulster stands in the way of the attainment of Irish freedom, Ulster should be coerced". How, he did not say. In August, W.T. Cosgrave won comfortably for Sinn Féin in Kilkenny.

These were hugely important shifts in Irish nationalist opinion. In four successive by-elections in nationalist Ireland in 1917, Sinn Féin had challenged the party and had won all four contests. The following year, the party defeated Sinn Féin in Armagh and Tyrone but this was no evidence of a revival: the IPP organisation in Ulster was on a much better footing than in the rest of the country. Even then, Sinn Féin beat the IPP in Cavan South – on the southern reaches of the province – when Arthur Griffith took almost 60 per cent of the vote in a straight head-to-head with the party candidate. Even more significantly, a by-election in King's County (Offaly) in April 1918 was not contested by the IPP and the Sinn Féin candidate, Patrick McCartan, was returned unopposed: this in a seat held by the party continuously since 1885.

The rise of Sinn Féin brought the eclipse of the Irish Parliamentary Party. But it also brought the allegiance of conservative elements within the nationalist community, previously comfortable in and with the party, to support the new body. Sinn Féin, no less than the party before it, was becoming a broad church – a coat of many colours. This explains the calculated ambiguity of de Valera's formula that while the objective was a republic, once that had been achieved the Irish people could decide on whatever system of government they desired. Dev would spend a long career proving that he could do calculated ambiguity better than most. However, the formal rhetoric of Sinn Féin remained firmly republican and revolutionary. This tension between rhetorical ambition and the sociology of nationalist Ireland remained occluded for the moment, but it built up trouble for the future, as the Treaty split would prove.

Most of 1917 was consumed in a vain attempt yet again to square the Irish circle by means of a conference. The moment had

passed for conferences, so the establishment of the Irish Convention by Lloyd George – now Prime Minister – in May 1917, largely at the rather desperate urging of John Redmond in what was his final contribution to Irish public life, seemed a futile and belated gesture. It certainly appears so in hindsight.

Sinn Féin, the rising star of nationalist Ireland, sensibly excluded itself from the Convention leaving the increasingly isolated Redmond to face the unionists. An attempted compromise with Lord Midleton, the leader of the southern unionists, on the basis of home rule with the maintenance of a customs union with Britain, proved impossible to sell to either side. The Ulster unionists – whose principal concern was permanent exclusion from home rule – abandoned Midleton. In like manner, the Ulster nationalists rejected Redmond's compromise, as did a significant number of Catholic bishops. At the point where they disappear

Sinn Féin members of the first Dáil. Count Plunkett is in the centre of the front row, with the heavy white beard.

John Dillon (right) *walking with John Redmond, leader of the Irish Parliamentary Party. In March 1918, in some despair, John Redmond resigned his seat and leadership of the party. He died a few months later. Dillon became the new IPP leader – he was handed the 'poisoned chalice'.*

from political history as an active force, the southern unionists had at last – belatedly, again – accepted the principle of home rule. Henceforth, unionism is concentrated in its radical northern cockpit, facing a nationalism whose demands are being ratcheted up in speeches and declarations. All hope of moderate compromise and accommodation was draining away.

The Irish Convention is generally short-changed in most accounts of these events, an irrelevant aside in the grand sweep of events. Certainly, it is a classic proof of the old saying that failure is an orphan. It was precisely the heady sweep of events, with tem-

pers rising alike among the nationalists and the Ulster unionists, that marginalised it. But the Convention crystalised intractable problems that had been visible since 1912 – and arguably since 1885. Neither British governments, nor Irish nationalists nor Ulster unionists could square the circle facing the members of the Convention, nor did any of their successors. There were to be great gusts of bluster and rhodomontade on all sides but no significant advance on the situation that faced the members of the Convention was made until the Belfast Agreement of 1998, and that was a creaky edifice thrown up in the wake of futile and bloody terrorist campaigns that had consumed over 3,000 lives for no good reason, and that itself required improbable shoring up in 2006. The Irish quarrel was not easy then and it is not easy now.

Redmond could not persuade the unionists and de Valera could not coerce them. They remain unpersuaded and uncoerced to this day, although their wilder spirits would dissent from that latter judgment. In the face of unionist intransigence, advanced nationalism of every kind has proved as impotent as poor Redmond.

As 1917 went on, the voice of Irish nationalism became that of Sinn Féin: the nationalist mainstream transferred its allegiance from the old party to the new. John Redmond was watching his life's achievement dissolving before his eyes. In March 1918, he resigned his seat and the leadership of the party: at least his son held the seat in the subsequent by-election. Redmond himself was dead before the year was out: he was only 62.

No single development did more to mobilise nationalism behind the Sinn Féin banner than the threat of conscription. Traditionally, Britain had maintained a very small standing army – in contrast to its all-powerful navy – and the suspicion of 'militarism' ran deep in British life. When the Great War began, Germany mobilised 1.7 million men, France 2 million. In all, 7 million soldiers were mobilised by the various European armies that deployed in August 1914. The British Expeditionary Force, the 'Old Contemptibles', hastily assembled, comprised a mere four divisions – later augmented to six – whose initial numbers were barely 100,000 men.

The British war effort thus became a prodigy of improvisation. Kitchener's New Army, based on volunteering, eventually developed to a deployable force of 2 million men but even then the fearsome casualties of the war – of which the Somme was merely the

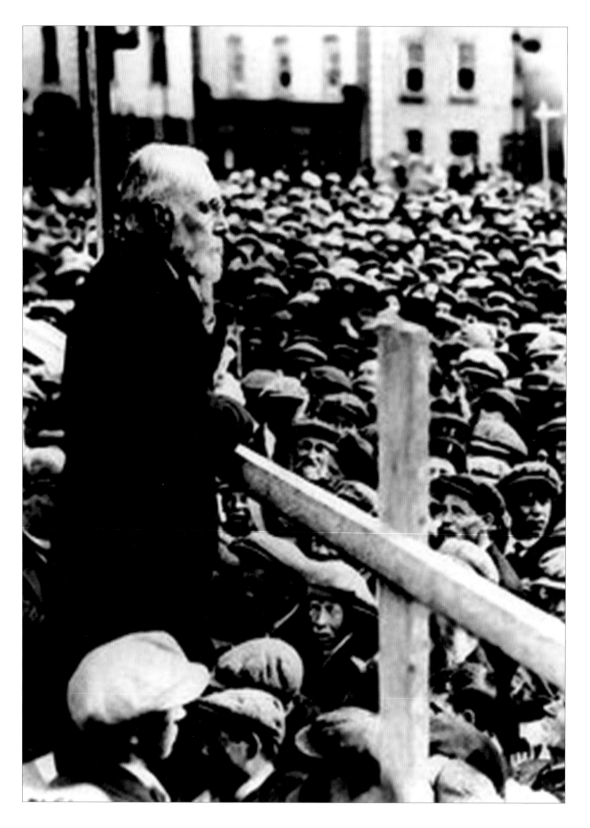

worst example – drove Britain for the first time in her history to the desperate expedient of conscription. That was in 1916. However, Ireland was excluded from the Military Service Act. In April 1918, Lloyd George tried to reverse this exclusion: he now proposed to draw Ireland into the conscription net.

John Dillon, the new leader of the IPP following Redmond's death, had been handed a poisoned chalice. Not only was the party associated with the failure of the Irish Convention, it now faced the disaster of conscription. In April 1918, in the face of renewed heavy losses on the Western Front caused by the alarming successes of the Germans' spring offensives, Lloyd George proposed enabling legislation to make it possible to extend the Military Service Act to Ireland. He had been warned time out of number that such a move would be met with universal outrage in nationalist Ireland, but given the military situation in France he could be forgiven for thinking that any action – however desperate – was better than military defeat. And the military situation was truly frightening: in the months of March and April 1918, the British Army lost over 300,000 men dead or wounded on the Western Front in the face of Ludendorff's offensive. Only a year before, Lloyd George had told the Commons that conscription in Ireland would produce barely 160,000 men, most of them at the point of a bayonet and many of them farm workers whose contribution to the war effort was vital and was better served on farms that produced food for the troops at the front than as cannon fodder. But now, in April 1918, he was forced to a change of mind.

It was a knife in the heart for the IPP. John Dillon withdrew the party from Westminster in protest, thereby tacitly conceding Sinn Féin's abstentionist point: after all, if abstention was merited, better to stick with Sinn Féin, the party that advocated it as a principle, rather than the one that only embraced it as a despairing last resort. The conscription threat galvanised nationalist Ireland like nothing before: all shades of opinion, lay and clerical, were opposed to the move. No more telling argument could be made for the complete collapse of British moral authority in nationalist Ireland.

The Lord Mayor of Dublin, Laurence O'Neill, organised a Mansion House Conference to build a unified platform against the threat. Dillon and de Valera were there, as were dissident Nationalist MPs like Tim Healy and William O'Brien. Bitter political

Opposite: *John Dillon addressing an anti-conscription rally.*

rivals united in a common cause in a manner not seen since Parnell's day. An anti-conscription pledge – drafted by de Valera – was signed by almost two million people across the country. It was a nationalist echo of the Ulster Solemn League and Covenant. The campaign had the overt support of the Catholic hierarchy, traditionally cautious but shrewd enough to recognise the way the wind was blowing. The Irish Trade Union Congress called a general strike which was observed everywhere except – no surprise, this – in Belfast and environs. Irish-American organisations, traditionally of a Fenian disposition, organised rallies and raised money for the cause.

Conscription was the issue that finally won Ireland for advanced nationalism. It united every shade of nationalist opinion around what was effectively a Sinn Féin agenda. The IPP was left a busted flush. Recruitment to the Irish Volunteers soared. In May, the government cooked up a totally spurious 'German Plot', in which Lord French, the commander of the original British Expeditionary Force to France at the beginning of the war and now Lord Lieutenant of Ireland, concocted 'evidence' of Sinn Féin's "treasonable communication with the German enemy". French had been a less than stellar general and had been relieved of his command after the Battle of Loos in 1915. His performance in the political minefield that was Ireland in 1918 was as clumsy as one might have expected from a military man of unexceptional intelligence. In May, he organised the arrest of most of the Sinn Féin leadership on grounds of complicity in the German Plot. De Valera was lodged in Lincoln jail. Naturally,

this did him and the rest of the leadership no harm at all in nationalist eyes.

Arthur Griffith was also lifted and sent to Gloucester prison. It was there that he learned of his election as a Sinn Féin MP in the East Cavan by-election in June. This was a significant result, not just because it confirmed the flow tide for Sinn Féin but because it did so in the IPP's organisational heartland: as previously noted, south Ulster was the part of the country where the party's structures had held up best against the Sinn Féin challenge.

On the very same day that Griffith was elected, the government's conscription plans were abandoned. It had taken just two months of furious agitation in Ireland to accomplish this. There were other reasons for the volte face. Ludendorff's offensives on

The wives and widows of Irish men serving in the British Army relied on their pay and allowances. This still left them on the bread line and also isolated in the changed political landscape.

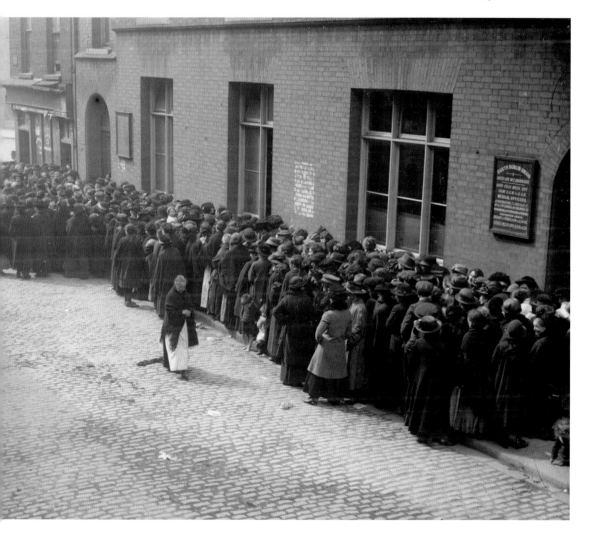

the Western Front were being contained by the late spring, although they were still inflicting heavy casualties. Moreover, the United States had entered the war on the Allied side in the autumn of 1917 and by the summer of 1918 the American Expeditionary Force was being augmented to the tune of 10,000 men a day. In this light, the panic over Irish conscription seems foolish and headless. But the pressure that all Allied governments were enduring – especially the British and the French – was almost intolerable. Not until August and September did the Allied counter-attacks make a decisive breach in the German ranks.

The Allies finally won the war in November and in December there took place the 'khaki election', held on a greatly expanded franchise. It was effectively the first UK election held under universal male suffrage. Women over 30 also had the vote for the first time. The effect was to increase the size of the Irish electorate from 700,000 to 2 million. It is reasonable to suppose that this accounted in part for the triumph of Sinn Féin and the near obliteration of the IPP. The party had won 73 seats in 1910. Now Sinn Féin had 73 out of the 105 Irish seats. The IPP was reduced to a miserable six. Of these, four were in Ulster where it and Sinn Féin had agreed a pact to allow the party an unopposed run lest a split nationalist vote facilitated a Unionist victory.

Regardless of cases of intimidation, irregularities and unopposed seats, one thing was clear. Sinn Féin was now the undisputed political voice of nationalist Ireland.

In all, about 200,000 Irish men joined the British Army and fought in the Great War. The figure generally accepted for casualties is 35,000. The men who returned came back to a world transformed. For many, it meant a cold shoulder in a country where the nationalist demand had been raised so dramatically since 1914. For others, sharing basic nationalist convictions despite their British service, it meant that that their military experience and expertise could now be placed at the service of the IRA. Tom Barry was the best known of these ex-servicemen. He became training officer of the West Cork Brigade of the IRA and commander of the flying column that won a celebrated, if controversial, victory over crown troops at Kilmichael on 28 November 1920, an event long celebrated in song and ballad.

One feature of this period that is often overlooked involved a

determined and successful attempt by the British to reform the Dublin Castle administration once and for all. Under the guidance of Warren Fisher, the Permanent Secretary at the treasury in London – and thus head of the United Kingdom civil service – the Castle's Augean stable was cleaned out once and for all. Ironically, it was a Catholic Under-Secretary – one of the very few Catholics ever to hold the post – who was principally in the firing line. James MacMahon retained his position but he was joined in May 1920 by Sir James Anderson as an 'additional Under-Secretary' and it was Anderson who ran the show from there on.

Moreover, Anderson had at his side as an assistant Andy Cope, one of the most resourceful and impressive British officials ever to come to Ireland. Not only did these new administrators bring Ireland's administrative systems into the modern era, they also skilfully maintained contacts with advanced nationalists: Cope was especially resourceful in this regard, even winning the trust of Michael Collins. They therefore had a more sophisticated understanding of the political realities and the possibilities arising therefrom than most of their predecessors.

It may have been too little too late, but it bequeathed to the new Irish Free State a fully reformed administrative machine, engineered along up-to-date Treasury lines, which independent Ireland was able to adopt and adapt for its own purposes. The administration of independent Ireland has followed the British (as distinct from, say, the French) model for the very good reason that it had effectively been gifted it by the departing imperial power. Mimesis played a part as well, for British cultural influence was overwhelming, which made the adoption of a familiar system understandable, especially in the chaotic conditions of the early 1920s. It also accounts for the close parliamentary modelling of independent Dublin upon Westminster.

In strict chronology, we have got ahead of ourselves but this seems as good a place as any to make this important point about administrative reform. Inevitably, the names of Anderson and Cope were principally associated with security issues and backstairs intrigues in the independence struggle that convulsed nationalist Ireland in 1920 and 1921. But they also left a benign legacy, one for which the new state that emerged from those years had cause to be grateful.

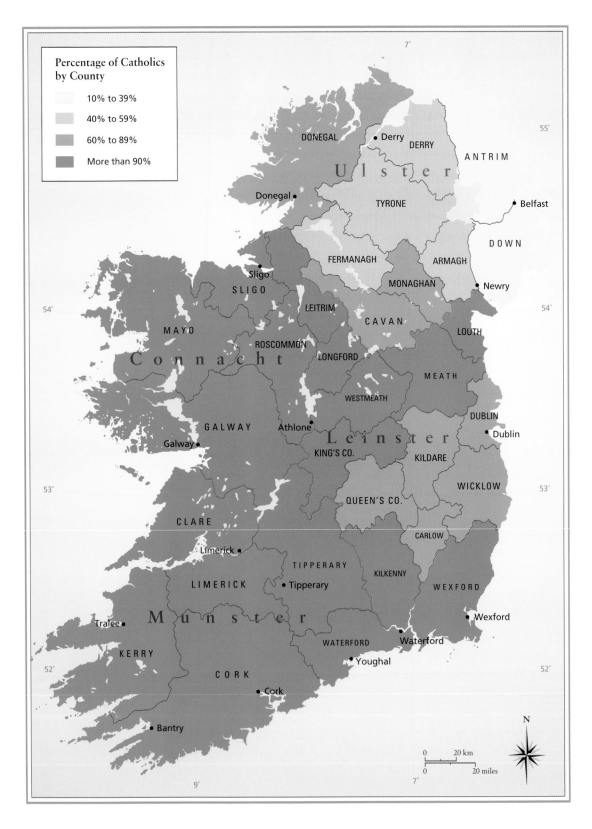

Percentage of Catholics
by County

- 10% to 39%
- 40% to 59%
- 60% to 89%
- More than 90%

DONEGAL
Derry
DERRY
ANTRIM
Ulster
Donegal
TYRONE
Belfast
FERMANAGH
ARMAGH
DOWN
MONAGHAN
Newry
SLIGO
Sligo
LEITRIM
CAVAN
LOUTH
MAYO
ROSCOMMON
LONGFORD
MEATH
Connacht
WESTMEATH
GALWAY
Athlone
Leinster
Galway
DUBLIN
Dublin
KING'S CO.
KILDARE
WICKLOW
QUEEN'S CO.
CLARE
CARLOW
Limerick
TIPPERARY
KILKENNY
LIMERICK
Tipperary
WEXFORD
Tralee
Munster
Wexford
KERRY
WATERFORD
Waterford
Youghal
CORK
Cork
Bantry

N

0 20 km
0 20 miles

CHAPTER 8
ELECTIONS, WAR, PARTITION

True to their principles, those Sinn Féin MPs elected in December 1918 and who were not in jail following the German Plot refused to take their seats at Westminster and instead constituted themselves as Dáil Éireann, the assembly of Ireland, which met for the first time at the Mansion House in Dublin on 21 January 1919. The Dáil appointed delegates to represent it at the forthcoming Paris peace talks, designed to hammer out a post-war settlement for Europe. An Irish Race Convention in Philadelphia voted for full recognition of Ireland as a separate entity at the peace conference, a vote echoed by the US House of Representatives, much to the chagrin of President Woodrow Wilson. An anglophile, Wilson deplored what he regarded as a piece of congressional populist grandstanding: he had no intention of supporting the claim to separate recognition of what he regarded as an integral part of Allied territory.

None the less, the Dáil duly sent delegates to Paris, where they were predictably cold-shouldered and failed to get a hearing. Perhaps they did not really expect one, regarding the exercise as a piece of propaganda. To that extent, they succeeded. While the world had larger matters to settle than the question of Irish nationalism, the delegates were at least able to make a small noise on the margin of things. The reality was that defeated states could be dismembered by international treaty and the parts distributed in accordance with the Wilson principle of the rights of small nations. But this noble principle was entirely predicated on a condition antecedent: the defeat of the relevant imperial power.

Britain, on the other hand, was a victorious power. There was no force at Versailles or in any other international assembly that could coerce London into abandoning any territory, let alone a part of its own metropolitan heartland. The only force available for that lay in Ireland.

The delegates at Versailles were not the only piece of whimsy to emanate from the new assembly in Dublin. The Dáil also adopted a Democratic Programme, subsequently distinguished for being honoured in the breach by the governments of independent Ireland. It stated inter alia that "the Nation's sovereignty extends not only to all men and women of the Nation, but to all its material possessions; the Nation's soil and all its resources, all the wealth and all the wealth-producing processes within the Nation and ... we re-affirm

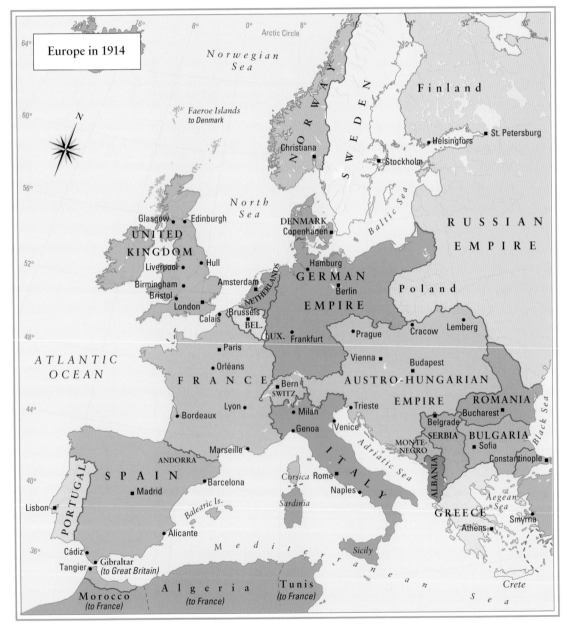

Europe in 1914

that all rights to private property must be subordinated to the public right and welfare."

There was more in a similar vein, much of it admirable and much of it anticipating social democratic reforms that were later to be introduced painfully, slowly and often grudgingly. But by and large it has been ignored, as the Irish left has never failed to point out by way of complaint. The Democratic Programme was drafted by the leader of the Irish Labour Party, Thomas Johnston, and edited (and toned down)

European Peace Treaties
1919–20

⌣ Disputed or unrecognised border

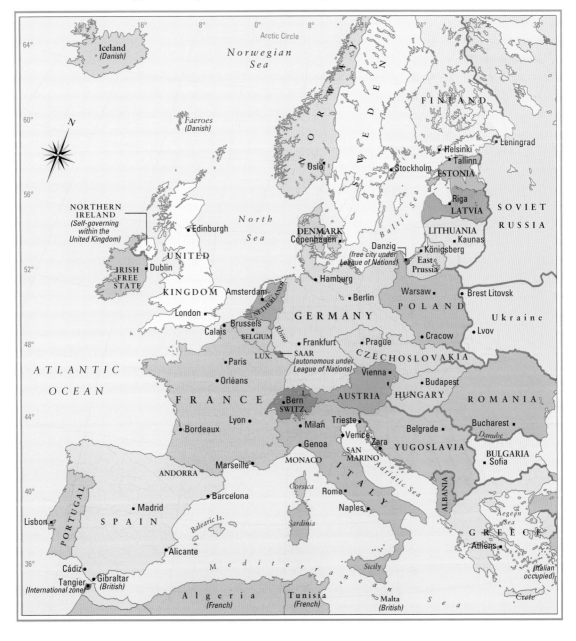

by Sean T. O'Kelly. The latter was shortly after to find himself a Sinn Féin delegate at the Paris peace conference – ensconced in the Grand Hotel on the Boulevard des Capucines – and later on, after 1932, a cabinet minister in de Valera's governments. He ended his career as a discreetly bibulous President of the Republic from 1945 to 1959.

The Democratic Programme was a creature of its time, with the Bolshevik Revolution in Russia heralding for some a millennial hope. It also furnished Johnston with a document that he could flourish at a forthcoming International Socialist conference in Switzerland. But it also highlighted the gap between aspirational politics – of which, understandably given the heady times, there was an awful lot about – and the sociological reality. Sinn Féin was constitutionally a revolutionary party: it aimed to capture the levers of state power from those who held them. But socially, it was deeply conservative, even reactionary, as much of the history of independent Ireland was to attest.

The social revolution in Ireland had happened in 1903, with the passage of Wyndham's Land Act that finally undid Cromwell's land settlement of the 1650s and established the tenants as proprietors, thus creating a huge rural petit bourgeoisie. This was the class from which Sinn Féin drew its membership and support (and which also provided a large part of the Catholic priesthood). It is hard to imagine a sociological group less attracted to socialism. Not only was there a determination to hold on to what had so recently been secured, but there was also the rural suspicion of a movement that was both urban and 'foreign'.

In the one great test between Irish capital and labour – the Dublin Lockout of 1913 – all shades of nationalism had been firmly on the side of the employers and against the union. Griffith had seen the locked-out trade unionists – whose conditions cried to heaven for redress – as fifth columnists threatening nationalist unity and the development of the national economy. The Catholic Church behaved disgracefully and brutally during the dispute. Ireland was a rural, agrarian country of independent proprietors and was an unpromising soil for socialism. De Valera himself had famously said that "Labour Must Wait", echoing Griffith's earlier point about nationalist unity trumping social reform. And Labour was indeed made to wait – and wait and wait – the Democratic Programme notwithstanding.

Indeed, one of the ironies of the document was that it might have been a programme but it was not democratic. Labour had stood aside

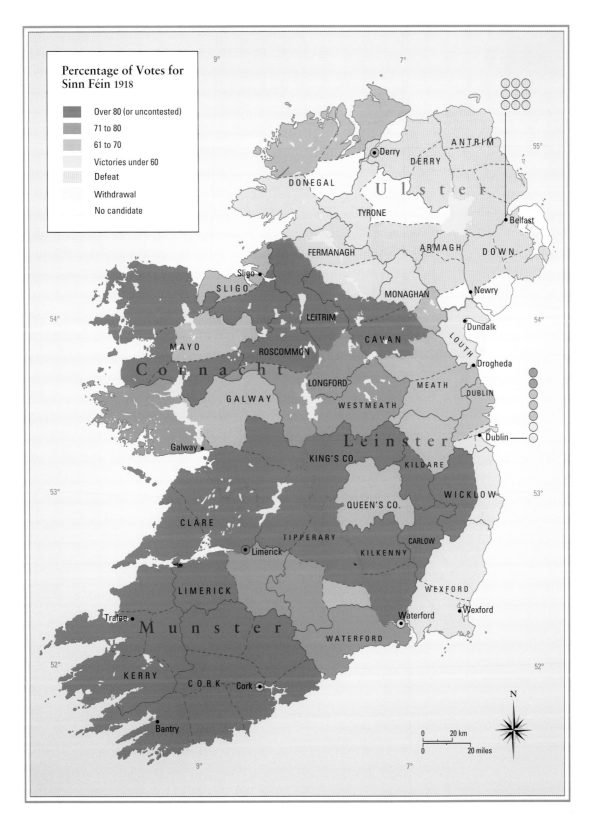

Percentage of Votes for Sinn Féin 1918

Over 80 (or uncontested)

71 to 80

61 to 70

Victories under 60

Defeat

Withdrawal

No candidate

Terence MacSwiney,
Lord Major of Cork,
with his wife and child.
His death, after a hunger
strike lasting 74 days,
was a propaganda
triumph for Sinn Féin.

in the election of 1918 – waiting, waiting – and so had no electoral mandate for anything, least of all something as ambitious as this.

On 3 February 1919, de Valera was sprung from Lincoln jail in an audacious escape orchestrated by Harry Boland and a young man from west Cork called Michael Collins. Still not 30, Collins had been 'out' in 1916, had been interned briefly, was secretary and later president of the Supreme Council of the IRB and a member of the executive committee of the Irish Volunteers. He was also Minister for Home Affairs in the shadow government formed by Dáil Éireann. He had contacts everywhere, and he was assiduously developing a spy network to worm its way into the British administration. Traditionally, the Dublin Castle spy system had been the rock on which Irish political conspiracies had broken. Collins was in the business of turning the tables. By the middle of 1919, he would be a household name.

In April, de Valera was elected President of Dáil Éireann and Michael Collins, by now Minister for Finance in the shadow government, began an issue of republican bonds in order to raise national funds. The result was an astonishing success. In June, de Valera left for the United States where he was to spend the next eighteen months rallying Irish-American opinion to the republican cause and trying to mobilise its influence to guide President Wilson's policy at Paris. The former proved easy, the latter not. But he also raised over $5 million for the cause. Revolutions can't run on air.

In the summer of 1919 the Dáil established a series of republican courts throughout much of the south and west, which effectively replaced the crown courts as the means of settling legal disputes. They were remarkably effective and widely resorted to by people of all political sympathies. In this way, the Dáil was able to make its writ run in large parts of Ireland in defiance of the British for the best part of a year.

How could the shadow administration in Dublin, on the run from safe house to safe house, initially strapped for cash, harassed by the British, pull off such an audacious coup in the countryside? The answer lay in the second half of the republican offensive. On 21 January 1919, the same day that the Dáil had met for the first time, a party of Irish Volunteers in Co. Tipperary had shot dead Constables MacDonnell

and O'Connell of the Royal Irish Constabulary at Soloheadbeg. These were the first shots fired in the Irish War of Independence. As in the 1916 Rising, the first to die in the war were Irish Catholics. The RIC men had been guarding a delivery of gelignite to a quarry. Dan Breen, one of the Volunteer leaders on the day and a nasty brute

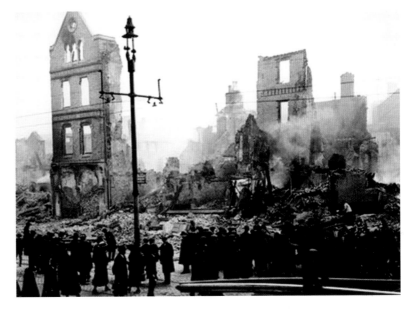

Part of the centre of Cork city following its destruction by crown troops.

who later sat as a Fianna Fáil backbencher in the Dáil for more than thirty years without ever threatening to secure office (the party was not always overwhelmed with talent, but never so desperate as to reach for Breen) made no secret of their intention that day. They had no interest in the gelignite. They were there to kill.

The relationship among the Volunteers – or the Irish Republican Army (IRA) as they became known in the course of 1919 – was an uncertain one. In theory, the IRA was now the army of the Republic, under ultimate civilian control. The personification of that control was the Minister for Defence in the Dáil administration, Cathal Brugha. However, the IRA contained within it (as had the Volunteers right from the start) a significant number of IRB men and the IRB considered itself, according to its own constitution, to be the provisional government of the Republic until a fully independent state could be established. And the head of the IRB was Collins, a swaggering, overbearing personality if ever there was one. Brugha, also a 1916 veteran and brave to a fault, naturally resented the younger man.

Moreover, what did civilian control actually mean in the context of the War of Independence? Communications between Dublin and local units of the IRA were uncertain to non-existent. The war was prosecuted by energetic local commanders who knew their own areas and were disinclined to take orders from Brugha, even if those orders could get through. The most remarkable thing about the War of Independence was how local it was, depending almost entirely on

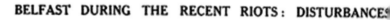

the initiative of individual commanders. A county as fiercely repub-
lican as Kerry hardly fired a shot in anger, while the neighbouring
county of Cork was a graveyard for crown forces. Co. Longford was
a hotbed of the war, largely thanks to the aggression and organisa-
tional skills of Sean Mac Eoin, the local commander.

The primary target of the IRA was the RIC, the local eyes and
ears of British government in Ireland. Rural barracks, most of them

JRING WHICH 18 WERE KILLED AND 200 WOUNDED.

Scenes of riots and civil disorder in Belfast accompanied the partition of the island and the establishment of Northern Ireland as a semi-autonomous province within the United Kingdom. The civil war that had been averted by the outbreak of a greater war in 1914 now erupted in the Ulster cockpit.

poorly defended, were targeted and progressively abandoned by the police. The quasi-military nature of the RIC was the reason that their premises were called barracks rather than stations, a revealing piece of nomenclature. Most RIC men were Irish nationalists and Catholics, but that availed them nought in the eyes of the IRA. Indeed, it compounded their treachery in their enemy's eye. From the middle of 1919, IRA killings were stepped up. District Inspector Hunt

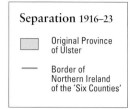

Separation 1916–23

Original Province
of Ulster

Border of
Northern Ireland
of the 'Six Counties'

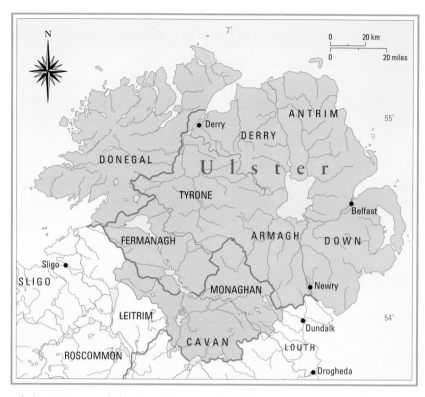

of the RIC was killed in Thurles, Co. Tipperary, in June. Detective Patrick Smith of the G Division (Special Branch) of the Dublin Metropolitan Police was shot in July. In August, Co. Clare was a hotbed of activity. By the end of September, over 5,500 raids by the police and military on private houses had taken place. British troops sacked Patrick Street in Cork. In December, the IRA came within a whisker of assassinating French, the Lord Lieutenant. By the end of the year, there were 43,000 British Army troops in Ireland.

The new year, 1920, brought a new and sinister development. The government was faced with the fact that there was an open military revolt in Ireland; that there was a shadow government capable of raising its own funds; and that an alternative system of justice was functioning in some parts of the country. Had Ireland been a distant crown colony, it would have been a relatively simple matter to send in the army. But Ireland was not a crown colony. It was an integral part of the metropolitan United Kingdom. It was this single fact that had made the whole Irish nationalist saga so difficult for the British, compounded of course by the Ulster unionist complication. London did not simply want to throw the army at the IRA, but it definitely needed to augment its military presence. Therefore it called it a po-

lice reserve. The RIC was the principal target of the rebels, so the new force would in effect be soldiers posing as police. As if to give the game away, they were to come under army control.

They started recruiting for the new reserve on 2 January and the first recruits arrived in Ireland on 25 March. They were issued with dark bottle-green RIC tunics but a shortage of trousers in the same colour meant that they had to wear British Army khaki: thus the name that has stuck to them ever since, the Black and Tans. (The reference was to a famous hunt in Co. Limerick, the Scarteen Black and Tans, whose colours were and are similar.) The Tans were stationed in areas of highest IRA activity and their reputation for unblinking reprisal and counter-terror was soon established. Most of them were veterans of the Great War, either bored or unemployed or both. Random firing at civilians and the looting and burning of towns became a commonplace.

Even more vicious than the Black and Tans were the Auxiliaries, a further force raised in the middle of the year. They were paid more than the Tans and given an even freer hand, which they cheerfully played. One of their most hated commanders, Major Arthur Percival, survived three IRA assassination attempts and lived long enough to have the honour of surrendering Singapore to the Japanese in 1941.

The burning of Cork came at the end of a year of escalating violence. In March, a magistrate, Alan Bell, was assassinated in Dublin by a murder gang called 'the Squad' under the direction of Michael Collins. An IRA attack at Ballylanders, Co. Limerick, brought Black and Tan reprisals in Limerick city the next day. So quickly had the Black and Tans acquired a reputation for atrocity that in June – barely three months after they were first deployed – the word of their excesses had travelled as far as India, tripping off a mutiny among Irish troops there. In the midst of all this chaos, Michael Collins was able to announce that his National Loan Scheme had been over-subscribed by 15 per cent.

The catalogue of violence went on. In August the IRA assassinated an RIC district inspector deep in the unionist heartland of Lurgan, Co. Antrim. DI Swanzy had been implicated in the murder in March of the Sinn Féin Lord Mayor of Cork, Tomás MacCurtain, who also doubled up as head of the local IRA. A Cork coroner's jury was in no doubt on the matter, finding that "the murder was organised and carried out by the Royal Irish Constabulary officially

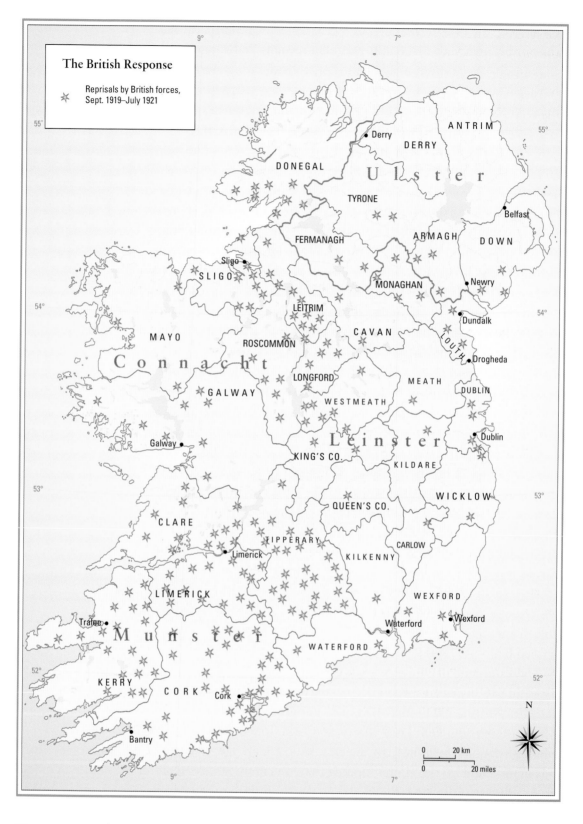

The British Response

✳ Reprisals by British forces,
Sept. 1919–July 1921

directed by the British government". Few doubted the basic truth of this verdict and MacCurtain duly entered the nationalist pantheon.

Through the autumn of 1920, the IRA campaign was stepped up, most particularly in its Munster heartland. In September, a force under the command of Liam Lynch and Ernie O'Malley captured the military barracks in Mallow, Co. Cork. The RIC barracks in Trim, Co. Meath, was captured two days later. The Black and Tans responded by sacking the town in reprisal. By October, the British government acknowledged that 675 RIC barracks had been destroyed, abandoned or damaged since the start of 1919. One hundred and seventeen RIC men were dead and 185 injured in the same period. On 24 October, MacCurtain's successor as Lord Mayor of Cork, Terence MacSwiney, died on hunger strike in Brixton jail, London, after 74 days without food.

In November – the events of which are related in more detail in the next chapter – Kevin Barry was hanged, joining MacCurtain and MacSwiney in the pantheon; Sean MacEoin and his IRA company held the village of Ballinalee, Co. Longford, for a week. Then came Bloody Sunday and the ambush at Kilmichael. Martial law was proclaimed throughout much of Munster and the Black and Tans and Auxiliaries between them torched much of the centre of Cork city in reprisal.

While all this mayhem was going on, the British government made a further attempt to legislate its way out of the Irish mess. In March 1920, it introduced the Government of Ireland Bill, in effect a fourth home rule measure. It repealed the 1914 Act and proposed a partition of the island. There would be two parliaments, one in Dublin and one in Belfast for the six counties of Northern Ireland. The six counties chosen – Antrim, Down, Armagh, Derry, Tyrone and Fermanagh – represented the maximum area in which a Protestant and Unionist majority could be guaranteed. The remaining three counties of the historic province of Ulster were to be left in Southern Ireland.

The legislation was passed before the end of the year. It was a dead letter in the South from the start. But it held in the North. Northern Ireland was formally established as an autonomous province within the United Kingdom in May 1921. The island was partitioned: what had been unthinkable – even for Sir Edward Carson – less than a decade earlier had come to pass.

The new statelet, Northern Ireland, was inaugurated in May 1921, while the War of Independence was still in full swing in the South. It

was the product of a legislative process that had flowed from the refusal of Sinn Féin MPs elected in 1918 to take their seats at Westminster. This meant that Irish nationalists had no input into the Government of Ireland Act 1920 which established Northern Ireland. Not only that, but Lloyd George's coalition government was dominated by Conservatives and Unionists. Craig himself was a junior minister at the Admiralty and the legislation was drafted by a committee headed by a Walter Long, a former parliamentary leader of the Irish Unionists.

The result was that the Ulster Unionists were able to tailor the legislation to suit their own convenience. This they did by throwing the southern unionists to the wolves and even abandoning the three marginal Ulster counties of Cavan, Monaghan and Donegal, whose inclusion would have left the confessional balance of the partitioned province too delicate for comfort. Instead they took as many counties as would produce a secure Unionist majority. And so Northern Ireland came to comprise the six remaining Ulster counties. Three of them had solid Protestant majorities, one a narrow Protestant majority and the remaining two – Fermanagh and Tyrone – Catholic majorities. Overall, the confessional balance, together with some judicious manipulation of constituency boundaries, was enough to ensure that 40 of the 52 MPs returned to the new regional parliament in Belfast were Unionists. Craig returned from the Admiralty in London and assumed his new role as the first Prime Minister of Northern Ireland.

This new arrangement did not go uncontested. Units such as the 4th Northern Division of the IRA under the command of Frank Aiken from South Armagh – later to be a long-serving Minister for External Affairs in Dublin – began to carry the war into the North. All Northern Catholics, whether republicans or not, were horrified by partition. Theirs was a reaction that mirrored the fear of the Protestants in a unitary home rule state: that of being hostage to the superior numbers of the sectarian enemy.

In effect, what happened in the North from 1920 to 1922 was the sectarian civil war that had threatened in 1914 and which had been averted only by the outbreak of the Great War in Europe. By now, however, the focus had shifted. In 1914, the UVF was set to resist the state. Now the state was in the hands of those who had formed and armed the UVF, and it was nationalists who were resisting the new arrangements proposed. The war in the South was between a guerrilla army

fighting in the name of a putative republic – virtually established, in the old Fenian formula – and the occupying British state. The war in the North was much more of an internal affair. It was the continuation of a nineteenth-century tradition of sectarian violence. But the violence was to attain a level not known before, as nationalists found the political tables turned on them in the most dramatic fashion.

There were serious riots in Derry in the early part of 1920 and gradually vigilante groups of Protestants began to form in west Ulster in the course of that year. In effect, the UVF was being re-born. The abandonment of rural police stations by the police under IRA pressure added to this impulse. The Protestant marching season threw fuel on this fire: by the second half of July, Catholics were being intimidated out of their workplaces in Belfast. Up to 10,000 may have suffered this fate: even if that number is an exaggeration, the reality of widespread intimidation was undeniable. Equally undeniable was the fact that the IRA, although poorly armed and outnumbered, fought a bitter guerrilla war aimed at destabilising the new state before it could get itself established.

Given the superiority of Protestant numbers and their access to arms, they were always more likely to prevail in this contest. Isolated Catholic areas came under attack from Protestant mobs, often abetted by the army and police. Craig explained to an alarmed government in London that "the loyalists … believe that the rebel plans are definitely directed towards the establishment of a republic hostile to the British Empire" and warned that "unless urgent action is taken, civil war on a very large scale is inevitable". In fact, what had emerged by the last quarter of 1920 was nothing short of civil war.

Even before the formal inauguration of the Northern Ireland state, the government decided to raise a police reserve in the North, to be known as the Ulster Special Constabulary. It was divided into three sections, A, B and C. Of these, the B Specials became the largest and most notorious group. They were for all practical purposes the UVF in state uniforms, a Protestant militia that proved efficient at petty harassment, spying on Catholic neighbours and brutally robust methods of law enforcement.

In May 1921, King George V had come to Belfast to inaugurate the new partition parliament and had made a speech calling on all sides to start afresh and to forgive and forget. It sent a signal to the Sinn Féin leadership in the South that may have led to the Truce that followed in

Members of the Irish delegation to the Treaty negotiations in London, 1921. Arthur Griffith is seated (front left). Michael Collins travelled separately, while the rest of the delegation, shown here, sailed. Collins flew as a security precaution.

July. But it was words on the wind in the North. The very next day, as the King's cavalry escort was returning to Dublin by train, it was ambushed by the IRA. Four men and 80 horses died. In June, the deaths of four policemen and B Specials brought reprisals against Catholics in Belfast that left ten dead. In July, just as the Truce took hold in the South, things got worse in the North. Sixteen Catholics and seven Protestants died. More than 200 Catholic houses were torched. By the end of 1921, the death toll in Belfast alone was 109 for the year, in addition to the injuries, intimidations and wrecking of homes and businesses.

The Truce in the South released IRA volunteers and arms for service in the North, thus raising the stakes further. The release of IRA prisoners under the terms of the Truce had a similar effect. Seventy-two IRA volunteers in Belfast were being paid a monthly stipend by the Dublin Sinn Féin government-in-waiting. In February 1922, 44 people died in Belfast including six Catholic children killed in a bomb attack. The number in March was 61. In April, there were further attacks and reprisals. In one instance, the police were implicated in a revenge attack on Catholic houses in Belfast that left a man and a child dead and 50 houses destroyed. Catholics burned out in Belfast fled to Dublin in the clothes they stood up in. Craig's government was thoroughly rattled: the mayhem was a direct challenge to the new provincial government's ability to maintain order in its own back yard. Was Northern Ireland viable as an entity? The IRA was doing everything it could to wreck it, or at least to compromise its internal security so badly as to paralyse it.

Craig responded with the Special Powers Act 1922. It gave the government draconian powers of arrest, indefinite detention without trial, and courts of summary jurisdiction that could hand down the death

penalty. Liberal British opinion was horrified at what it regarded as powers of Asiatic severity. Unionist backbenchers, on the other hand, thought it too pussyfooting. One MP took the view that the Act should simply empower the Minister of Home Affairs to do whatever he liked.

The IRA response to this was to step up their campaign in west Ulster, where the local Catholic majority gave them relative safety in numbers. Protestant houses and businesses were targeted. In May 1922, the war returned to Belfast as the IRA set over 40 major fires in the city. As the summer came on, it got worse. An MP was murdered. Internment without trial was introduced. Even then, it was a close run thing. The decisive event was the civil war in the South which broke out in earnest at the end of June. By dividing the IRA and diverting its northern command from what had been its primary purpose, it contributed to the fizzling out of the campaign. How much of the IRA retreat was due to this and how much to the severity of Craig's response is impossible to gauge.

At any rate, by 1923 the North, like the South, was restored to a nervous peace. But there was no denying that the IRA had taken on the new government and had challenged its viability as a functioning unit. The new state was, therefore, born of a victory by the state over armed republicanism. Once again, the more vigorous the assertion of nationalist rights the more terrible the unionist response. It was a vicious three years which set the pattern of zero-sum politics in Northern Ireland for the future. Perhaps it would be more correct to say that it merely underlined the zero-sum nature of the sectarian quarrel that had been evident since the 1880s.

More people died in Northern Ireland in 1922 as a result of political violence than in most years of the post-1968 Troubles. In many respects, the violence of 1920–22 anticipated the later Troubles. The principal difference was the unbridled licence permitted to and assumed by the forces of the new state. It would have been difficult, to put it no stronger, for Catholics to accommodate themselves easily to the Protestant statelet. The circumstances of its birth made it quite impossible. Contrariwise, the province's foundation experience convinced Protestants that only the sternest, most uncompromising opposition to Catholic aspirations was appropriate. It meant that public life in Northern Ireland became a forcing house for every kind of petty-minded provincial reaction, a stagnant pool of the imagination and the intellect.

Topcaigeace peadmannad
na hÉipeann.
IRISH DELEGATION OF PLENIPOTENTIARIES

SECRET.

COPY

10, Downing Street,
Whitehall,
30th. November 1921.

M. Collins 2.0

Sir,

I enclose a draft of the Treaty which we are prepared to submit for the approval of Parliament. Provisions for protecting the interests of Southern Unionists are not included in this draft, because we understand that you have agreed with their representatives to provide safeguards for the representation of Minorities, especially in the Second Chamber and in respect of education, religious freedom and Church property, etc,, not less effective than those afforded by the Government of Ireland Act,1920, as well as to make provision for the completion of Land Purchase.

Yours faithfully,
(Signed) D.Lloyd George.

A.Griffith Esq.

———— CHAPTER 9 ————
TRUCE IN THE SOUTH

Meanwhile, the South went its own way. Sinn Féin ignored the Government of Ireland Act 1920. Instead, the Dáil continued to meet from time to time as circumstances and British Army surveillance allowed. At the very end of 1920, the leader of Sinn Féin and nominal Commander-in-Chief of the IRA, Eamon de Valera, arrived back in Ireland having spent almost 18 months in the United States.

The War of Independence showed no sign of relenting. The first half of 1921 saw a succession of incidents, mainly concentrated south of the Dublin-Galway line. In January, the IRA in Co. Clare killed six policemen, including a district inspector, in an ambush. Major-General Philip Armstrong-Holmes, the Munster Divisional Commander of the RIC, met a similar fate in Co. Cork. Eleven RIC men and Black and Tans died in an ambush in Co. Limerick in February. In March, at Crossbarry, the West Cork No. 3 Brigade of the IRA took on more than a thousand troops of the Essex and Hampshire regiments, inflicting 86 casualties – including 39 dead – for the loss of three dead and four wounded. There was a particularly nasty incident in May near Gort, in south Co. Galway (not far from Coole Park, seat of Lady Gregory). A priest had been murdered nearby by the Black and Tans. The IRA retaliated by raiding Ballyturrin House. A captain and a lieutenant in the 17th Lancers were killed, as was the local district inspector of the RIC. His wife, now widow, who was seven months pregnant, grabbed his revolver and held the attackers at bay until she herself was killed. A second RIC man later died of his wounds. The IRA suffered no casualties, but there were reprisals in Gort and shops and property were ransacked.

The most bloody and dramatic month of the war was November 1920. On the 1st, Kevin Barry – an 18-year-old medical student and IRA volunteer – was hanged in Mountjoy prison. He is remembered to this day in a famous ballad. Less well remembered is the name of

Opposite: A note from Lloyd George to Arthur Griffith introducing the draft Treaty intended for parliamentary approval.

one of the three British soldiers for whose death he paid with his own life: Henry Washington. He was 15, a member of the Duke of Wellington's Regiment. An IRA raid on members of the regiment had gone wrong; most of the Volunteers scattered but Barry, whose pistol had jammed, had dived under a lorry to try to clear it. With the others gone, he was captured. It was the first time an IRA volunteer had been caught red-handed by crown forces in the course of the entire war. Given that his gun had jammed, it is doubtful if he even fired the shot that killed Washington or the other two, who were barely older than himself. Nevertheless, he was hanged for it.

From 2 to 9 November, the village of Ballinalee, Co. Longford, was captured and held by the local IRA under the command of General Seán Mac Eoin, one of the most resourceful and aggressive of local IRA commanders. The Black and Tans burned it on recapture. Then the 21st brought 'Bloody Sunday'. Collins' hitmen, known as The Squad, killed 14 alleged British Secret Service agents in their beds at various locations around Dublin. Most were indeed Secret Service, although at least two – while in the military – were not. It hardly mattered: it was a stunning *coup de main* and an indication of how Collins' counter-intelligence system had compromised Dublin Castle's spy system, the crown's traditional weapon of choice in dealing with Irish insurgency. In reprisal, the Black and Tans killed eleven spectators and a player at a Gaelic Football match in Croke Park, the headquarters of the GAA, that afternoon. It was the single bloodiest day of the war.

Moreover, there followed the cold-blooded execution of three IRA prisoners in Dublin Castle. Then, on the 28th, exactly a week later, came Kilmichael, the ambush in Co. Cork that wiped out a patrol of 18 Auxiliaries for the loss of two IRA men. To this day, it is a matter of controversy as to whether the Auxiliaries were killed in combat or after surrendering. There is some evidence for a false surrender, but it is doubtful if the matter will ever be definitively settled. Whatever, it was celebrated and remembered as a victory, prompting yet another ballad. It also prompted the Auxiliaries and Black and Tans to rampage through Cork a few weeks later and to put the city centre to the torch.

The IRA was undoubtedly the aggressor in the war. Its men fought in mufti and employed classic guerrilla tactics. The British found themselves facing an unconventional enemy. Moreover, embedded as the IRA was in a population sympathetic to it, or at least tolerant of

it, crown forces faced the same nerve-shredding experiences in hostile territory as many other conventional armies were to face in the course of twentieth-century guerrilla wars. This may account in part for the notorious lack of discipline among the Auxiliaries and the Tans. While reviled in the Irish memory (except, oddly enough, among some IRA veterans who at least acknowledged their courage and dash) they were also despised by regular British Army officers.

In February 1922, Brigadier-General Frank Crozier resigned his command of the Auxiliaries in despair at his inability to control his men. In March, three men including the Sinn Féin Lord Mayor of Limerick were murdered by the Black and Tans. The Mayor, George Clancy, had been a university friend of James Joyce and was the model for the character of Madden in *Stephen Hero* and Davin in *A Portrait of the Artist as a Young Man*. He was the very model of the sort of young man drawn to Sinn Féin, a Gaelic Leaguer, a hurler and an enthusiast for national pursuits of every sort. Joyce counterpoints Clancy's earnest provincialism with his own developing cosmopolitanism: even allowing for this schematic purpose, his portrait of Clancy is one of the sharpest portraits we have of a middle-ranking Sinn Féin activist.

By mid-April, the British cabinet was informed that the Irish military campaign was costing the government £20 million a year. In May,

Meeting of the First Dáil, 21 January 1919. Front row (left to right): Laurence Ginnell, Michael Collins, Cathal Brugha, Arthur Griffith, Eamon de Valera, Count Plunkett, Eoin MacNéill, W.T. Cosgrave, Ernest Blythe. Terence MacSwiney is second left in the second row. Kevin O'Higgins is in the third row, far right.

de Valera met Craig at a secret location in Dublin. No progress was made. Craig claimed that de Valera regaled him with a lecture on Irish history that took half an hour just to get to Brian Boru. The fact was that Sinn Féin had as little clue about the Ulster Protestants as the IPP or any preceding nationalist group had. It was a dialogue of the deaf. For nationalists, the brute reality of Protestant numbers in Ulster could be met only with rhetoric, violence and insult. No nationalist policy could reach them. Therefore the policies that were proposed, whether in 1912, 1921 or later, smacked of fantasy and heart's desire.

In May, the Dublin IRA burned the Custom House. It was the headquarters of the Local Government Board. Its offices were duly torched, but the IRA were caught by a detachment of Auxiliaries and lost over 100 men captured following a shoot-out. It was a disaster for the IRA, paralysing what had already turned out to be a less than vigorous campaign in the capital. Moreover, they destroyed the finest classical building in the city. The incident contributed to a widening gap between Collins and de Valera, the former with a soldier's dislike of spectacular gestures for their own sake, the latter with the politician's understanding of their symbolic value.

It was the last major incident in the war. Both sides had fought each other, if not to a standstill, at least to a stalemate. And that alone was a triumph for the republicans. A Truce was agreed after a series of back channel communications with Lloyd George. It came into effect on 11 July.

A week later, de Valera was in London for talks with Lloyd George. The Prime Minister offered Dominion Home Rule to the South. De Valera rejected it, insisting on the recognition of the Irish Republic. The Dáil supported his position unanimously. By the end of September, a conference had been arranged for London "with a view to ascertaining how the association of nations known as the British Empire may best be reconciled with Irish national aspirations". This formula, with its emphasis on the imperial context, contained the seeds of a republican concession.

De Valera did not go to London this time. Instead, he sent a delegation of five headed by Arthur Griffith. The others were Michael Collins, Robert Barton, Edmund Duggan and George Gavan Duffy. Their written instructions contained a basic semantic and logical contradiction. They were granted full plenipotentiary power, subject to a requirement that they convey any prospective agreement back to

Dublin for cabinet approval. Why the Sinn Féin leader and President of the Irish Republic did not attend the Treaty discussions has vexed the minds of historians ever since. His was the most subtle and serpentine, if exasperating, intellect on the Irish side, and he was certainly the most skilled negotiator. The explanation usually advanced is that he knew a compromise was inevitable, that this meant something less than the full republic, and that he was the person best positioned in Dublin to sell such a deal to his own radicals.

De Valera's preferred formula was external association. This meant that Ireland would be associated with the Empire but would not be a member of it. That would mean no oath of allegiance to the King. De Valera proposed this formula as a concession to Ulster Unionist concerns "to meet whose sentiments alone this step could be contemplated". It is doubtful if even de Valera's naiveté concerning the Unionists extended to the idea that this would satisfy them. But he certainly advanced it as a basis for a settlement that might fall short of the simon-pure republic but would still commend itself to most republican radicals.

The problem with external association was that Lloyd George had rejected it out of hand in July. It was difficult to see how he might accept it in October, especially with his parliamentary majority depending on the Conservative Party. In addition to external

Pro-Treaty and anti-Treaty officers of the IRA meet in the period between the ratification of the Treaty by the Dáil and the outbreak of the civil war. The meeting was one of a number intended to avert such a tragedy, in which of course, they were all unsuccessful. Left to right: *Sean Mac Eoin, Sean Moylan, Eoin O'Duffy, Liam Lynch, Gearoid O'Sullivan and Liam Mellows.*

association, the Irish delegation was instructed to ensure that any breakdown in the talks should come on the question of partition. The British, on the other hand, wanted any break to come on an Irish refusal to accept ultimate British sovereignty.

The early negotiations turned on these points. Griffith began by proposing a possible Ulster parliament subordinate to a sovereign parliament in Dublin, not London. Lloyd George countered by emphasising the risks he was running with his precarious Tory backwoods support in the Commons and Bonar Law in the wings to take over as Prime Minister were he to fail. He therefore needed an answer to certain fundamentals: would Ireland accept membership of the Empire and allegiance to the King? Would it provide defence facilities?

Lloyd George was a masterly negotiator, with more than a touch of the hysterical about his self-projection. Moreover, he was supported by some the greatest heavyweights of the age: Churchill, Birkenhead and Austen Chamberlain among them. Facing him were Griffith, who did not impress him, and Collins, who impressed everybody but was still barely 30 years of age. By setting these fundamental questions, Lloyd George was able to focus the negotiation on constitutional matters rather than on partition. Once settled on that ground, the Irish found it difficult to get off it.

Lloyd George formed the view that the Irish would ultimately accept the crown in return for reunification. He may well have been right: Griffith's prescription for the original Sinn Féin had been dual monarchy, born as much as anything from a belief that no settlement that excluded the crown would be acceptable in Ulster. Indeed he told Lloyd George that "if we came to an agreement on all other points I could recommend some form of association with the Crown" which, although well short of what Lloyd George needed, was enough to alarm de Valera back in Dublin. By now, the main burden of negotiation on the Irish side was being carried by Griffith and Collins in a series of bilateral meetings with two British delegates. The idea was floated of Ulster autonomy in an independent Ireland, but an Ulster reduced in size to exclude peripheral areas of the new Northern Ireland with Catholic majorities. Griffith thought this idea had promise.

Craig did not. Arriving in London from Belfast in early November, he was horrified to discover that Northern Ireland was being used as a bargaining chip in Downing Street. He dug his toes in and refused flatly to support any change whatsoever in the arrangements so re-

cently made for Northern Ireland. (Bear in mind that it was established less than six months at this stage.) Lloyd George pleaded with Craig, threatened to resign and generally displayed the full range of his rhetorical display. Craig was unmoved and unmoveable. The Prime Minister now turned back to Griffith.

He proposed a Boundary Commission to review the Northern Ireland settlement, the clear implication being that any such commission would be bound to transfer large areas of Catholic population on the margins of Northern Ireland to the South. The consequence of this, it was suggested, would be to leave the Northern Ireland rump statelet completely unviable and oblige it in time to subside into a union with the South. Griffith and Collins believed what they wanted to believe – as with so much nationalist fantasy before and since about the North. Griffith's guarded reply was that while the proposal came from the British, not the Irish side, who would therefore not be bound by it, "we realise its value as a tactical manoeuvre and if Lloyd George made it we would not queer his position". Having secured this tacit concession, Lloyd George now persuaded Griffith to initial a hastily drafted document. It stated that if Ulster declined to join an all-Ireland parliament it would be necessary to revise the province's boundary by the means of a Boundary Commission.

The negotiations continued, reaching a melodramatic climax on 5 December. The Irish delegation was exhausted, not least from various to-ings and fro-ings back to Dublin to consult the cabinet. De Valera was concerned that they might get neither the republic nor unity and radicals like Cathal Brugha gave a foretaste of the bitterness that the civil war would bring within the year. On the delegation's return to London, Lloyd George's sense of theatre and timing enabled him to inject real urgency into the negotiations. He threatened a break on the question of the oath of allegiance to the crown. He threatened war. In despair, Griffith conceded that if Ulster would come in he would accept the crown. At this point, Lloyd George, like a conjurer, produced Griffith's initialled note from weeks before accepting the principle of a Boundary Commission instead of a firm requirement to coerce Ulster. He accused Griffith of reneging on his word, a charge that Griffith – prickly at the best of times – could not endure.

It was the decisive psychological moment. Lloyd George applied more time pressure demanding that the articles of agreement be signed by 10 pm that night, failing which he threatened "immediate

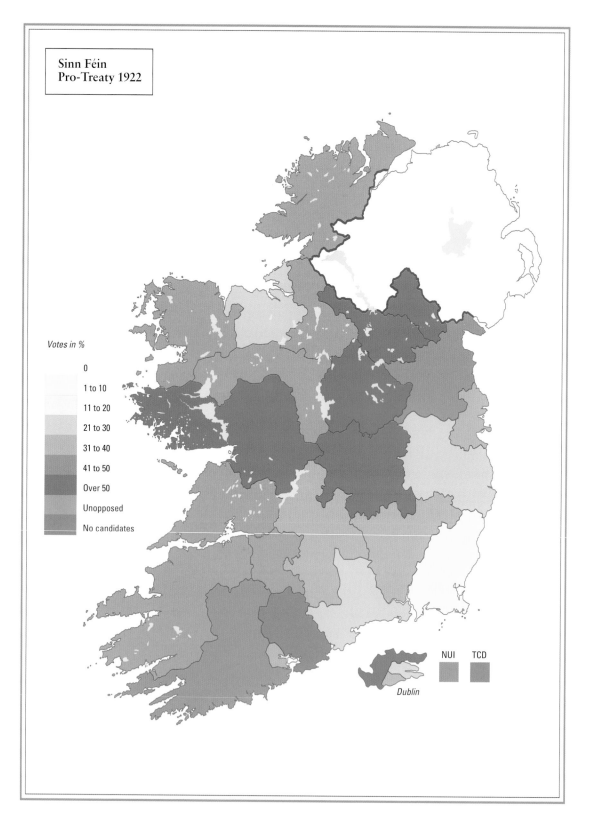

Sinn Féin
Pro-Treaty 1922

Votes in %

0
1 to 10
11 to 20
21 to 30
31 to 40
41 to 50
Over 50
Unopposed
No candidates

NUI TCD

Dublin

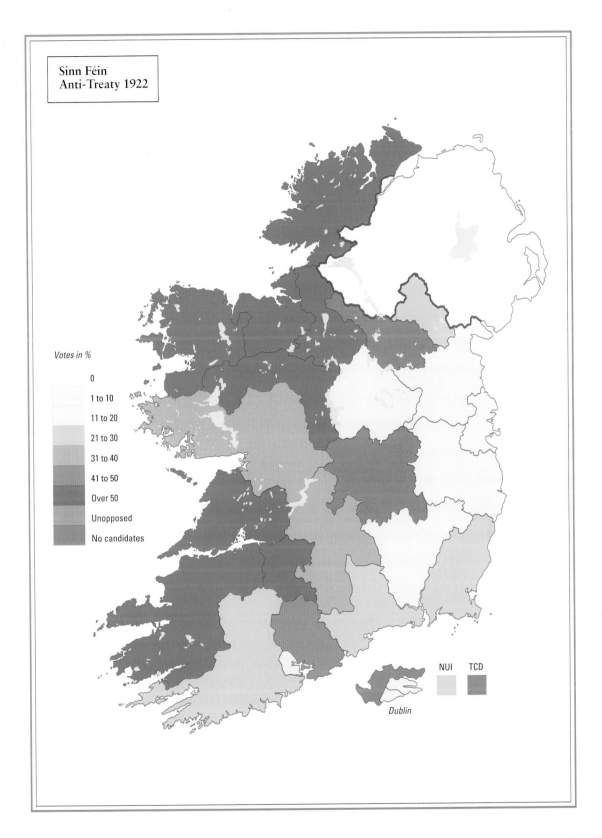

Sinn Féin
Anti-Treaty 1922

Votes in %

0
1 to 10
11 to 20
21 to 30
31 to 40
41 to 50
Over 50
Unopposed
No candidates

NUI TCD

Dublin

and terrible war". It was a masterly performance by the Prime Minister, forcing a conclusion to a negotiation that had threatened to collapse. Instead, it was the Irish delegation that collapsed. They signed.

In fact, they had got a very good deal. The Anglo-Irish Treaty of 1921 effectively conceded full independence in Southern Ireland. Its provisions went way beyond what was on offer in the Home Rule Act of 1914 or the Government of Ireland Act. The Irish Free State, as it was to be known, was to be fiscally and politically independent to a degree undreamed of by the home rulers ten years earlier. Ireland would have absolute autonomy in her internal affairs, albeit formal sovereignty still resided in the crown. The British Army would withdraw, leaving only three Royal Navy bases, and an Irish National Army would be formed.

The problem lay not in the substance of the deal, but in its wrapping. In order to appease the Tory backbenchers, Lloyd George had to sell it as having an imperial context: thus the oath of allegiance and the presence of a Governor-General representing the King. But the very things that mollified the Tories outraged the republicans in Ireland. The whole focus of opposition to the Treaty lay in the oath of allegiance.

Partition was not a big issue for the anti-Treaty people. The issue was parked for the moment and they assumed like everyone else that the Boundary Commission would produce such transfers of land and population from Northern Ireland to the Free State as to leave the North an unviable rump.

At any rate, the Treaty split Sinn Féin. In the republican cabinet, it passed only by four votes to three: Griffith, Collins, Barton and W.T. Cosgrave were in favour; de Valera, Cathal Brugha and Austin Stack were opposed. The Dáil debates on the Treaty went on for almost a month, either side of Christmas, until eventually it was approved on 7 January 1922 by the ominously narrow margin of 64 to 57.

Why did nationalists, some of whom could have accommodated themselves to a form of home rule barely ten years earlier, now oppose the Anglo-Irish Treaty with such passion? Everything that had happened in that time had raised the stakes. The Great War had radicalised a generation, especially those who chose not to answer Redmond's call to arms in France. The Easter Rising was the central event of that radicalising process. Regardless of its conspiratorial and undemocratic provenance, it now stood as the foundation moment of

a new nationalism, explicitly republican in ambition. There were martyrs who must not be betrayed, whose sacrifice must not be dishonoured. And whatever the Treaty had delivered, it was not a republic.

That said, it furnished the substance of republican independence. The ease with which de Valera was later to move the new state from dominion to republican status is evidence of that. Why had the British baulked at conceding the symbolism of a republic? It was an idea too advanced, not just for the Tory backbenchers – for whom most ideas are too advanced – but also for the other dominions within the existing British Empire. There was no analogue in the contemporary British imagination for such a possibility. Just as the British were now prepared to concede vastly more than in 1912, it would take more time before they could comfortably accommodate the idea of a fully republican state in what had so recently been part of the British metropole.

As to the anti-Treaty republicans, their concentration on the symbolic value of the oath derived from two sources, the Church and the Fenians. Ireland was an intensely Catholic society, in which the cultural variety of Catholicism practised was itself authoritarian, rigorous and legalistic. Even school children were introduced to Catholic apologetics, a series of questions and (more important) answers on religious and moral matters which were orthodox in substance and legalistic in form. In such a culture, the dishonouring of a solemn oath was a serious matter. For many on the anti-Treaty side, that meant that they had to stand by their oath of allegiance to the Republic at all costs. And that was simply not compatible with the Treaty. As for the Fenians, the importance of oath-taking and oath-honouring in what had been a secret society for so long should not be discounted.

With all that, most of the IRB supported the Treaty, influenced no doubt by Michael Collins, the head of the organisation. Likewise, most of the officers in the IRA – those in the best position to know how precarious their military position had been immediately before the Truce – were pro-Treaty. But it was clear that there was a significant minority of officers and men who were opposed.

All sides had been radicalised by the Great War and by the primacy and finality of the gun. The mundane temporising of politics seemed shabby in comparison. The military had bullied the politicians in London throughout the war. The English judiciary had

Liam Mellows, speaking at the grave of Theobald Wolfe Tone, the leader of the 1798 rising, at Bodenstown churchyard, Co. Kildare.

repeatedly delivered judgments that gave primacy to security over liberty. In nationalist Ireland, too many had died in what, by the time of the Treaty, was universally regarded as a noble cause. The near deification of Pearse; the horrible death by force-feeding of the hunger-striking Thomas Ashe in 1917; the murder of the Lord Mayor of Cork, Tomás MacCurtain, by the RIC; the death by hunger strike of his successor Terence MacSwiney after 74 days: all these and other deaths prompted irresistible appeals to the martyred dead. And such appeals commanded no retreat from the ideals for which they died.

The republican pantheon of death was mirrored by the British sense of loss for the vast casualties of the Great War. In both cases, the memory of heroic sacrifice made compromise more difficult, or at least inclined a minority on both sides towards irreconcilable positions. Griffith and Collins had the republican refusniks; Lloyd George the Tory backbenchers. In all these circumstances, the Treaty was a remarkable achievement. Ironically, the 18 months of warfare that had preceded it had created conditions that made an agreement

more rather than less likely. It was not so much that war-weariness set in, although Collins (who was in a position to know) reckoned that militarily, the British had the IRA almost beaten by the middle of 1921. It was rather that both sides felt that they had made their case in arms and that honour had been served – if such a term is appropriate to what was often a squalid little war.

It could even be argued that the sacrifices of the War of Independence created a necessary condition for the peace. The Irish were able to believe that they had shot the British out of most of the country. They had not: the British could have sustained a much more ferocious military campaign indefinitely, as Lloyd George threatened to do towards the end of the negotiations. He meant it, and Collins had no reason to doubt him. On the other hand, the British knew that the legitimacy of their rule in nationalist Ireland was shattered beyond repair. Anderson and Cope and the others in the Dublin administration knew full well that their writ ran feebly in many parts of Ireland and not at all in others. The parallel Sinn Féin administration, established and sustained in what should have been impossible circumstances, was proof of that.

As in every quarrel, there is a moment that seems right for a deal. What was achieved in December 1921 would have been impossible twelve months earlier, let alone in 1912 or 1916.

But there was always the shadow of the martyred dead. Whatever impelled the parties towards the Treaty settlement, its inevitable compromises could be and were represented as a betrayal of the great national sacrifice. The Treaty debates in the Dáil turned on the question of the Republic, to which oaths had been sworn by the honoured dead and the living alike. The Republic had not been delivered. Instead, there was to be retained another oath, a hateful oath of allegiance to the crown (still, in constitutional theory if not in political substance, to be the ultimate repository of sovereignty). It was too much for a large minority in Sinn Féin.

There is little doubt, however, that the Treaty had public support. A general election in June 1922, just before the outbreak of the civil war, produced a vote of 239,193 votes for pro-Treaty Sinn Féin candidates as against 133,864 for those opposed. The election was based on a pact between Collins and de Valera in which the two wings of Sinn Féin nominated candidates in proportion to their existing strength in the Dáil. The move was widely condemned by people on

both sides and by the British. Despite this dubious expedient, the result in favour of the Treaty was sufficient to indicate where public opinion lay. Interestingly, the aggregate number of votes cast for non-Sinn Féin parties – Labour, Farmers, independents and others – exceeded the pro-Treaty tally: 247,276. There is no way of knowing exactly how these votes related to the Treaty issue, although it may be confidently asserted that the Farmers Party vote – 48,748 – was overwhelmingly pro-Treaty.

This result once again highlighted the gap between sociology and aspiration. The catch-all nature of the post-1917 Sinn Féin – an echo of the IPP that it had displaced – meant that it was a broad church. It contained passionate republicans but others as well. Arthur Griffith, to offer the most obvious example, had never been a republican by conviction. He was not alone, either in the party or the country. The IPP's support may have transferred to Sinn Féin but at the price of diluting its simon-pure republicanism. The Republic was a powerful symbol and rallying-cry, but the Treaty was a deal – and it was clear that the country wanted a deal.

The Collins-de Valera electoral pact was just one of a series of efforts in the first half of 1922 aimed at avoiding open conflict between the factions. Under the terms of the Treaty, the Irish Free State was to come into formal existence one year after signature, on 6 December 1922. In the meantime, a Provisional Government was put in place with Michael Collins as Chairman and Minister for Finance. Its membership overlapped with the Dáil government, not recognised formally by the British, headed by Arthur Griffith as President. He had assumed this office following the Treaty vote in the Dáil, which had precipitated de Valera's resignation.

By the end of March, Rory O'Connor, speaking on behalf of the 'Irregulars' (the anti-Treaty IRA), repudiated the authority of the Dáil as having betrayed republican legitimacy. The next day, anti-Treatyites wrecked the printing presses of the *Freeman's Journal*, a nationalist paper that supported the Treaty. By early April, the Irregulars had appointed Liam Lynch as their Chief of Staff and Rory O'Connor led a platoon which seized control of the Four Courts and Kilmainham jail in Dublin in a gesture so redolent of 1916 that it was unmistakeable.

All was not yet lost, although clearly the situation was deteriorating. Collins and de Valera remained in contact in the hope that

Michael Collins takes time out from the negotiations of the Treaty in London.

politics could find a way of stabilising the situation before the military men took over. It was in vain. De Valera was increasingly side-lined by the Irregular militants. He disappears as a significant figure until after the civil war.

In the meantime, the pro-Treaty IRA was in the process of forming itself into the National Army under the command of the ubiquitous Collins. In late June 1922, Irregulars based in the Four Courts captured the deputy Chief of Staff of the National Army, Lt-General J.J. 'Ginger' O'Connell. This was the proximate *casus belli*.

Even then, Collins was reluctant to move. It was the British, horrified that the new constitutional arrangements they had agreed might result in serial chaos and instability, who forced his hand. On 28 June 1922, the National Army of the Irish Free State launched artillery fire at the Four Courts garrison. The civil war was on.

IRISH FREE STATE

Irish Free State Army
Regular *Reserve*

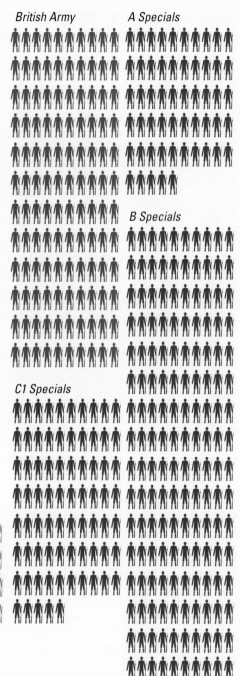

NORTHERN IRELAND

British Army *A Specials*

B Specials

C1 Specials

IRA

Ireland in Arms 1922

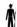 Each symbol represents 100 men

CHAPTER 10
CIVIL WAR IN THE SOUTH

The civil war lasted from 28 June 1922, with the opening artillery assault on republican positions in the Four Courts, until 24 May 1923 when a statement from de Valera was coupled with an order from Frank Aiken, Chief of Staff of the Irregulars, to dump arms.

The issue was the Treaty and its failure to secure a republic. That was what divided Sinn Féin: the general population, in contrast, was more accepting of what had been achieved. Partition was not a major civil war issue. It was now a fait accompli and to that extent no longer a matter of current dispute; besides, there was a general assumption that the Boundary Commission to be established under the terms of the Treaty would emasculate the new statelet.

The delay between the Dáil's acceptance of the Treaty on 7 January and the first hostilities reflected a genuine desire on all sides to avoid a military conflict. But it was of greater value to the pro-Treaty side than to the Irregulars. It gave time to create the bones of a national army. By the start of the war, the Free State had about 8,000 men under arms, a number that quickly doubled. In addition, a reserve of more than 30,000 men was formed. Michael Collins was appointed Commander-in-Chief, answering in theory to Richard Mulcahy, the Minister of Defence. The

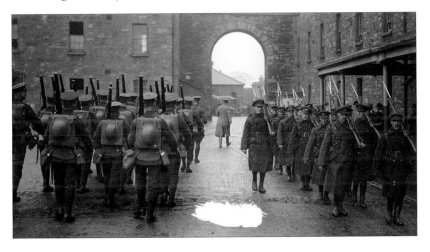

Changing the guard – at a barracks in Dublin the British Army marches out as the Free State Army marches in. After the hard-won Treaty, the British left sufficient military supplies to equip the Free State Army.

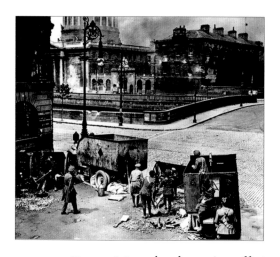

Troops of the Provisional Government, established under the Anglo-Irish Treaty, deploy artillery against the republican garrison in the Four Courts on the far side of the River Liffey.

Chief of Staff was Eoin O'Duffy, later to be head of the Garda Síochána (the police) and later again, in the 1930s, to be leader of the Blueshirts – a pitiful quasi-fascist movement that lasted long enough to achieve next to nothing in Ireland and nothing but ridicule in Spain where some of them repaired in support of Franco.

Numbers were one thing, arms were another. The Free State Army sourced much of its matériel from the British, who had no desire to see the Treaty, so painfully and so recently achieved, overthrown. They supplied military hardware in sufficient quantity to ensure that Free State troops were properly armed and that supplies of ammunition were sufficient. They may also have supplied men, for among the armaments were eight 18-pound artillery pieces: there is no evidence that anyone on either side of the civil war had any competence in handling artillery. So, who fired the 18-pounders at the Four Courts? There is a strong likelihood that the opening salvoes in the Irish civil war were in fact fired by British troops seconded to aid the forces of the new state.

The Irregulars numbered something in excess of 10,000 men according to government estimates. (Henceforth, all unqualified references to government are to that of the Free State.) Although nominally organised in a series of divisions that embraced the whole island – including two divisions in Northern Ireland – they relied very much on local initiative, rather like the pre-Truce IRA. Their two leading figures were Liam Lynch and Liam Mellows. Lynch had been appointed Chief of Staff of republican forces at an army convention in March which had in effect been an assembly of IRA dissidents. They argued that the betrayal by the Dáil in accepting the Treaty absolved the army from its allegiance to that body. Further, the new Free State Army then forming was a body that answered not to any republican institution but to one that was anchored in the Treaty itself – and therefore illegitimate in republican eyes.

Mellows was appointed Quartermaster-General. He had been on the socialist left of the republican movement and had been close to James Connolly. Influential as an organiser, propagandist and journalist, he played little active part in the civil war. He joined the Four Courts garrison and was captured when it fell. He was shot in De-

cember as a reprisal for the murder of a pro-Treaty TD, one of 77 republicans executed in cold blood in the course of the civil war.

The single biggest weakness among the Irregulars was faction. Another army convention on 18 June, just ten days before the beginning of hostilities, revealed clear divisions between officers of the 1st Southern Division, covering the vital mid and south Munster area, and the Four Courts garrison. That meant a split between Lynch and Mellows. There were two basic issues. First, Liam Lynch persisted in the doomed hope that the IRA could somehow be reunited, despite the fact that the Free State constitution had just been published and agreed with the British, and the Pact election had just produced a thumping pro-Treaty majority. Once the constitution was agreed, the logic of the March army convention – that the Free State Army was an enemy of the Republic – was irrefutable. It is hard to know what Lynch was hoping to achieve.

Rory O'Connor, the effective leader – along with Mellows – of the Four Courts garrison, had no time for Lynch's motion. An enragé, O'Connor had told a press conference in March, at the time of the original convention, that if it took a military dictatorship to overthrow the Free State and defend the Republic, so be it. Now, however, he faced not only Lynch's impracticality but also a mad motion from Tom Barry, to the effect that if the British troops still in Dublin – the last of them were not due to depart until the formal establishment of the Free State in December – did not now leave within 72 hours they would be attacked.

Tom Barry was no ordinary ranter. From west Cork, he had fought in the British Army in the Great War, not on the Western Front but under Allenby in Palestine. More to the point, he was one of those demobbed troops who joined the Irish Volunteers on his return and was in command of the flying columns of the Cork No. 3 Brigade of the IRA responsible for the ambush victories at Crossbarry and Kilmichael in 1920. Tom Barry was an IRA hero. His idea might have been mad but he commanded the respect that he had earned.

Between the two motions, Lynch's and Barry's, any semblance of unity on the Irregular side was lost before the war began. The convention pretty well split down the middle. The Four Courts delegates under O'Connor and Mellows decamped to their garrison, Lynch and his supporters first to the Clarence Hotel on the other bank of the Liffey and thereafter to their Munster heartland. Even before a shot was fired, the Irregulars had not only abandoned unity; some of them had abandoned reality.

The consequent absence of a unified national command on the Irregular side proved fatal. It would have been difficult enough to sustain anyway, given that the government commanded the national communications network and had an army in formation that was acquiring arms and ammunition by the day. None the less, the sort of local initiative and brio demonstrated by the better IRA commanders in the War of Independence might have been replicated, at least in part, had there been an overall unity of purpose. But there was not.

On 22 June, two Irish men, Reginald Dunne and Joseph O'Sullivan, confronted a third outside his house in Eaton Square, London. Field-Marshal Sir Henry Wilson had been born in Edgeworthstown, Co. Longford, in 1864, into that ferocious caste of Anglo-Irish military families that had supplied so many senior officers to the British Army. Wilson was rather obviously a different kind of Irishman to Dunne and O'Sullivan. Wilson was a marchland pro-consul, a British Junker. He had risen to be Chief of the Imperial General Staff by the end of the Great War; he was an implacable enemy of Irish nationalism and at this time military advisor to the new government of Northern Ireland.

Dunne and O'Sullivan were two of the IRA's key men in the British capital. Both were London-born of Irish parents and both had served in the Great War. O'Sullivan had lost a leg at Ypres in 1917. They shot Wilson dead on the spot. They also fired at policemen in their attempt to escape, which was unsuccessful, O'Sullivan's wooden leg a pretty obvious impediment to flight. Both were hanged in August for the murder.

The assassination of so senior a figure in the centre of London raised the stakes for all sides. The British government resolved to retaliate by mobilising its troops still in Dublin against the Four Courts garrison – in effect, by-passing the Provisional Government of the Free State and possibly re-igniting the War of Independence. It also issued an ultimatum to Collins to rout out the Four Courts garrison forthwith. Within days, it reversed its decision to act unilaterally but the pressure on Collins was the proximate cause of the attack on the Four Courts.

To complicate matters, there is suggestive evidence that Collins was behind the Wilson assassination. He was particularly close to Dunne, whom he had met in Dublin for a long meeting some time previously. He detested Wilson and particularly his role in Northern Ireland, then in the throes of the most violent inter-communal conflict. The assassination may have been an attempt to take some heat off the beleaguered Northern nationalists, or at least to avenge them. The truth of the

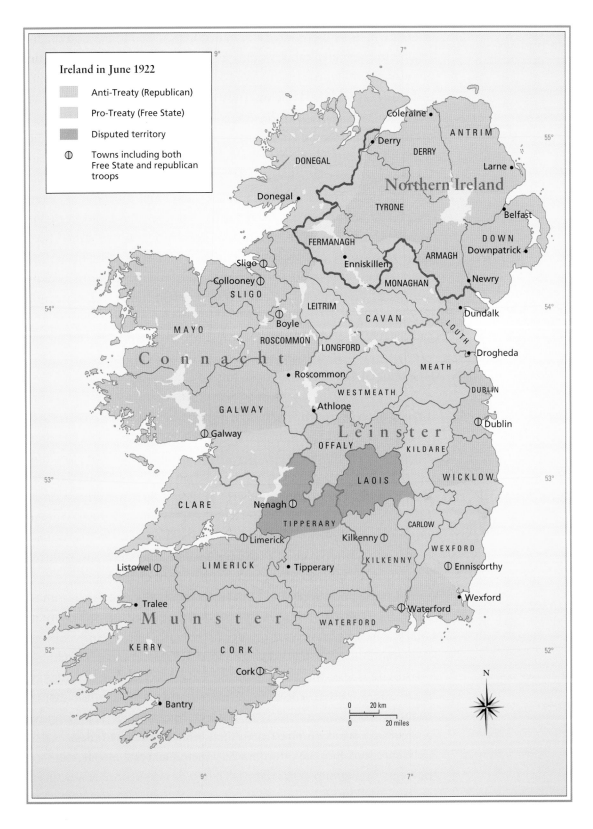

Ireland in June 1922

- Anti-Treaty (Republican)
- Pro-Treaty (Free State)
- Disputed territory
- ① Towns including both Free State and republican troops

Coleraine

Derry

ANTRIM

DERRY

Larne

DONEGAL

Northern Ireland

Donegal

TYRONE

Belfast

FERMANAGH

DOWN

Downpatrick

Sligo ①

Enniskillen

ARMAGH

Collooney ①

Newry

SLIGO

MONAGHAN

LEITRIM

CAVAN

Dundalk

Boyle ①

MAYO

ROSCOMMON

LOUTH

Connacht

LONGFORD

Drogheda

Roscommon

MEATH

WESTMEATH

DUBLIN

GALWAY

Athlone

Leinster

Galway ①

OFFALY

KILDARE

① Dublin

LAOIS

WICKLOW

CLARE

Nenagh ①

TIPPERARY

CARLOW

Limerick ①

Kilkenny ①

WEXFORD

Listowel ①

LIMERICK

Tipperary

KILKENNY

① Enniscorthy

Tralee

Wexford

Munster

WATERFORD

① Waterford

KERRY

CORK

Cork ①

Bantry

0 20 km

0 20 miles

N

matter will never be known for certain, but the British were not the only ones with their suspicions. Collins was an IRB man, a ruthless conspirator who maintained an ultra-loyal personal network of agents on both sides of the Irish Sea. If he was involved in the Wilson assassination, it was wearing his IRB hat rather than his Provisional Government one.

The assault on the Four Courts did not take long to succeed. The British/Free State artillery made short work of the republican garrison of about 200 men, which surrendered in less than four days. The building was badly damaged by the artillery shells but the real tragedy came as a result of reckless arson on the part of the defenders. On the instructions of Ernie O'Malley – whose memoir *On Another Man's Wound* was to be one of the finest literary works to emerge from these tragic events – fires were set within the great building prior to its evacuation. It is difficult to understand what possible purpose this action served, other than futile and spiteful protest. Members of the garrison recall a total absence of strategy or tactics on the part of the defenders.

The Four Courts building was not just the centre of the Irish legal system. It also housed the Public Record Office, established since 1867 as a repository for administrative and legal documents. Its holdings went back to documents from the twelfth century, the raw material of the Irish past. But the PRO was also used by the republican garrison as its principal munitions store and a large cache of gelignite had been placed deliberately in that part of the building. When the fires reached the PRO the gelignite exploded with a report heard all over the city, sending a huge plume of black smoke high into the sky. Priceless historical documents were lost forever. Men who asserted the purity of their patriotism had destroyed the means of understanding their country's past. And for nothing: they were already beaten. It was an act of pure nihilism.

The action now moved to O'Connell Street. In a macabre re-run of 1916, the Irregulars occupied public buildings and invited counter-attack. There was no grand strategy for actually winning the civil war: it was more an inchoate protest, a howl of defiance. A series of buildings on the east side of the street, at the upper end nearest the Parnell monument, were invested. Ironically, this was the section of the street least affected by the destruction of 1916. But its turn came now. The inevitable counter-attack by Free State troops forced the evacuation of the occupied buildings. By 5 July, the position was hopeless and one by one, the various republican groups surrendered. The last group to concede were those under Cathal Brugha's command. Once he had seen them all safely out

under a flag of surrender, this heroic, doomed figure – Charles St John Burgess that had been – who had fought with such reckless bravery at the South Dublin Union in 1916, charged out, all guns blazing, and was cut down in a hail of bullets. He died two days later.

That effectively ended the civil war in the capital. The fighting now moved south to the so-called 'Munster Republic', in reality a series of scattered and unco-ordinated commands. But the momentum was all with the Free State Army and was all one way. Limerick was strategically vital, commanding as it did the Shannon estuary. It fell to the Free State on 20 July, the same day as Waterford on the far side of the province. Meanwhile, a seaborne convoy sailed down the east coast from Dublin with troops bound for Cork, the provincial capital. In disembarking them, the Free State effectively took the Munster Republic in the rear. It was a devastating response to the Irregular tactic of destroying land communications, with the railway system a particular target. Cork fell on 20 August.

By then, Arthur Griffith was dead. On 12 August, he suffered a cerebral haemorrhage believed to have been caused by stress and overwork. He had succeeded de Valera as President of Sinn Féin after the Treaty vote and would have been the first head of an independent Irish government had he lived until December. He was only 51. Always an advanced nationalist but never a republican, he contained many of the contradictions and ambiguities inherent in the whole saga known as the Irish Revolution.

Even worse was to follow. On 22 August, just two days after the capture of Cork, Michael Collins, the Commander-in-Chief of the Free State Army and the most charismatic figure in the entire story, fell to a sniper's bullet in west Cork. The city may have been captured but the county still held desperate pockets of resistance. To demonstrate how intimate a war this was, Collins had earlier been welcomed to the town of Bandon, gateway to the west of the county, by the Free State brother of one of the republican ambush party waiting at Béal na mBláth. He was 31. At his funeral in Dublin, his coffin rested on a gun carriage that had been deployed in the initial attack on the Four Courts.

The new President of Sinn Féin was the colourless W. T. Cosgrave – although anyone might have appeared colourless in succession to Collins. He showed no lessening of resolve. The civil war now descended into an ugly pattern of atrocity and reprisal. There were assassinations of Free State figures, including one TD – Sean Hales, the very man who had

Michael Collins attending the funeral of Arthur Griffith, the first President of the Free State. A few days later he fell to a sniper's bullet in west Cork.

welcomed Collins at Bandon while his brother Tom lay in wait with the ambush party nearby at Béal na mBláth – and house burnings. There was wholesale destruction of property and communications infrastructure. The authorities responded with cold-blooded reprisals on a scale that the British would not have dared to attempt: 77 republicans were killed in cold blood. Most were shot, but there were some especially macabre incidents. At Ballyseede, near Tralee, Co. Kerry, nine men were tied to a mine which was then detonated. Eight died. It was a miracle that one man, Stephen Fuller, survived. It was not the only such incident but it was the worst.

The government pleaded terrible necessity, as governments always do in these circumstances. But in a strange way, these atrocities – they were horrible crimes by any reckoning – underlined the fundamental legitimacy of the emerging state. While the executions and murders left a long trail of bitterness that poisoned and divided Irish political life for two generations (and still forms the basic division between the two largest political parties in the Republic), there was no widespread revolt against the Free State authorities. They were able to get away with things that would have paralysed the country had the British tried half as much. In the eyes of nationalist Ireland, or at least in those of a majority, the new regime was legitimate. That legitimacy was further underlined by the formation of a new unarmed police force, even as the

The Gresham Hotel, an IRA stronghold, ablaze in O'Connell Street after being attacked by Free State troops.

civil war continued, although diminishing in ferocity and purpose.

It dragged on into the early part of 1923, a lost cause. By April, even remote upland parts of the vestigial 'Munster Republic' were being invested by Free State troops. It was in one such redoubt, in the Knockmealdown mountains in south-east Tipperary – below Clonmel and practically in Co. Waterford – that Liam Lynch died. He was shot by a Free State patrol as he and a few colleagues were trying to flee. They were tired, demoralised and poorly armed.

Lynch's death opened the way for the final republican concession. One of the others who had been in his party in the mountains on the day he died was Frank Aiken from Co. Armagh, Commandant of the 4th Northern Division of the Irregulars. On 20 April, he was elected Chief of Staff in succession to Lynch. It was a strange choice in view of the paltry contribution that the northern divisions made to the fight – they had their own troubles closer to home – but it was also a 'peace vote'. Aiken was known to have severe reservations about the entire civil war enterprise.

A joint meeting of political and military leaders from what was left of the republican cause met on 13–14 May and agreed to end the conflict. Accordingly, Aiken issued an order to cease fire and dump arms on 24 May. This was the moment when the civil war officially ended, accompanied by a statement from Eamon de Valera, who re-enters the scene at this point: "Soldiers of the Republic, Legion of the Rearguard. The Republic can no longer be successfully defended by your arms. Further sacrifice of life would now be vain and continuance of the struggle in arms unwise in the national interest and prejudicial to the future of our cause. Military victory must be allowed to rest for the moment with those who have destroyed the Republic."

The order to cease fire and dump arms meant that there was no formal surrender and no negotiated peace settlement. No reliable or agreed figures are available for casualties or financial cost, although deaths in low four figures and costs of about £50 million – between material destruction and the cost of prosecuting the war – are broadly accepted as reasonable estimates.

The re-emergence of de Valera in May – he had hardly been heard of since the loss of the Treaty vote in the Dáil in January – was significant. The 'politicals' on the republican side were coming out from the shadows of the militarists, who had prosecuted their cause to destruction. Nationalist Ireland was a political nation; its default setting was political, not military, as the next few years were to prove. It did

politics almost by instinct. By 1926, almost every senior survivor from the revolutionary period was in mainstream Dáil politics. In that sense, the military impulse that animated 1916 and dominated the years from January 1919 to May 1923 was the exception, not the rule.

Once the civil war was over, nationalist Ireland reverted to type.

The North, however, was as ever another matter. The birth of Northern Ireland was accompanied by an orgy of violence in the years 1920–22. The War of Independence spread North and became entangled with the trauma of partition. The IRA attacked police and army as in the South. Protestant mobs, many of them returning ex-servicemen, drove Catholic workers from the Belfast shipyards; many were themselves former shipyard workers who had gone to war and, in addition to traditional sectarian animosity, resented nationalists who had not but who had taken 'their' jobs instead. The IRA retaliated by burning businesses and big houses in rural Ulster to try to take the pressure off their beleaguered co-religionists in Belfast. The UVF was re-formed as the Ulster Special Constabulary – the notorious B Specials – a viciously partisan Protestant militia.

Sixty-one people died in Belfast alone in the single month of March 1922. In essence, the civil war that had been postponed by the outbreak of the Great War had now broken out in the Ulster cockpit. Inevitably, given the local superiority of Protestant numbers and the fact that they now controlled the levers of the state, the Protestants were able to bring a greater terror to bear than the Catholics. There were atrocities committed on both sides: it was not all one-way traffic. But the Protestant traffic was more lethal. Moreover, it polluted its own community, as well as terrorising the Catholic one, by permitting the agents of the newly partitioned statelet literally to get away with murder.

In these circumstances, it was hardly surprising that the Northern divisions of the IRA made such a paltry contribution to the civil war in the South. They had their own civil war in their own backyard. This was an uncovenanted blessing for the new devolved government in Belfast. Craig's administration had felt some pressure from the so-called Belfast Boycott, a Collins-inspired initiative during the War of Independence in which goods produced in Belfast were boycotted in the South. It was an understandable response to the situation in which Northern nationalists found themselves and it had the active support of many from that community, including Bishop (later Cardinal) Joseph MacRory. But it was a futile gesture, as if an enfeebled

agrarian economy like the South's could do much damage to a major industrial economy like the North's, one which was moreover orientated towards export to Great Britain and the Empire.

In general, therefore, the new government of Northern Ireland could get on with its business uninhibited either by London – which was sick of Ulster and simply did not want to know – and Dublin, which had its own problems. But its business was dismal. In January 1922, as the Dáil was voting for narrow acceptance of the Treaty, the province erupted. The IRA effectively declared war on the new statelet.

In the first elections for the new Northern Ireland provincial parliament in May 1921, partition had done its work. The Unionists won 40 of the 52 seats. This would seem to have justified the Unionist strategy, of holding only as many counties as could guarantee a unionist majority, while abandoning the three Ulster counties that were most strongly nationalist. In fact, it was an insensitive partition which – far from separating irreconcilable communities – merely made trouble for the future. By refusing absolutely to breach county boundaries, it invited anomalies. As one historian summarised it years later, it condemned the two communities not to live apart but to live together.

Most obviously, two of the six counties, Fermanagh and Tyrone, had nationalist majorities. So had south Armagh and south Down. Yet these were embraced in the new statelet, in the case of Fermanagh and Tyrone because their inclusion was consistent with an overall unionist majority in the maximal space; in the case of south Down and Armagh, because the overall county numbers were in favour of the unionists. On a similar logic, north Monaghan, a salient that pushed into the underbelly of Northern Ireland and whose political demography was almost identical to that of south Armagh to the east of it, was abandoned to the South because the overall county headcount was in favour of the nationalists.

The net effect of all this was to leave a nationalist minority of about 35 per cent trapped in the Protestant statelet, a figure not at all reflected in the election result which, as we saw, gave 43 per cent of seats to Unionist candidates. It meant that there was a large, alienated and desperate minority within the borders of the new provincial administration, feeling itself abandoned to the tender mercies of the sectarian enemy. It was, in fact, the mirror image of the fear that had gripped Ulster unionists when home rule first loomed in sight all those years before.

Northern nationalist fears were amply justified by the new Belfast

government's reaction to the first IRA actions against the state. In April 1922, it passed the Special Powers Act. As we saw in Chapter 8 (pp. 176–179), the violence in the first half of that year was ratcheted up on both sides. The government formed a new police force, the Royal Ulster Constabulary, in effect a provincial extension of the old RIC. It also mobilised a police reserve, the Ulster Special Constabulary, known more commonly as the B Specials. This was an exclusively Protestant force, for all the world like the Irish militia of the 1790s that had helped suppress the 1798 rising. It was formed for a similar purpose and with a similar sensibility. One estimate of police and B Special numbers reckoned that one in six households in the province were represented in uniform, an even more startling figure when you exclude nationalists from the calculation. Protestant Ulster may not have been a police state as commonly understood, but it was a pretty good imitation of one.

The IRA violence of the first half of 1922 failed in its objective, the strangling of Northern Ireland at birth. Hundreds died, with Catholics bearing the worst brunt of the casualties. Following the assassination by the IRA of a Unionist MP, W.J. Twaddell, in May, internment without trial was introduced by Craig's government. Nationalists boycotted the Belfast parliament. Twenty-one nationalist-controlled local authorities – mainly in the west of the province – declared their allegiance to Dáil Éireann. Between these decisions and the IRA campaign, unionists drew the conclusion that all nationalists were opposed to the very existence of the state and that therefore any attempt to appease them was futile. It was a conclusion that was already pre-formed in many unionist minds.

It brought out the worst in Ulster unionism, personified not by Craig – who was not a bigot – but by the Minister of Home Affairs, Richard Dawson Bates, who was. He was granted a free hand in security matters and he played it ruthlessly. A solicitor, he had been secretary of the Ulster Unionist Council since 1906 and Craig reckoned that "he knew the mind of Ulster better than almost anyone else". (It was not the first or last time that a Unionist politician used the word Ulster in a context that implicitly excluded the nationalist minority.) Bates was not the only Protestant supremacist in high office but he was the most prominent by dint of his control of security: while he was responsible for stabilising the institutions of the new statelet following the IRA's 1922 campaign, he did so in a context that reinforced the alienation of the nationalist community. Northern Ireland was confirmed in its course of zero-sum politics.

In 1921, the local authorities that had pledged allegiance to the Dáil were suppressed. Proportional representation was abolished in local elections and was replaced for parliamentary elections in 1929. PR had been decreed for Ireland under the Government of Ireland Act 1920 in order to ensure the fair representation of minority interests. It was not thought necessary to introduce a similar measure for the 'mainland'. Precisely because it threatened to achieve its purpose, it was hateful to the new Belfast administration. To make assurance doubly sure, local authority electoral boundaries were enthusiastically gerrymandered – Dawson Bates, with his intimate knowledge of unionist electoral geography, in the van of this enterprise. Nationalists boycotted the commission that drew these boundaries, leaving Bates and his cronies a clear run. It is unlikely that results would have been much different had nationalists engaged with the process.

There remained one substantial piece of unfinished business: the Boundary Commission. Under Article 12 of the Treaty, the final determination of the border between Northern Ireland and the Free State was to be determined by such a commission. For nationalists, it offered the hope of such substantial transfers of territory from North to South as to render the vestigial Northern Ireland unviable. The same anxiety gripped Craig. Although he was himself prepared to engage with the commission, the very thought of such a thing enraged Bates and other ultras, to whom he deferred.

The government of Northern Ireland therefore had no formal representative on the commission, which met for the first time in November 1924. London asked a unionist journalist, J.R. Fisher, to represent Belfast's interest. Eoin MacNéill, Minister for Education in the Dublin government, was appointed Free State representative. London was represented by the chairman, Richard Feetham, a South African judge. The chairman's position was critical, for he was the only lawyer among the three, and his interpretation of Article 12 was decisive. He read it in minimal terms, as proposing only minor territorial transfers.

The deliberations of the commission occupied the best part of a year and then, at the last minute, were leaked to the press. Its proposals caused outrage in Dublin, which had harboured what were probably exaggerated expectations. The outcome was that all parties resolved to ignore the report, shelve it, and work the status quo. Thus the border lay where it was – and where it is.

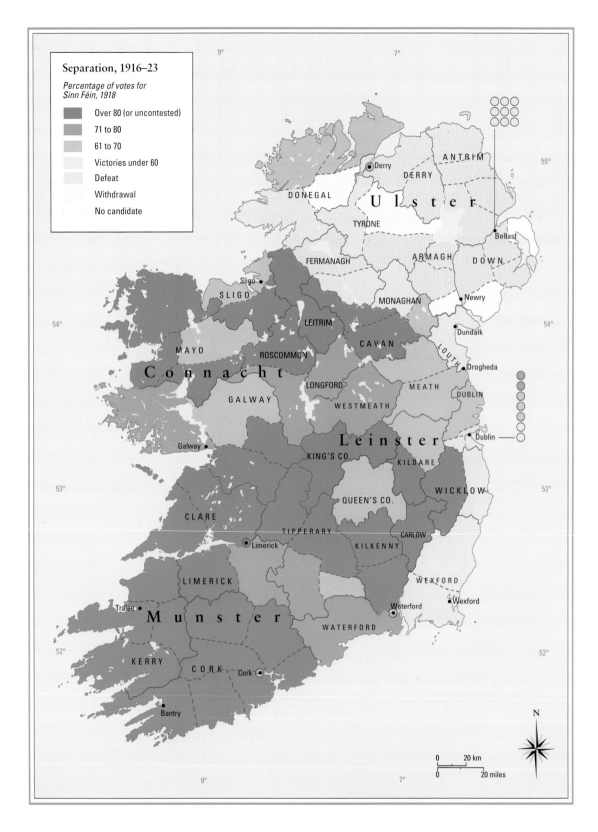

Separation, 1916–23

*Percentage of votes for
Sinn Féin, 1918*

Over 80 (or uncontested)
71 to 80
61 to 70
Victories under 60
Defeat
Withdrawal
No candidate

CONCLUSION

The Irish Revolution is a term sometimes used to summarise the events described in this book. Not all historians agree with it, but it has the merit of brevity. And whatever one thinks of the period from 1912 to 1925, it was turbulent and transformative. As noted earlier, it was a revolution in the sense that nationalist Ireland broke away from the British state; the governing elite of the state was a new class – overwhelmingly Catholic – that had been disadvantaged under the old regime.

The partition of the island, previously unthinkable, quickly became practical politics and was eventually accepted, albeit with resignation and reluctance. Even those who complained most bitterly about the injustices of partition were unable to offer any alternative that might work in the real world. I write as the centenary of partition approaches. If anything, it is more secure now than it was in 1921. The Belfast Agreement of 1998 and the St. Andrew's Agreement of 2006 saw to that: for the first time, the Catholics of Northern Ireland acquiesced in a partition settlement – not as their first option, but as the best that could be hoped for: the art of the possible. Ulster unionism, which has been making its point one way and another since 1885, has had its position vindicated – although its more frantic adherents can sometimes be slow to realise it.

Partition was contested and the legitimacy of Northern Ireland was challenged by its nationalist minority. No such ambiguity attended the new nationalist state established in the South. The Irish Free State/Republic has faced no existential challenge from within. Its rule has been legitimate in the eyes of its population and its international standing has never been questioned. Even those who opposed the nature of the new state – as a betrayal of republican

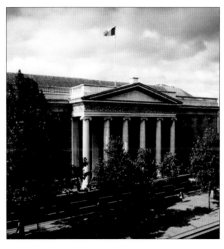

The tricolour flies over the GPO in Dublin; the most symbolic advance that the 1922 settlement represented relative to home rule.

ideals – quickly learned to work its machinery and to adapt it to their own purposes. This effectively describes de Valera's governments after 1932. Only a tiny, irreconcilable minority – statistically of no account – denied the legitimacy of the state. After 1922, nationalist Ireland south of the border was comfortable in its skin – too comfortable, in the eyes of those few who saw in it only a dismal, fearful theocracy.

So the events of the Irish Revolution were decisive. They resulted in a series of enduring new departures. Moreover, these were of a kind that could not possibly have been predicted at the beginning of the process. We can take one example from literature. One of the most compelling insights into the mind of popular Irish nationalism is set in 1904, in Barney Kiernan's pub in Little Britain Street, just off Capel Street in Dublin. The Cyclops episode of *Ulysses* is a mixture of conversational realism and satirical lampoon: although Joyce was a nationalist and a Parnellite (like his father before him) he was sceptical of nationalism's cultural insularity, and made hay with it in this pub scene. But for the purposes of this review, two things stand out. First, it is hard to imagine any other city in the contemporary United Kingdom where the royal family could be spoken of openly with such scorn and malice: the fundamental illegitimacy of British rule was already established and its most sacred symbol could be publicly and volubly ridiculed and traduced without fear of reprisal. Second, it is clear from the context that most of those speaking to this theme believed that while home rule was coming, British rule was not departing. Nowhere is there a hint that separatism is practical politics, while its principal advocate, the Citizen, is represented as a soak, a cadger and a blowhard.

Yet separatism was a reality within twenty years.

Partition created two new government entities on either side of the border, and each faced a challenge in arms from within. Both governments reacted brutally to these challenges, but the Free State was more ruthless than the Belfast government. Bad as the latter was, it did not execute prisoners in cold blood. Some of the atrocities perpetrated by the Free State would have been denominated war crimes by later generations. The stresses on the fledgling Free State government were enormous – in Kevin O'Higgins' memorable formulation, "just a group of eight young men in City Hall, with mad-

men screaming through the keyhole" – but the response betrayed more than stress. There was a strong authoritarian streak in Irish nationalism, reflecting perhaps the culture of the authoritarian Church to which the vast majority on both sides adhered, and echoed in the iron discipline that Parnell had instilled in the Parliamentary Party.

The speed with which the losers were reconciled with electoral democracy was impressive. It required some intellectual gymnastics from de Valera when eventually taking the oath of allegiance in 1927, but Dev was just the man for that kind of work. Normality was restored. It was a drab kind of reality, not least after the lightning flashes of the Revolution, but it represented the great continuity in Irish nationalist life. Indeed, the entire revolutionary period might plausibly be seen as an exceptional era in Irish history, a departure from the normal pattern which quickly reasserts itself when the dust settles.

One of the enduring myths created by the Revolution was the apostolic succession of rebellions against British rule: 1641, 1691, 1798, 1848, 1867 and – top of the bill – 1916. Pearse was the principal maker of this myth, and it has stuck fast. It seems that no amount of subtle qualification and quibble can subvert it. Never mind that the very idea of nationalism did not exist in the seventeenth century: Owen Roe O'Neill and Patrick Sarsfield are still dragooned into Pearse's Pantheon. And then the curse came upon us, for not only did Irish nationalists come to swallow this hokum of continuity, others did as well – as casual references to 'Ireland's tragic and violent past' bear testimony.

In fact, political violence in Ireland was the historical exception rather than the rule. The violence that was more endemic and pervasive was of the agrarian variety. The Whiteboys, Defenders and Ribbonmen of the eighteenth and early nineteenth century; the Tithe War of the 1830s; the Land League and the Plan of Campaign in the 1880s; and even later cattle drives and depredations directed against so-called 'ranchers' represented a more plausible continuity. The Land Act of 1903 drew the sting of that tradition and accomplished the real, enduring revolution in Ireland – and a thoroughly reactionary one at that. Land mattered most. Once that issue was settled, the national question took centre stage. It found expression primarily in parliamentary politics, at Westminster until 1912 and in Dáil Éireann tentatively from 1922 and definitively from 1927. The three tributary streams that made the so-called Irish Revolution

possible were: the treason of the Ulster loyalists; the accelerating moral collapse of British rule in the south; and the unique opportunity afforded by the Great War. It was a chance conjunction of circumstances, a fluke, which is why so many things that had been unthinkable in 1910 were reality by 1925.

Rebellion and violence are irresistible, sexy. They frame history as a heroic freedom narrative. In a world in which nationalism is taken for granted as the natural order of things (a very recent assumption in historical time) they propose a structure to the past which is easily grasped and understood. And it makes people feel good: we fought for it, seized it for ourselves. All nations fool themselves in this way: it is a necessary fiction. Compared to France or the Low Countries or Germany, Ireland has had a notably non-violent past, at least in military terms. Ireland does have a violent past if the only point of comparison is with Britain, and it is this subtle colonialism of thought that has helped to get the idea of Irish violence so universally accepted. About 30,000 people died in the 1798 rising, the most turbulent month in modern Irish history. That is almost certainly fewer than died at Austerlitz in 1805; it is fewer than the deaths at Waterloo; fewer than the total casualties at Gettysburg alone; not to mention the slaughterhouses of the Western Front.

It is because Ireland's past has been so non-violent in the military and political sense that the period after 1912 seems to flame like a meteor. The tributaries that flowed together to make the revolutionary moment possible had never flowed that way before, nor have they since.

If, as I believe, the real revolution was the land settlement of 1903, it is hardly surprising that the idealism of the political revolution was so quickly discounted. In the Irish civil war, the Irregulars had all the best tunes and most of the attractive people. Young writers like O'Faolain and O'Connor were republicans; Ernie O'Malley's *On Another Man's Wound* was the most distinguished literary testament to emerge from the conflict. Energy and creativity inclined to the Republic. The Free State had the safe and snug people, the winners from 1903 who had too much to lose by truckling with idealism.

But these people were without question a majority in nationalist Ireland, and even when they transferred their support to de Valera after 1932, Ireland remained a deeply conservative country, domi-

nated by an adhesive class of farmers, teachers, members of the professions, bureaucrats and – ever and always the integrating element – the Catholic clergy, to whose interests mere politics almost always deferred. In every other European country which had achieved independence following the Great War and the destruction of empires, agrarianism, clericalism and the cult of nativism all inclined towards some form of authoritarian or military government. It was part of the appeal of Italian fascism and of the Nazis. It was present in Poland, Hungary and Romania, all of which had authoritarian regimes between the wars.

Yet the Irish version of romantic, anti-modern agrarianism found no such military outlet, despite the authoritarian undertow in the political culture already noted. This requires some explanation. It is hard to account for this exceptionalism without reference to the nature of the state from which nationalist Ireland had separated itself. The UK differed from the defeated imperial powers of central and eastern Europe in having a long tradition of representative institutions, in particular the House of Commons. The UK did politics. The Habsburgs and the Romanovs and the Ottomans did government and administration from the top down, full stop. The British system, in which Irish nationalism was immersed and from which it sought to detach itself, created a public opinion and a series of powerful representative political institutions that had no analogue in the defeated continental empires.

This was the context in which Irish nationalism found its feet from 1829 on. Substantial reforms in 1841 and 1898 introduced greater levels of popular and democratic control at local government level. Politics in Ireland was not just about Westminster: it was about the progressive development of a public sphere, right down to county and town level. It was about elections, with an ever widening franchise as the nineteenth century went on. Nationalism took to a populist version of democracy that often horrified gentlemen in parliament, but Ireland embraced it with a vengeance and exported it throughout the English-speaking world on the backs of the post-Famine diaspora.

It is hard to escape the conclusion that the remarkable stability of post-revolutionary Ireland, and its reflexive search for political rather than military solutions, derived at least in part from the long political incubation under British rule.

Partition was the key development of the Irish Revolution. It

created two states where there had previously been an unthinking assumption of insular unity. Moreover, the line of partition was drawn on openly confessional grounds. Protestant Ireland separated itself, as best it could, from Catholic Ireland.

This was a source of real social stability in the South. The Free State was now overwhelmingly Catholic, something that was pleasing to many for whom Catholicism was the true badge of Irish identity. It was a country whose displays of unthinking Catholic triumphalism persisted until the gradual secularisation of society, which began tentatively in the 1960s, developed an alternative civic ethic. The Eucharistic Congress of 1932; the overwhelming public support for Franco in the Spanish civil war; the censorship of books and the banning of contraception and divorce; the packed churches; public processions such as Corpus Christi with Irish Army personnel providing guards of honour; the deference to the Catholic clergy; the Mother and Child debacle of 1951 – these were defining images of time and place.

What the South had obtained was something with which it was comfortable: withdrawal from modernity into an agrarian stasis, the kind of arcadia celebrated by de Valera in his famous St. Patrick's Day address of 1943. This has been the source of much mirth in recent decades. In 1943, it was unremarkable and uncontested, conventional wisdom eloquently expressed.

There was a price to pay for all this, and it was paid by those excluded from this petit bourgeois idyll: emigrants driven by economic necessity; the urban working class, still waiting; writers, artists and business people with larger horizons whose faces did not fit the right little, tight little state. But at least government and administration had something that the late British regime had lacked: legitimacy. Whatever its shortcomings, and as time went on there was no shortage of critics to point them out, the Irish Free State/Republic of Ireland worked.

Its small Protestant minority was, for the most part, left alone; ignored rather than anything else. There had been a number of overtly sectarian attacks and murders during the War of Independence and the civil war, and the burning of country houses in what seemed at times like a nihilistic peasants' revolt. After 1922, there were occasional flashes of Catholic sectarian intolerance but the wonder was, given the historical overlap of confessional and constitutional allegiance, that there had not been more. The secular, Wolfe

Tone tradition in Irish nationalism troubled the nationalist conscience and helped to save the South from the unapologetic sectarianism of Northern Ireland.

Up North, of course, no comparable equilibrium was possible. Such stability as there was rested on an internal apparatus of ferocious control, which even then was subject to frequent challenge from an irreconcilable minority big enough to be troublesome. Rather like the settlement in the South, the arrangements put in place by partition lasted until the 1960s and then began to unravel. In the case of Northern Ireland, as everyone knows, the unravelling was the source of tragedy and farce.

The requirement to establish ethnically secure national states in Europe after World War II was accomplished only at the price of the greatest forced transfer of population in history. The old multinational and multi-lingual and multi-cultural empires were dust. To replace them with nation states meant majoritarian rule and displacement for minorities.

The one major part of the continent where this process of ethnic uniformity was impossible was the Balkans. With the fall of communism after 1989, we know what happened: aggressive expansive nationalism in Serbia and Croatia and the tragedy of Bosnia, where the ethnic and religious mix was particularly tangled. It took the force majeure of the United States to re-stabilise the region.

Northern Ireland was and is a mini-Balkans, a narrow ground occupied by a divided population with competing and irreconcilable national claims. The only external force potentially capable of mediating between these claims – the government of the United Kingdom – was compromised by its identification with the unionist side. The decision, under the Anglo-Irish Agreement of 1985, to give the Dublin government a voice in the affairs of the province was an indispensable condition for the nervous peace that eventually followed and that still holds.

The great intractable conundrum of the Irish Revolution of 1912–25 had been how to satisfy nationalist demands while maintaining insular unity. It proved to be beyond everyone. That problem has now shrunk to the little territory of the Ulster Balkans, where it is held in a nervous suspense. Some see it as unfinished business. Others, perhaps wiser, see it as business incapable of any fulfilment. We muddle through as best we can.

BIBLIOGRAPHY

Bardon, Jonathan, *A History of Ulster*, Belfast 1992

Bardon, Jonathan, *A History of Ireland in 250 Episodes*, Dublin 2008

Barry, Tom, *Guerilla Days in Ireland*, Dublin 1949

Bartlett, Thomas, *Ireland: A History*, Cambridge 2010

Bew, Paul, *Ideology and the Irish Question: Ulster Unionism and Irish Nationalism 1912–1916*, Oxford: Clarendon Press 1994

Bew, Paul, *Ireland: The Politics of Enmity 1789–2006*, Oxford University Press 2007

Bowman, John, *De Valera and the Ulster Question, 1917–73*, Oxford 1982

Boyce, D. George, *Nationalism in Ireland*, London 1982

Boyce, D. George, *Nineteenth-Century Ireland: The Search for Stability*, Dublin 1990

Brooke, Peter, *Ulster Presbyterianism: The Historical Perspective 1610–1970*, Dublin 1987

Bruce, Steve, *The Red Hand: Protestant Paramilitaries in Ireland*, Oxford 1992

Bull, Philip, *Land, Politics and Nationalism: A Study of the Irish Land Question*, Dublin 1996

Callanan, Frank, *The Parnell Split 1890–91*, Cork 1992

Caulfield, Max, *The Easter Rebellion*, Dublin 1995

Comerford, R.V., *The Fenians in Context: Irish Politics and Society 1848–1882*, Dublin 1985

Connolly, S.J., ed., *The Oxford Companion to Irish History*, Oxford 1998

Coogan, Tim Pat, *The IRA*, London 1980

Coogan, Tim Pat, *Michael Collins: A Biography*, London 1990

Coogan, Tim Pat, *de Valera: Long Fellow, Long Shadow*, Dublin 1993

Curran, Joseph M., *The Birth of the Irish Free State, 1921–23*, Alabama 1980

Dudley Edwards, Ruth, *Patrick Pearse: The Triumph of Failure*, London 1977

Elliott, Marianne, *The Catholics of Ulster: A History*, London 2000

English, Richard, *Irish Freedom: The History of Nationalism in Ireland*, London 2006

Ferriter, Diarmaid, *The Transformation of Ireland 1900–2000*, London 2004

Fitzpatrick, David, *Politics and Irish Life 1913–21: Provincial Experiences of War and Revolution*, Dublin 1977

Foster, R.F., *Modern Ireland 1660–1972*, London 1988

Garvin, Tom, *The Evolution of Irish Nationalist Politics*, Dublin 1981

Garvin, Tom, *Nationalist Revolutionaries in Ireland*, Dublin 1987

Garvin, Tom, *1922: The Birth of Irish Democracy*, Dublin 1996

Hart, Peter, *The IRA and Its Enemies: Violence and Community in County Cork 1916–1923*, Oxford 1998

Hegarty, Shane and O'Toole, Fintan, *The Irish Times Book of the 1916 Rising*, Dublin: Gill & Macmillan 2006

Hickey, D.J. and Doherty, J.E., eds, *A New Dictionary of Irish History from 1800*, Dublin 2003

Hopkinson, Michael, *Green Against Green: The Irish Civil War*, Dublin 1998

Hopkinson, Michael, *The Irish War of Independence*, Dublin 2002

Jackson, Alvin, *Ireland 1798–1988*, Oxford 1999

Johnston, Kevin, *Home or Away: The Great War and the Irish Revolution*, Dublin 2010

Keogh, Dermot, *Twentieth-Century Ireland: Revolution and State Building*, Dublin 2005

Lalor, Brian, ed., *The Encyclopaedia of Ireland*, Dublin 2003

Lyons, F.S.L., *Charles Stewart Parnell*, London 1977

Lyons, F.S.L., *Culture and Anarchy in Ireland, 1890–1939*, Oxford 1979

McCormack, W.J., *Dublin 1916: The French Connection*, Dublin 2012

McGee, Owen, *The Irish Republican Brotherhood from the Land League to Sinn Féin*, Dublin 2005

Maume, Patrick, *D.P. Moran*, Dublin 1995

Miller, David W., *Church, Station and Nation in Ireland, 1898–1921*, Dublin 1973

Miller, David W., *Queen's Rebels: Ulster Loyalism in Historical Perspective*, Dublin 1978

Mitchell, Arthur, *Revolutionary Government in Ireland: Dáil Éireann, 1919–22*, Dublin 1995

Moody, T.W., ed., *The Fenian Movement*, Cork 1968

Murphy, Gerard, *The Year of Disappearances: Political Killings in Cork 1921–22*, Dublin 2010

O'Brien, Conor Cruise, *States of Ireland*, London 1972

O'Day, Alan, *Irish Home Rule, 1867–1921*, Manchester 1988

Ó Gráda, Cormac, *Ireland and New Economic History 1780–1939*, Oxford 1994

O'Halpin, Eunan, *The Decline of the Union: British Government in Ireland, 1892–1920*, Dublin 1987

Stephens, James, *The Insurrection in Dublin*, Dublin 1916

Stewart, A.T.Q., *The Ulster Crisis: Resistance to Home Rule, 1912–14*, London 1967

Stewart, A.T.Q., *The Narrow Ground: Aspects of Ulster, 1609–1969*, London 1977

Townshend, Charles, *Political Violence in Ireland: Government and Resistance Since 1848*, Oxford 1983

Townshend, Charles, *Easter 1916: The Irish Rebellion*, London 2003

Wright, Frank, *Northern Ireland: A Comparative Analysis*, Dublin 1988

Yeates, Padraig, *Lockout: Dublin 1913*, Dublin 2000

INDEX

ACKNOWLEDGEMENTS

For permission to reproduce photographs, the author and publisher gratefully acknowledge the following:

© Alamy: 18, 22/23, 44, 58, 66, 136, 211; © Corbis: 107, 131, 153, 156, 183; © Getty Images: 13, 14, 15, 19, 20, 24/25, 30, 46, 49, 53, 57, 60, 65, 72, 76/77, 78, 82/83, 96, 102/103, 110/111, 117, 121, 122, 135, 137, 141, 144/145, 149, 151, 154, 169, 178, 185, 192, 195, 198, 203, 204; © Irish Military Archive: 79; © Mary Evans Picture Library: 92, 170; © National Maritime Museum, Greenwich, London: 99; BELUM.Y8255 © National Museums Northern Ireland, Collection Ulster Museum: 51; © Peter Newark's Historical Pictures: 37; © RTÉ Stills Library: 91; © Topfoto: 168; Courtesy of Dublin City Public Libraries: 70, 125; Courtesy of George Morrison: 55; Courtesy of Limerick City Museum: 132; Courtesy of the National Library of Ireland: 48, 61, 64, 68, 95, 104/105, 158/159, 180, 197.

The author and publisher have made every effort to trace all copyright holders, but if any have been inadvertently overlooked we would be pleased to make the necessary arrangement at the first opportunity.

Cartography and Design: Jeanne Radford, Alexander Swanston and Malcolm Swanston